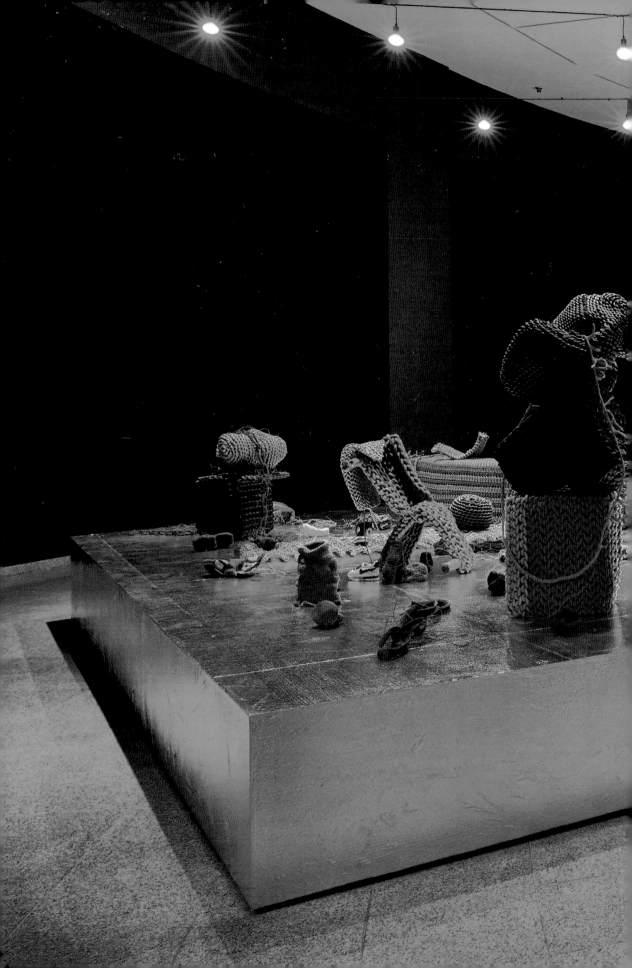

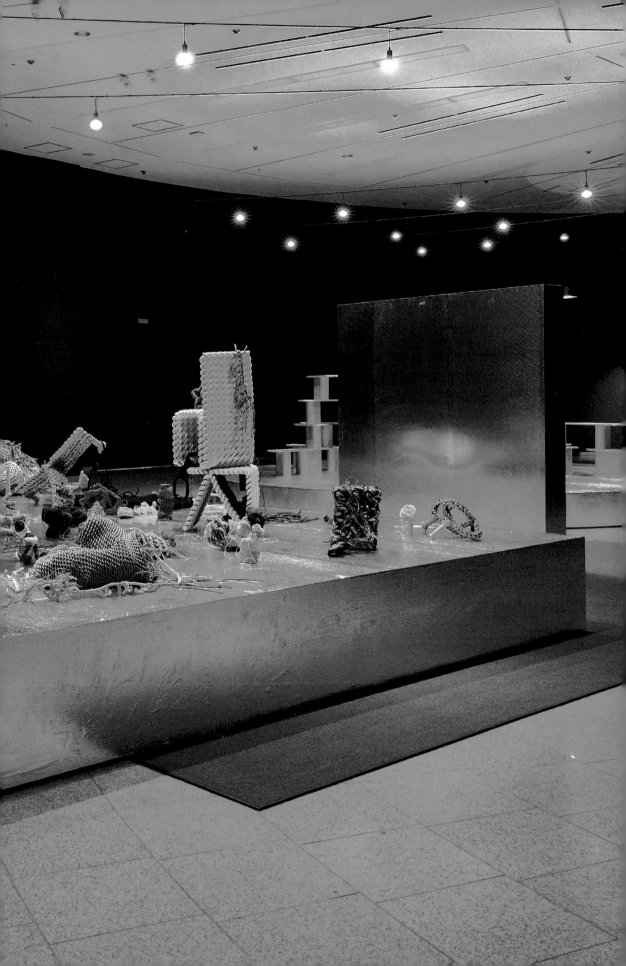

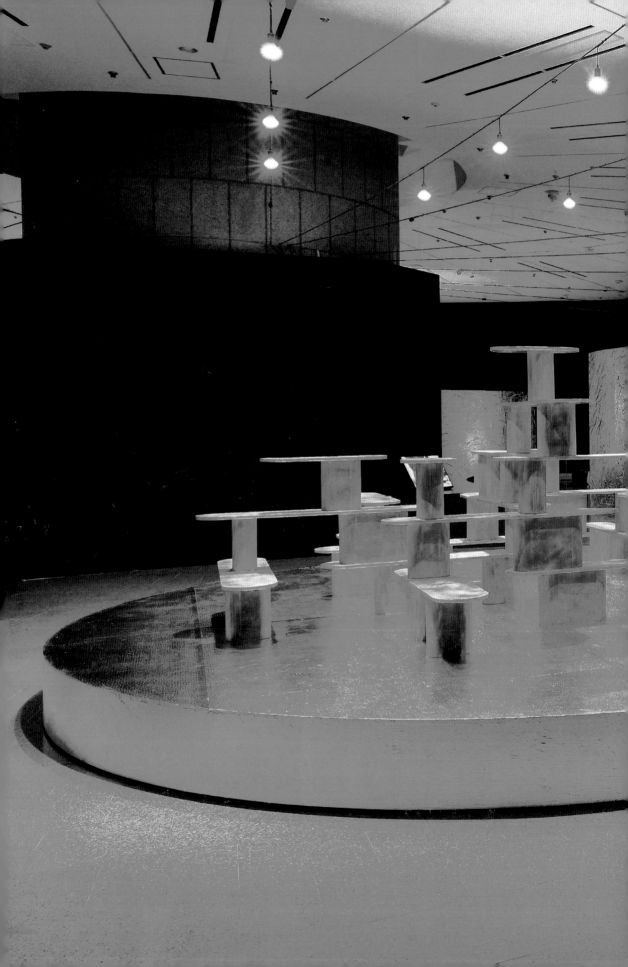

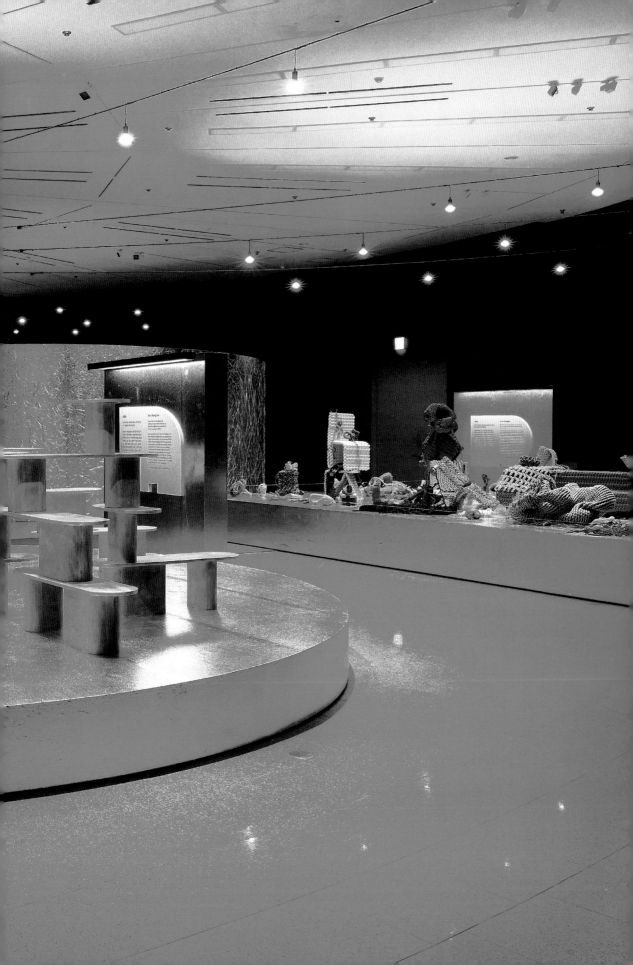

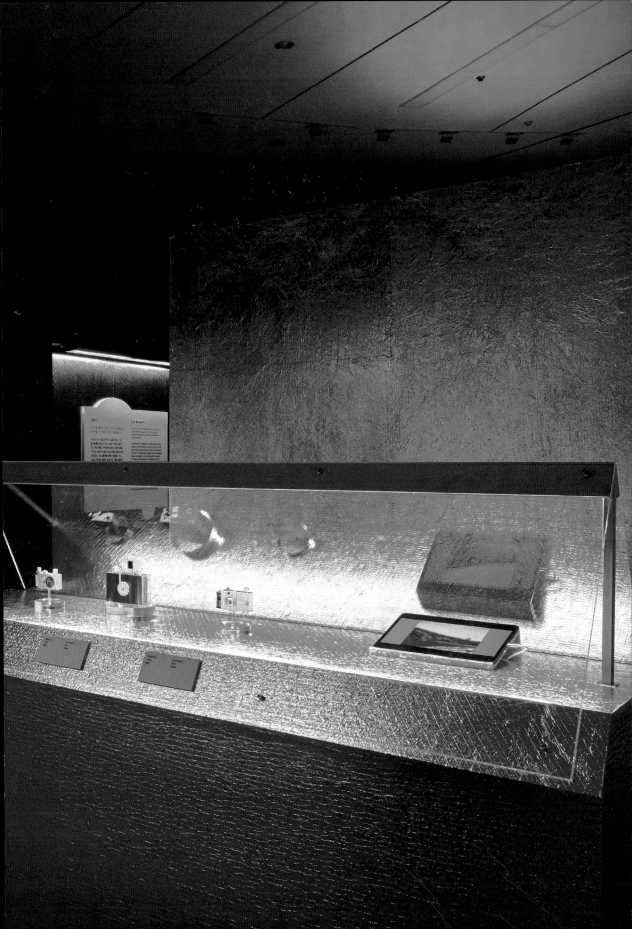

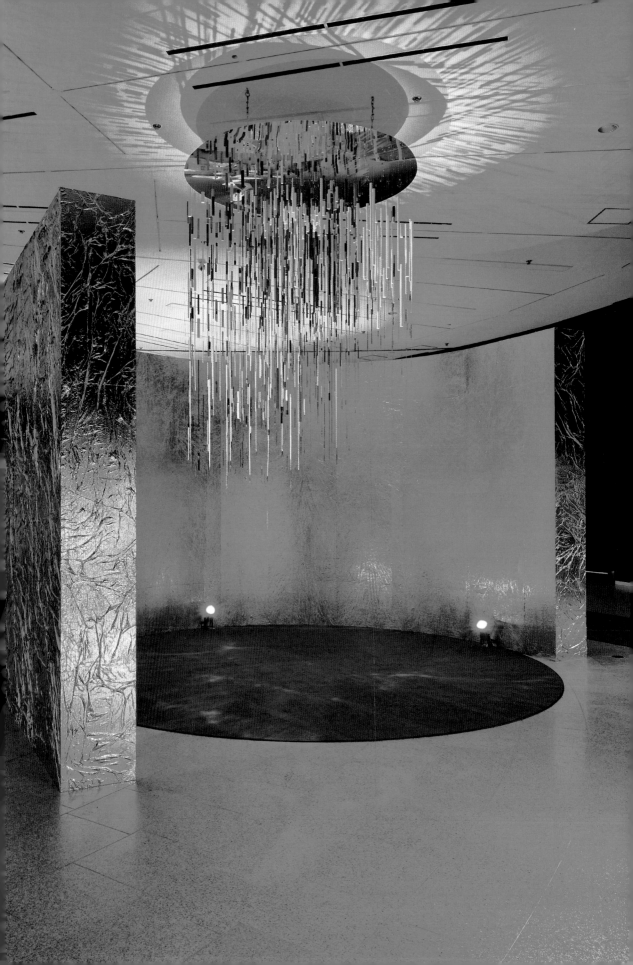

놀이하는 사물

국립현대미술관 발행
경기도 과천시 광명로 313
02-2188-6000
www.mmca.go.kr

발행일: 2021년 8월
발행인: 윤범모

글: 노명우, 박남희
편집: 도화진
편집 지원: 김유란
디자인: 코우너스
사진: 정현우
번역: 황선혜
인쇄, 제본: 세걸음

ISBN: 978-89-6303-276-4

SWITCH THINGS UP

Published by National Museum of Modern and
Contemporary Art, Korea
313 Gwangmyeong-ro, Gwacheon-si, Gyeonggi-do,
13829, Korea
+82 2 2188 6000
www.mmca.go.kr

First Edition: August 2021.
Publisher: Youn Bummo

Text: Nho Myungwoo, Park Namhee
Editing: Do Hwajin
Editorial Coordination: Kim Yuran
Graphic Design: Corners
Photography: Jung Hyunwoo
Translation: Hwang Sunhye
Printing, Binding: Segeoleum

ISBN: 978-89-6303-276-4

일러두기
작가 순서는 전시장 구성 방향에 따라 표기하였습니다.

Acknowledgement
The names of the artists are listed in the viewing
order of the exhibition.

차례

Contents

발간사

《놀이하는 사물》은 '손'의 능력을 활용하여 작품을 창조적 '놀이'의 영역으로 승화시키는 작가들과 함께 꾸몄습니다. 이 전시는 '제작'의 의미와 가치를 동시대적 경향으로 재생산하고 창작활동의 사회적 역할을 살펴보게 합니다. 나아가 재료가 가진 고유한 물성과 숙련된 기술을 통합하여 조화로운 사물의 언어를 '손'으로 빚어내는 호모루덴스(Homo Ludens 놀이하는 인간), 즉 작가를 제작자(makers)로 보고 그들을 재조명하려 합니다.

전시는 네덜란드의 문화사가 요한 하위징아(Johan Huizinga, 1872–1945)가 인간을 "놀이하는 인간"으로 명명한 데에서 시작하여, 효율성을 우선시하는 현대사회에서 인간의 본성인 놀이하는 능력의 재정립과 필요성을 환기시키고, '놀이' 그 자체에 의미를 두고, 과정을 즐기는 것에 주목했습니다. 《놀이하는 사물》의 8명(팀)의 참여 작가들은 자신의 기억과 경험을 바탕으로 다양한 소재로 '놀이하는 사물'을 선보이며, 우리가 살아가는 세계와 새롭게 관계 맺기를 권합니다. 일반적인 사물의 '색다른 쓰임'을 들여다보는 시간, 일상에 상상력을 불어넣는 환상의 공간을 제시합니다.

국립현대미술관 과천은 건축, 공예, 디자인 등을 주목하여 장르 확장 및 균형을 지속적으로 모색하고, 그리고 가족 중심의 미술관으로 자리매김하고자 합니다. 이러한 기저에서 다양한 재료와 물성을 기반으로 하는 매체적 성격을 지닌 공예 작가와 그들의 작품을 통해, 공예의 미적 가치를 환기하고 일상을 발견하는 장소로서

Preface

SWITCH THINGS UP has been made possible through artists who have applied the capability of their "hands" to progress their works into the creative realm of "play." This exhibition reproduces the meaning and value of "making" as a contemporary tendency, and examines the social role of artistic activities. Furthermore, the exhibition sheds a new light on the artists as "makers," or Homo Ludens (Man the Player) who combine their skilled technique with the unique properties of their materials to create a harmonious language of objects through their "hands."

The Dutch historian and cultural theorist Johan Huizinga (1872–1945) termed humans "Man the Player," and he re-established the importance and necessity of the human instinctual ability to play in the contemporary society which values efficiency, and focuses on valuing "play" itself and enjoying its process. The eight participating artists and artist teams in the exhibition presents "playing objects" under various subjects based on their memories and experiences, inviting the audience to form new relationships with their world. They offer the audience the chance to witness "unconventional ways of using" objects, and a fantastic space which infuses imagination into the quotidian life.

The National Museum of Modern and Contemporary Art, Gwacheon, continues to explore ways to expand and balance different genres with focus on architecture, craft and design, and endeavors to establish itself as a family-oriented art

기능하기를, 더불어 장기간 코로나19로 지친 관객들에게 위로와 새로운 영감의 기회가 되기를 바랍니다.

이번 전시가 가능하도록 애써주신 참여 작가들과 전시 개최를 위해 협업해주신 많은 분께 감사의 말씀을 올립니다.

윤범모
국립현대미술관장

museum. As an extension of such efforts, we hope that the museum can become a site where the aesthetic values of craft and everyday life are revived and discovered, through the works by craft artists who place a strong emphasis on the medium of diverse materials and properties of matter. Finally, we hope that the exhibition can present comfort and new inspirations to the visitors, in our long weary days of COVID-19.

We would like to express a heartfelt gratitude to the participating artists and to many collaborators who worked hard to make this exhibition possible.

Youn Bummo
Director, National Museum of Modern and Contemporary Art, Korea

놀이하는 사물

SWITCH THINGS UP

놀이하는 사물

SWITCH THINGS UP

도화진
국립현대미술관 학예연구사

놀이, 놀이하기

놀이는 인간의 삶 속에서 어떤 행동을 지칭하는 단어로 자주 쓰인다. 그것은 유희적 성격을 포함하며, 가장 광범위한 영역의 신체적 활동과 함께 정신적인 유희상태까지 놀이의 범주로 여겨진다. 사유를 통한 놀이는 자유롭게 바다와 사막, 하늘과 우주를 오가며 무한한 상상력을 품은 어린아이의 세계로 유도하며 우리를 한껏 자유롭게 한다. 동시에, 가장 원시적인 손을 통해 세상을 모방하고 새로운 것을 만들 수 있는 원리를 깨달으며, 더 아름다운 것, 더 고상한 것으로 만들려고 한다. 이처럼 놀이는 인간의 사유가 수반되는 고차원적인 행위로 전 시대와 연령을 아울러 흥겨움을 동반한 자유롭고 해방된 활동이다. 이를 통해 얻어지는 유희적 감성은 우리를 또 하나의 가상과 상상의 공간으로 회귀시키며, 우리 삶이 가진 불완전함으로부터 새로운 생성의 과정으로서 바라보고 꿈꿀 수 있게 만들어준다. 즉 놀이는 즐거움과 흥겨움을 동반하는 가장 자유로운 활동이며, 삶의 재미를 적극적으로 추구하는 활동이다.

"우리의 시대보다 더 행복했던 시대에 인류는 자기 자신을 가리켜 감히 "호모 사피엔스(Homo Sapiens: 합리적인 생각을 하는 사람)"라고 불렀다. 하지만 세월이 흐르면서 우리 인류는 합리주의와 순수

Do Hwajin
Curator, National Museum of Modern and Contemporary Art, Korea

Play, Playing

Playing is often used to define a certain human action. This action with a playful personality ranges from the broadest scope of physical activities to the psychological state of amusement. Cognitively playing allows us to freely traverse across the ocean, desert, sky and universe, liberating and leading us to a world of infinite imagination of a child. At the same time, play allows us to mimic the world through the primitive hands, leading us to make new things that are more beautiful and sophisticated. As such, play is a highly dimensional pursuit that accompanies human thought, as well as a truly liberating activity that brings joy and delight to all ages and generations. The playful sensibility as an outcome of such activity transfers us to another space of imagination and fantasy, and allows us to dream and look at the imperfections of our life as new processes of creation. To sum up, play is the most spontaneous and liberating activity that's charged with delight and pleasure, which exuberantly pursues the element of fun in life.

"A happier age than ours once made bold to call our species by the name of Homo Sapiens. In the course of time we have come to realize that we are not so reasonable after all as the Eighteenth

낙관론을 숭상했던 18세기 사람들의 주장과는 다르게 그리 합리적인 존재가 아니라는 게 밝혀졌고, 그리하여 현대인들을 인류는 "호모 파베르(Homo Faber: 물건을 만들어내는 인간)"라고 부르기 생각했다. (중략) 인간과 동물에게 동시에 적용되면서 생각하기와 만들어내기처럼 중요한 제3의 기능이 있으니, 곧 놀이하기이다. 그리하여 나는 호모 파베르 바로 옆에, 그리고 호모 사피엔스와 같은 수준으로, 호모 루덴스(Homo Ludens: 놀이하는 인간)를 인류 지칭 용어의 리스트에 등재시키고자 한다."[1]

네덜란드의 문화사가 요한 하위징아(Johan Huizinga, 1872–1945)가 우리를 "놀이하는 인간"으로 명명한 것은 단지 학문적 발견 이상의 놀이하는 인간으로 전환을 요청하는 것이기도 하다. 이는 재빨리 실행하고 '아주' 효율적인 것에만 가치를 두는 현대사회에 인간의 본성인 놀이하는 능력의 재정립과 필요성을 일으켜주며, '놀이'라는 그 자체에 의미를 두고, 목표를 이루는 것보다 과정을 즐기는 것, 생활의 즉각적인 필요를 초월하는 그 행동 자체에 주목한다. 노동으로만 단순하게 환원될 수 없는 우리 인간의 행위를 '놀이'를 중심으로 보며 '놀이하는 인간'으로 되돌림으로써 현시대의 비극에서 벗어날 수 있는 가능성을 찾기를 바랐다.

우리 곁의 호모 루덴스, '제작자들'

우리는 어린 시절 놀이 경험들을 성인이 되는 과정에서 스스로 닫아버리며 손과의 대면을

Century with its worship of reason and naive optimism, though us; hence modern fashion inclines to designate our species as Homo Faber, Man the Maker ... There is a third function, however, applicable to both human and animal life, and just as important as reasoning and making--namely, playing. It seems to me that next to Homo Faber, and perhaps on the same level as Homo Sapiens, Homo Ludens, Man the Player, deserves a place in our nomenclature."[1]

The Dutch cultural historian Johan Huizinga (1872–1945) referred to humans as "Man the Player" to suggest that the scholarly term actually transforms us into playing humans. This stirs up the urgency and necessity to re-establish the human instinctual ability to play in the modern society which values things that are quick and extremely efficient. It places significance on "play" itself, and focuses on the enjoyment of the process rather than the purpose, as well as the very activity that transcends the immediate necessities of life. Refusing to reduce human actions merely as labor, Huizinga regarded human activities as a center of "play" and attempted to restore "Man the Player" in us, hoping to find the possibilities to escape the tragedy of this age.

Makers: The Homo Ludens among us

Our childhood experiences of play erase themselves, and we come to take on a passive attitude in using our hands as we grow into adults. Artists on the other hand, expand their curiosity. H.-G. Gadamer(1900–2002), who suggested the existential dimension of play, asserted that "play" has a seriousness that draws out a

1 요한 하위징아 지음, 『호모 루덴스』, 이종인 옮김, (고양:연암서가, 2010[1938]), 20.

1 Johan Huizinga, *Homo Ludens*, trans. Lee Jongin (Goyang: Yeonam Seoga, 2010[1938]), 20.

수동적으로 받아들이는 데 반하여, 예술가들은 그 호기심을 연장한다. 놀이의 존재론적 차원을 개시한 가다머(H. -G. Gadamer, 1900–2002)에 따르면 '놀이함'은 어떤 신성한 힘을 끌어내는 진지함이 있고 놀이하는 사람이 진정으로 심취하였을 때 내면세계를 이끌고 표현하게 하며, 그것은 예술작품을 탄생시키는 근원이 될 수 있다고 강조한다. 이렇게 만들어진 예술작품은 미적 존재로서 의미를 지니며, 놀이 속에서 행해진 하나의 완결된 세계를 의미한다.

특히 개인의 감수성과 재료의 물성, 손의 숙련된 기술을 조화롭게 통합하여 사물을 만들어가는 예술가들은 '제작자'이자 '놀이하는 인간'이다. '정신이 손을 만들고 손은 정신을 만든다'는 프랑스의 미술사학자 앙리 포시용(Henri Focillon, 1881–1943)의 말처럼 단순히 눈과 상상, 정신으로 끌어낼 수 없는 공간, 재료, 터치를 통해 손의 가치와 재능을 통해 표현하는 이들이 제작자들이다. 이들은 다양한 소재를 다루며 쌓아온 기억과 경험을 바탕으로, 저마다의 무게와 거리를 재는 과정에서 세계에 대한 새로운 관계와 사용을 위한 낯설지만 즐거운 규칙을 제안한다. 때론 상상력을 보태어 기능적 목적 너머의 열망을 이야기하거나 현실에서 잠시 벗어난 환상의 공간을 선보이기도 한다. 또한 '상상'이라는 정신적 놀이를 매개로 '오브제의 변형과 재조합'이라는 행동적 놀이를 통해 하나의 결과물보다는 사물과 사람 사이에서 끊임없이 유희적 소통을 유발할 수 있는 매개체적인 성격을 지닌 '유희적 사물'을 보여준다.

《놀이하는 사물》전의 8명(팀)의 작가들은 자신만의 재료와 상상력으로 즐거운 놀이에 빠진 우리 곁의 호모루덴스들이다. 이들은 우리 사회의 원칙과 체계가 더욱 정교해지는 과정에서 생기는 지나친 진지함의 무게에 짓눌리지 말 것을 권유한다. 사물에 대한 보통의

certain sense of sacredness. He stressed that play has the power to lead and express the inner world of one immersed in their play, and emphasized this ability as the source of what creates a work of art. Artworks produced this way has meaning as an aesthetic entity, and signifies a complete world performed in play.

In particular, artists who create objects by harmoniously combining their own sensibility and skilled hands with the properties of their material are "makers" and "Man the Player." The French art historian Henri Focillon(1881–1943) once said "The mind rules over the hand; hand rules over mind." As illustrated by Focillon's statement, makers are those who apply the values and capabilities of the hands to express the space, materials and touches that cannot become manifest simply through the eyes, imagination and mind. Based on their accumulated memories and experiences of dealing with various materials, the makers propose their own unfamiliar but pleasing rules for using and forming new relationships with the world, in their own process of gauging weight and distance. At times, they add imagination to talk about the desires beyond the functional purpose, or present a fantastical space that momentarily deviates from reality. The makers also engage in a performative game of "transforming and recombining objects" through the psychological play of "imagination." And this play gives birth to "playful object" with an intermediary personality that can infinitely instigate playful communication between objects and people, rather than being one single outcome.

The eight makers and collectives in SWITCH THINGS UP are Homo Ludens among us who engage in a fun play through their own materials and imagination. They encourage us not

시선으로 다른 쓰임을 실험하며, 우리의 판단이 동요하거나 일상생활의 감각을 유지하도록 돕는다. 작업공간이 놀이터가 되고, 그 안에서 채집된 소재와 기억, 경험들이 서로 연관성을 가지며 과정을 즐기는 이들이다. 끝없는 상상과 호기심으로, 손으로 이어지는 수행자와 같은 과정으로, 명료한 형태에 자신의 뜻을 담으며, 그저 유연한 태도로 작품을 만들 뿐이다.

놀이하는 사물, Things Up

《놀이하는 사물》전은 '제작'의 의미와 가치를 새롭게 조명하고, '창조적 놀이'를 제안한다. 전시에 참여하는 8명(팀)의 작가들은 재료의 고유한 물성과 숙련된 기술을 통합하여 조화로운 사물의 언어를 빚어낸다. 그들의 손의 놀이로 만들어낸 제작과정과 결과물을 통해 자유롭고 창의적인 질문들을 우리에게 던진다. 느리지만, 다양한 재료를 새롭게 다시 보는 작가들을 '제작자'로 칭하고, 자신만의 시간을 엮어가며 손으로 '만드는 것', 그 과정을 즐기는 이들을 조명하고자 했다.

　　전시는 원형 공간에 총 8명(팀)의 제작자들의 작업방식과 운동, 변화, 연결, 결합 등 놀이의 요소를 통해 구현되는 사물에 따라 '관계하는 사물', '움직이는 사물', '사고하는 사물'의 세 개의 섹션으로 구분하였다. 동시에 각각의 제작자들의 자유로운 상상과 노고의 산물을 독립적이되 일부 간섭할 수 있도록 유기적으로 배치하여, 시각적인 감상 너머의 유희와 상호작용을 끌어내고자 하였다.

― 관계하는 사물

이광호, 서정화, 신혜림은 반복되는 과정과 다양한 재료들로 구성된 유닛이 만나 하나의 새로운

to be weighed down by the excessive seriousness that comes with the increasingly sophisticated principles and systems of our society. Experimenting with other uses while maintaining the ordinary perspective on objects, the makers strike a chord in us or help us maintain a balanced sense of everyday life. Their studios become a playground, and the makers enjoy the process of observing how the subjects, memories and experiences collected in such site come to have relationships with each other. As their endless imagination and curiosity take over their hands and bodies, the makers capture their will and intentions in definite and clear forms, working with an open and flexible attitude.

Things Up

SWITCH THINGS UP sheds a new light on the meaning and value of "making" and proposes the idea of "creative play." The eight makers and collectives in SWITCH THINGS UP combine their sharpened expertise and the unique physical properties of various material to create a harmonious language of objects. The exhibition gives us open and creative questions through the making process and outcomes of the hands in play. In this exhibition, "makers" refers to the artists who look at the various materials through a new perspective, even if it may take time. SWITCH THINGS UP illuminates those who enjoy such process of weaving and "making" their own time through their hands.

　　In a circular space, the total of eight makers and collectives in the exhibition are divided under three sections "Objects of Relationships," "Objects of Movement" and "Objects of Thought" depending on their work methodology and

풍경을 연출한다. 자발적인 행위가 거듭되면서
얻은 감각적 규칙과 질서들을 통해 '관계하는
사물'을 보여준다.

이광호의 작업은 유년 시절 주변의 일상
소재들로 다양한 놀이와 도구를 만들었던 순수한
호기심에 맞닿아있다. 이번 전시작은 나일론,
스펀지 폼, 전선, 알루미늄 등 기존 재료와 방식에
더해, 캐스팅과 3D프린팅 기술로 제작한 작품을
선보인다. 개개의 사물이 가진 다양한 색과
형태, 소재와 기법들은 짜임을 거듭하면서 '선'을
'면'의 형태로 유연하게 확장시킨다. 색과 재료를
연결시키는 '선'은 그 자체로 감정을 지니고 있어
작품의 분위기를 자유롭게 주도하고 있다. 이는
보는 이의 상상력을 자극하여 사물의 쓰임새를
한정짓지 않는 유연함으로 사물의 존재를 새롭게
다시 보는 즐거움, 그 속에서의 자신만의 놀이를
발견하도록 한다.

서정화는 형태와 소재에 대한 깊이
있고 유기적인 이해를 바탕으로 사물을 더욱
단순하고 순수하게 담아낸다. 신작 〈사용을
위한 구조〉(2021)는 직선과 곡선의 매스를
조합하여 익숙한 가구의 구조를 확장시킨다.
기존의 형태와 기능을 공간 안에서 극대화시키고,
구조의 반복과 중첩을 통해 작가의 형태적
탐색과 실험을 드러내는 작업이다. 주물로 뜬
알루미늄의 표면을 수십 번 사포로 다듬어 또 다른
텍스쳐를 만들어내고, 오일을 덮어 마감한다.
단일화된 형태를 의도적으로 반복함으로써 균형과
부피, 크기와 비례 같은 개별적 요소들을 더욱
단단하게 묶어준다. 다중적 구조 안에서 선보이는
네거티브 공간은 그 공간 속에 또 다른 형식의
포지티브한 형태를 드러냄으로써 다의적인 메시지
전달을 가능하게 만들고, 이는 주체적 공간으로
전환되기도 한다.

신혜림은 개인의 서사와 감정, 기억이
유기적으로 관계하며, 감고 쌓는 반복적인 행위를

through which element of play—such as movement, transformation, connection and combination—their objects are actualized. At the same time, the works are organically arranged in a way so as to allow the free imagination of each of the makers as well as their fruition of hard labor stand independently as well as partly intervene with each other, and to also draw out play and interaction beyond visual appreciation and reading of the works.

— Objects of Relationships

Lee Kwangho, Seo Jeonghwa and Shin Healim create a new landscape of units combining repeated processes and diverse materials. They demonstrate the correlations formed among objects through the rules and orders of the senses obtained by the repetition of voluntary actions.

Lee Kwangho's works stem from a sense of pure curiosity that drove him to come up with various tools and ideas for play using everyday materials in daily life during his childhood. The works in this exhibition take off from the methods and materials like nylon, sponge foam, cables and aluminum which the artist previously applied to his work, and include casting and 3D print works. The diverse colors and forms of each of the objects, and the materials and techniques continuously weave together to flexibly expand the "line" to a form of "plane." The line itself which connects colors and material is charged with emotions, freely leading the aura of the work. This stimulates the imagination of the viewer, allowing one to discover their own play in the joy of finding a new perspective on the object and its presence, with a flexibility that does not limit the use of the object.

Based on his profound and open understanding of form and subject,

통해 자신만의 시간을 끊임없이 기록한다. 〈시간의 비가 내린다〉(2021)의 선과 면 작업은 '작은 점'을 쌓아 선을, 그 선들이 '면'을 만들어가는 작업이다. 작은 개체가 반복적으로 쌓여 만들어낸 시간의 흔적은 마음을 동요시키는 밀도있는 공예적 제작과정의 결과로서 새로운 차원의 공간을 여는 매개체가 된다. 물리적인 밀도가 행위적인 것이 아니라, 그 행위 속에서 매일매일 완벽한 이미지를 획득하려는 집요함이 표현된 것이다.

— 움직이는 사물

현광훈, 이상민은 정확하고 복잡한 움직임을 위해 정교하게 구성되고 미묘한 반응을 유도하는 가변성을 지닌 사물을 제작한다. 하나의 사물 안에서 유기적으로 분리·결합하는 운동성을 부여하기 위해 기계의 매커니즘을 섬세하고도 집요하게 엮어간다.

　　현광훈은 자연스러운 움직임 속에 담긴 기계의 본질을 전한다. 신작 〈하트비트 III〉(2021)는 시계의 움직임을 볼 수 있는 시스루백케이스(See through back case)와 노출을 계산하는 매커니즘을 결합하여 물리적 연결 구조를 직관적으로 보여주는 작품으로 형태적 미감과 기계식 구조를 동시에 관찰할 수 있는 작품이다. 세상을 가장 작게 집중해서 관찰하고, 맞물려 돌아가며 기능하고, 기다림과 시간을 고스란히 담아내는 작은 우주를 보는 듯하다.

　　이상민은 어릴 적 움직이는 사물에 대한 호기심과 놀이를 통해 손에 남아있는 익숙함이 작업의 원동력이 된다. 호두 깨는 기구는 늘 사용하지는 않지만 특별한 날, 의미를 부여하여 사용할 수 있는 재미있는 형태와 기능을 가진 사물이다. 〈호두깨는 장치〉(2012–2021)시리즈는 기계적 움직임을 바탕으로, 전동용 기계요소의

Seo Jeonghwa captures the matters in a simpler and purer way. His new work *Structure for Use*(2021) combines the mass of straight lines and curves, expanding the structure of familiar furniture. Maximizing the existing form and function within space, the works demonstrate the artist's formal explorations and experimentations through the repetition and layering of structure. Seo sands down the surface of the cast aluminum dozens of times to create another texture, and coats it with oil. By intentionally repeating a unified form, individual elements like balance, volume, size and proportion are even more strongly bound together. The negative space within a multiple structure delivers several messages by exposing another type of positive form in the space, which sometimes turns into a space of its own.

　　Shin Healim's work is an organic relationship of personal narratives, emotions and memories. Through her work that involves repeated gestures of wrapping and layering, Shin constantly records her own time. In *As Time Goes Rain Falls*(2021), lines and planes compose the work where "small points" pile up into lines which then create "planes." Traces of time created by repeated accumulations of small units become a medium that opens up a new dimension of space, as a result of an intense craft-making process that resonates in the mind of the audience. It's not that the physical density is performative, but that it expresses the persistence to achieve the perfect image everyday through such gestures.

— Objects of Movement

Hyun Kwanghun and Lee Sangmin create works with variability that are exquisitely constructed for complex and precise movements, and induce subtle reactions.

기본 동작원리를 이용한다. 정밀하게 설계된 망치나 추는 낙하하는 힘으로 호두가 깨지도록 고안하여, 실제 작동에 직접 참여를 유도하며 즐거움을 유발시킨다.

— 사고하는 사물

이헌정, 이준아, 엔오엘은 내면 깊숙이 잠재되어 있던 개인적인 기억들을 형형색색의 시각적인 표현들로 드러낸다. 완벽한 기술과 결합하며 감각적으로 표현해내는 행위의 흔적들을 통해 과정 지향의 작업세계를 펼쳐낸다.

이헌정은 흙이 가진 물성을 바탕으로 하나의 서사와 무대를 상정하여 풀어냄으로써 특정장르에 국한되지 않는 자신만의 언어를 구축해 나아간다. 〈집적〉(2019–2021)시리즈와 〈수비니어〉(2016)는 염원을 담는 돌쌓기처럼 작은 오브제를 축적하는 작업으로, 내면의 잠재된 개인적 이야기와 기억들이 상상력을 타고 밖으로 나오는 과정을 유희적으로 부여준다. 형태와 형태 사이, 공간과 공간의 연속으로 균형적 리듬이 전해지며 여러 개의 반복된 유닛을 통해 시각적으로, 의미적으로, 이미지의 확장성을 담아낸다. 각각의 의미와 내용을 강조하기보다 소리, 움직임, 빛, 시간과 같은 비물질적인 언어로 공감각적으로 체험할 수 있는 하나의 현장을 제시한다.

이준아는 경험과 감정, 섬세함을 녹여낸 텍스타일을 선보인다. 〈시간과 흔적〉(2021)은 편직된 섬유밴드를 엮고 겹침으로써 새로운 흔적들을 남긴다. 순환하는 반복은 제한된 공간에서 그곳을 넘어선 끝없이 이어지는 새로운 공간을 경험하게 해준다. 비가 온 뒤의 산길을 오르기도 하고 눈길을 걷기도 하고 물이 묻은 신발을 신고 뜨거운 아스팔트를 걸으며 쌓이고 지워지는 발자국과 같이 섬유 자체를 물리적으로

They weave together the mechanical relations and connections in the most delicate and persistent manner in order to endow a sense of organic movement created by disassembling and assembling within an object.

Hyun Kwanghun conveys the essence of the machine in natural movement. The new *Heartbeat III*(2021) combines the see-through back case, which shows the movement of the clock, and a mechanism for calculating exposure. Directly demonstrating the physical structure of connection, this work allows the viewer to observe both the formal aesthetics and mechanical structure at once. *Heartbeat III*(2021) is like a microcosmos that observes the world in the most meticulous and focused manner, functioning in conjunction with this world and capturing an element of waiting and time.

Lee Sangmin's childhood curiosity about moving objects and the familiar memories they left in his hands through play are the driving forces behind his work. Although not something used every day, the nutcracking machine is an object with a fun form and function that can be used in a meaningful way on a special day. Based on mechanical movements, the *Nutcracker Series*(2012–2021) applies the basic operating principles of an electronic machine. A precisely-designed hammer or pendulum is designed to break walnuts with falling force, inducing direct participation in the actual operation, and making the process a fun-filled one.

— Objects of Thought

Lee Hunchung, Lee Joona and NOL reveal their personal memories lying dormant deep within their inner world through colorful visual expressions. Their process-oriented works are portrayed through

쌓는 행위를 통해 시간과 기억, 감정들을 하나하나 잇고 남긴다.

엔오엘(NOL)은 유연한 곡선을 따라 이어지는 명확한 공간적 분할과 은박 소재의 반사와 흡수에 따른 다채로운 색감은 공간에서 발생할 수 있는 모든 사물을 아우르며 공간의 생기와 활력을 풍만하게 한다. 또한, 독특한 재료의 잠재력을 바탕으로 우리에게 부여한 비일상적 경험은 소통의 장벽을 낮추고, 전복적인 상상이 가능하도록 한다.

이번 전시는 제작자들의 사적인 놀이와 작업과정을 미술관이라는 공공 공간으로 옮겨와 우리에게 새로운 놀이의 영역을 재발견하고 다른 나를 상상하게 한다. 또한 코로나 이후, 놀이가 배제된 우리의 삶이 얼마나 무미건조하고 유희에 목마른지, 놀이를 잃은 인간이 얼마나 무력해지는가를 실감하게 한다. 이곳 놀이의 정원에서 삶의 또 다른 측면을 기웃거리고 유익한 경계선을 넘나들며 새로운 관계들을 품을 기회가 되길 희망한다.

traces of their sensorial expressive gestures, combined with perfect craftsmanship.

Setting up a stage and working with narratives based on the physical properties of clay, Lee Hunchung constructs his unique language that's not limited to a specific genre. Small objects are stacked up like piles of stones that capture human prayers in *Accumulation Series* (2019–2021) and *Souvenir* (2016). The two works playfully demonstrate the process through which the personal narratives and memories that lie dormant within an individual surface through imagination. A balanced rhythm is produced in between forms and spaces, visually and semantically capturing the expandability of the image through the several units that are repeated. Rather than emphasizing each meaning and content, Lee's works compose a site where the audience can experience his art synesthetically through the immaterial language of sound, movement, light and time.

Lee Joona presents textile works that weave together experiences, emotions and sensitivity. The *Trace with the Time*(2021) leaves behind new traces by weaving and overlapping woven fabric bands. The cycles of repetition bring the audience to a new infinitely endless space beyond the finite space. As if to climb a path in the woods after a rain or walk on snow, or like the printed and vanished footprints of wet shoes on hot asphalt, Lee leaves behind each time, memory and emotion one by one through the physical gesture of stacking up fabric.

In NOL's work, the clear spatial division along the flexible curves, and the multiple colors as a result of light reflecting and absorbing on the aluminum foil, bring together all the objects that can be produced in the space, imbuing the space with vitality and energy. In addition, the unusual experiences presented to the audience based on the potential of unique

materials bring down the usual barriers to communication and enable subversive imagination.

SWITCH THINGS UP transports the makers' personal play and work processes to the public space of the art museum, as it invites the audience to rediscover the new sphere of play and to imagine a different self. It also makes us realize how dull and flat human life can be without play in this age of COVID-19, how hungry and thirsty we are when we don't play, and how helpless human beings feel when they cannot play. *SWITCH THINGS UP* presents a garden of play where the viewers have the opportunity to experiment with the different aspects of life, traverse across constructive boundaries, and form new relationships.

우리 시대의 헤파이스토스는 어디에 있는가?
— 놀이하는 인간을 찾아서
노명우

Where is the
Hephaestus of our age?
— In search of the Man
the Player
Nho Myungwoo

우리 시대의 헤파이스토스는 어디에 있는가?
— 놀이하는 인간을 찾아서

노명우
사회학자, 아주대학교 사회학과 교수

제우스와 헤라 사이에서 태어난 헤파이스토스는 불을 사용하는 모든 공예, 특히 금속공예의 신이다. 절름발이로 태어났다는 이유로 헤라가 올림포스 산에서 내던진 헤파이스토스를 바다의 여신 테티스와 에우뤼노메가 거두었다. 부모로부터 내쳐진 불구의 처지였지만 헤파이스토스는 빼어난 솜씨로 숱한 걸작을 만들었는데 호메로스의 〈일리아스〉와 〈오뒷세이아〉는 전체가 헤파이스토스 찬양이라고 해도 과언이 아닐 정도로 헤파이스토스가 손으로 만들어낸 다양한 물건을 곳곳에서 소개하며 제작자 헤파이스토스를 추켜세운다. 끊임없이 무엇인가를 궁리하고 손으로 궁리한 것을 구체적인 물건으로 만들어낸다는 점에서 헤파이스토스는 희랍의 신 중에서 가장 인간을 닮았다.

　　미와 사랑의 여신 아프로디테와 전쟁의 신 아레스는 밀애를 즐기다가 그 벌로 그물에 갇히게 되는데, 그 그물은 자연의 산물이 아니라 헤파이스토스의 손을 통해 만들어진 인공물이다. 올림포스의 신들은 헤파이스토스가 지은 청동 저택에 거주한다. 그의 손을 거치면 상상도 하지 못했던 진귀한 물건이 모습을 드러낸다. 그는 고대의 안드로이드(Android) 제작자이다. 헤파이스토스는 자신을 시중드는 하녀를 황금으로 만들었다. 그의 하녀는 사실상 황금으로 만들어진 인조인간, 즉 안드로이드이다. "황금으로 만든 시녀들이 주인을 거드니, 살아 숨 쉬는 소녀들과 다를 바 없었다.

Where is the Hephaestus of our age?
— In search of the Man the Player

Nho Myungwoo
Sociologist, Professor of Sociology at Ajou University

Hephaestus, born between Zeus and Hera, was a god of all craft using fire, especially metalworking. Thrown from Mount Olympus by Hera just because he had a lameness, Hephaestus was helped by the sea gods Thetis and Eurynome. Although crippled and rejected by his parents, Hephaestus produced numerous masterpieces with exquisite craftsmanship. In fact, Hephaestus' handcrafted works are constantly described and applauded throughout Homer's *Iliad* and *Odyssey*, so much so that one might even say the two works were written for the purpose of singing praises to Hephaestus. He takes the most human resemblance of the Greek gods in that he constantly conceptualized things and manifested them into concrete objects.

　　Aphrodite and Ares, the goddess of beauty and love and the god of war, respectively, were caught in a net as a punishment for indulging in a secret love affair. This net was not a natural substance but a manmade one, created at the hand of Hephaestus. The gods of Olympus lived in a bronze mansion built by Hephaestus. Rare and precious matters beyond anyone's imagination were produced by his hands. He was the creator (Android) in ancient times. He made his handmaidens out of gold. They were actually artificial

이들은 횡격막 속에 슬기가 있었고, 목소리와 근력도 있었으며 죽음을 모르는 신들에게서 일들도 배워 알고 있었다."[1]고 호메로스는 전한다.

그의 손을 거치면 불가능한 것이 없다. 그는 고대의 로봇 설계자이다. 나우시카아의 아버지인 스케리아 섬의 왕 알키노오스의 궁정에는 헤파이스토스가 황금과 은으로 만든 개가 있다. "양쪽으로는 금제 개들과 은제 개들이 있었는데 헤파이스토스가 안목 있는 솜씨로 만든 그 개들은 대범한 알키노스의 궁전을 지키고 있었다. 그 개들은 영원히 늙지도 않고 죽지도 않는다."[2] "헥토르의…. 앞에는 포이보스 아폴론이 두 어깨에 구름을 걸치고는, 두루 술이 달린 채 압도적인 빛을 뿜어내는 가공할 아이기스를 쥐고 나아가고 있었다. 이는 청동을 잘 다루는 헤파이스토스가 제우스에게 걸치게 하여 인간들에게 공포를 심어주려고 선사했던 것"[3]이다.

헤파이스토스는 고대의 컨베이어 벨트 발명가이다. 트로이 전쟁의 영웅 아킬레우스의 어머니인 테티스가 헥토르가 파트로클로스를 죽이고 빼앗아간 아킬레우스의 무구를 제작해달라고 헤파이스토스를 찾아갔을 때, "그는 마침 세발솥 스무 개를 만들어놓은 참이었는데 하나하나마다 바닥에 황금 바퀴를 달아놓아 저절로 신들의 회의장까지 갔다가 다시 집으로 돌아오도록 해놓았으니, 보기에도 경이로울 지경이었다."[4]

헤파이스토스가 마침내 청을 받아들여 아킬레우스를 위한 무구를 만들었으니, 그가 만든 무구에 대한 호메로스의 묘사를 듣고 있자면

humans, or androids, made of gold. Homer wrote that the handmaidens wrought of gold had *"understanding in their hearts, and in them speech and strength, and they know cunning handiwork by gift of the immortal gods."*[1]

Nothing was impossible in Hephaestus' hands. He was an ancient robot designer. In the palace of Alcinous, the King of Scheria and the father of Nausicaa, there were dogs cast in gold and silver, made by Hephaestus. *"On either side of the door there stood gold and silver dogs, which Hephaestus had fashioned with cunning skill to guard the palace of great-hearted Alcinous; immortal were they and ageless all their days."*[2] It's also written that before Hector *"went Phoebus Apollo shrouded in cloud about his shoulders. He bore aloft theterrible Aegis with its shaggy fringe, which Hephaestus the smith had given Zeus to strike terror into the hearts of men."*[3]

Hephaestus was also the inventor of the ancient conveyor belt. When Thetis, the mother of Achilles, the hero of the Trojan War, went to see Hephaestus to ask him to make Achilles' armor, which Hector took away after murdering Patroclus, Hephaestus was making tripods that moved on their own. *"He was fashioning tripods, twenty in all, to stand around the wall of his well-builded hall, and golden wheels had he set beneath the base of each that of themselves they might enter the gathering of the gods at his wish and*

1 호메로스, 『일리아스』, 이준석 옮김 (서울: 민음사, 2021년 9월 출간 예정), 15권
2 호메로스, 『오뒷세이아』, 김기영 옮김 (서울: 민음사, 2021년 9월 출간 예정), 7권
3 호메로스, 『일리아스』, 15권
4 호메로스, 『일리아스』, 18권

1 Homer, *Iliad*, trans. Lee Junseok (Seoul: Minumsa, will be published in September, 2021), Volume 15.
2 Homer, *Odyssey*, trans. Kim Kiyeong (Seoul: Minumsa, will be published in September, 2021), Volume 7.
3 Homer, *Iliad*, Volume 15.

기베르티가 만든 피렌체 세례당의 〈천국의 문〉이 연상된다. 헤파이스토스는 채집 경제에서 농경문화로, 즉 야만에서 최초의 문명으로 이끈 영웅이다. 문명은 현생인류가 헤파이스토스의 손을 흉내내면서 시작되었다. 손이 문명을 만들었다.

*

시간을 더 거슬러 올라가 본다. 인류의 조상 호미닌(Hominin)이 네 발이 아니라 두 발로 땅을 딛기 시작했다. 인간은 직립하기 시작하면서 손으로 무엇을 만들어내는 원형적 헤파이스토스가 되었다. 직립은 매우 중요한 변화이지만, 직립 그 자체가 호미닌을 헤파이스토스로 만들어주지는 않았다. 직립 보행은 호미닌이 헤파이스토스가 되기 위한 전제 조건에 불과하다. 직립 보행으로 인해 완전히 다른 의미를 획득한 호미닌의 손이, 호미닌을 헤파이스토스를 닮게 했다.

손은 점점 더 섬세해졌다. 움켜쥐는 것이 가능한 손은 손끝의 감각 능력이 발달하면서 일종의 인지 기관이 되었다. 그 손으로 인간이 250만 년 전 최초의 도구 올도완 석기(탄자니아 올바두이 협곡에서 발견된 인류의 가장 오래된 도구)를 만들자, 인간은 동물과 다른 존재가 되었다. 인류는 그 손으로 불을 다루었고 해부학적 현생인류는 20만 년 전에 시작된 중기구석기 시대를 지나며 4만 년 전부터는 오늘날의 인류와 거의 차이가 없는 '문화적 현대성'을 획득했다. 4만 년 전의 호모 사피엔스와 현재의 우리는 복잡하고 정형화된 도구와 기구를 생산한다는 점에서, 장신구를 만들어 걸치고 다닌다는 점에서, 아름다움과 감성에 대한 감각을 발달시켰으며 죽음을 알고 있었고 사후세계를 궁금해하며, 조형미술과 음악까지 만들어냈다는

again return to his house, a wonder to behold.[4]

Hephaestus accepted her request and made the armor for Achilles. Homer's description of this armor reminds one of the *Gates of Paradise*, designed by Lorenzo Ghiberti for the Baptistery of San Giovanni in Florence. Hephaestus was a hero who advanced the human race from a food-gathering society to an agricultural one, that is, from barbarism to the first civilization. Civilization began when modern human imitated the hands of Hephaestus; therefore, it's ultimately the hands that constructed the human civilization.

*

Let us go back in time a bit further. Hominin, the ancestor of mankind began to walk on two legs rather than on all fours. As humans began to stand erect, they began making things by hand and became the prototype of Hephaestus. Although the ability to stand and walk erect was a major advancement, it did not in itself turn Hominins into Hephaestus; rather, this ability was just a precondition for the Hominins to become Hephaestus. Human hands, endowed with a completely different significance when humans began walking upright, allowed Hominins to resemble Hephaestus.

Human hands became more delicate and agile. Able to grasp things, the hands became a kind of a perceiving organ as the sensory ability of the fingertips developed. When humans made Oldowan stoneware (humankind's oldest tool discovered in the Olduvai Gorge in Tanzania) with their hands, they became a completely different entity than animals. Mankind handled fire

4 Homer, *Iliad*, Volume 18.

점에서 동일하다. 오리냐크 시기(4만 년에서 2만 7천 년 전)에 호모 사피엔스는 피리를 만들었고 동굴에 벽화를 그렸고 상아와 석회암으로 조각을 했다. 이 모든 일을 손이 해냈다.

*

중세의 금세공 장인은 기능인이자 동시에 윤리적 인간이었다고 한다. 금은 귀한 재료이다. 귀금속 주화가 화폐 역할을 하던 시대였기에 금에 이물질을 섞어 금의 함량을 속이는 사기꾼이 드물지 않았다. 금세공 장인은 금으로 무엇인가를 제작하는 헤파이스토스의 후예이자 동시에 자신의 작업 재료인 금의 진위 여부를 판정하는 판정관이기도 했다. 금세공 장인은 광석에서 순금을 녹여내는 일뿐만 아니라 금에 침투한 가짜 금 성분을 가려내어 진실을 수호하는 임무도 떠맡았다. 금세공 장인의 기능은 이런 윤리적 역할과 분리될 수 없었다.

금의 성분을 분석하는 과정을 시금(試金)이라 하는데, 시금은 금세공사의 전문성과 윤리성이 시험되는 과정이다. 그러하니 시금은 아무나 할 수 없다. 금세공사는 시금을 손수(hands-on)했다. 금세공사는 손으로 시금한다. 시금할 금속을 굴려보고 짓눌러보며 금세공사는 촉각으로 시금의 대상이 얼마나 순금에 가까운지 판단했다. "중세에는 촉감이 신비하고 종교적인 의미까지 담고 있었다. 금세공인이 시금할 때 손놀림이 느리고 신중할수록 같은 직종 동료들과의 고객의 신뢰를 더 많이 받았다."[5]

금세공 장인이 쓸모 있는 물건을 만들어내는 기능인이자 동시에 윤리적 기준의 수호자였다는 점은 금세공 장인은 제작하는 인간, 즉 호모 파베르이었지만 호모 파베르로 환원되기를

5 리처드 세넷, 『장인』, 김홍식 옮김
 (서울: 21세기북스, 2010), 108.

with their hands, and the anatomically modern man passed through the mid-stone age which began 200,000 years ago, and acquired a "cultural modernity" 40,000 years ago that is almost identity to that of humankind today. Homo Sapiens 40,000 years ago were the same as humans today in the sense that they produced sophisticated and structured tools and instruments, made ornaments and wore them, developed aesthetics and sensibility, were aware of death and questioned life after death, and even created formative arts and music. Homo Sapiens in the Aurignacian culture, between 40,000 and 27,000 years ago, made flutes, painted on cave walls, and sculpted ivory and limestone. And all this was done by hand.

*

The medieval goldsmith was considered both a craftsman and an ethical man. Gold was a precious material. Since precious metal coins served as currency, it was not uncommon for swindlers to lower the content of gold by mixing in foreign substances with gold. Making things out of gold, the goldsmith was both a descendant of Hephaestus as well as a judge who determined the authenticity of gold, which was the material he worked with. In addition to melting pure gold out of ore, the goldsmith's task was to sort out fake ingredients that had tainted the gold and protect the truth. The function of the goldsmith was inseparable from this ethical role.

The process of analyzing the ingredients of gold is called "assaying," which is a process that tests the goldsmith's expertise and ethics. Not anyone could perform an assay. The goldsmith assayed with their own hands by rolling and pressing on the metal, and used their sense of touch to judge how

거부했다는 뜻이기도 하다. 호모 파베르는 쓸모를 지향한다. 호모 파베르는 쓸모 있는 물건을 만들어내고 그 물건을 시장에서 판매하여 경제적 이득을 기대한다. 금세공 장인이 수호자 이고자 했던 호모 파베르로 환원될 수 없는 다른 가치 체계를 무엇이라 명명할 수 있을까?

어느 박물관이든 그 박물관이 자랑스럽게 내세우는 슈퍼스타 급의 전시품이 있다. 파리 루브르 박물관의 〈모나리자〉가 그러하고 피렌체의 아카데미아 미술관의 슈퍼스타는 미켈란젤로의 〈다비드〉이다. 용산국립중앙박물관의 〈반가사유상〉처럼 대만의 국립고궁박물원에도 소장품 698,854개 중 특별 대접을 받는 작품이 하나 있는데 〈상아투화운룡문투구 (象牙透花雲龍紋套球)〉라고 불리는 상아조각이다. 상아를 바깥으로부터 파내며 조각해서 원형 구 안에 겹겹이 구를 17개나 만들어낸 조각품이다.

플라톤은 어떤 일이든 그 이면에는 추구하는 품질목표가 있는데, 그 최고의 경지를 아레테라고 불렀다. 〈상아투화운룡문투구〉는 아레테 그 자체라 할 수 있다. 아레테는 최대치를 지향한다. 인간은 한편으로 "이만하면 충분하다(Enough is Enough)"라고 자족하며 최소 기준을 지향하기도 하지만 동시에 인간은 "만족할 수 없음(Can't get satisfaction)"을 지향한다. 〈상아투화운룡문투구〉를 만든 장인은 품질을 추구하는 열망 때문에 적당히 마무리하지 않고 더 낫게 만들려고 애쓰며, 높은 경지를 향해 달려간다. 하위징아는 아레테를 지향하는 인간의 활동을 놀이라 명명했고, 놀이하는 인간 즉 호모 루덴스가 문명의 주역이라 칭송했다. 하위징아의 관점에서 보자면 호모 루덴스는 인격화된 헤파이스토스이다.

강제에 의해 억지로 해야 하는 행위를 하며 신바람이 나는 사람은 없다. 그래서 누구나 억지로 하는 일은 하는 시늉만 내지, 자신이 하는 활동에

close their subject is to pure gold. *"The sense of touch was itself in the Middle Ages endowed with magical, indeed religious properties….the slower and more searchingly the goldsmith worked with his hands, the more truthful he appeared both to his peers and to his employers."* [5]

The fact that the goldsmith was a craftsman who produced useful goods as well as a protector of ethical standards, meant that, while he was the "Man the Maker," or Homo Faber, he also refused to be reduced to a Homo Faber. A Homo Faber pursues function. He makes useful objects, and expects economic gains by selling them in the market. How else could one term the medieval goldsmith, both a functional maker of objects as well a guardian of ethics, without simplifying him as a Homo Faber?

All museums usually have a representative work that they proudly exhibit, like *Mona Lisa* in The Louver in Paris, and Michelangelo's *David* in the Academia Gallery in Florence. Like the *Gilt-bronze Pensive Maitreya Bodhisattva* in the National Museum of Korea, there is one work among the 698,854 works in Taiwan's National Palace Museum that receives a special treatment, which is the ivory sculpture called *Ivory Ball — Concentric ivory spheres carved in openwork with cloud-and-dragon motifs*. This ivory ball has been carved from the outside to the inside, and consists of a total of 17 levels of engraved spheres within one ball.

Platon used the term "arete" to define a fulfillment of purpose or function in everything. The *Ivory Ball — Concentric ivory spheres carved in openwork with*

5 Richard Sennett, *The Craftsman*, trans. Kim Hongsik (Seoul : Book21, 2010), 108.

대한 애착과 긍지도 몰입도 없다. 하지만 자신이 원해서 행하는 일을 할 때 사람은 돌변한다. 억지로 해야 하는 일을 할 때 동작이 굼떴던 사람도 빠르게 움직일 수 있으며, 의자에 오래 앉아 있지 못하던 사람도 하룻밤쯤은 거뜬히 지새울 수 있다. 그 에너지의 원천은 자발성이다.

놀이는 어린아이의 유치한 행동이 아니다. 관성적 사고방식으로 우리는 놀이와 오락을 동일시하거나 놀이를 오락과 구별하지 않고 놀이는 시간 때우기 용 심심풀이 행동이라 간주하지만, 보수를 받고 요구되는 과업의 최소기준을 만족시키는 데 급급한 호모 파베르에서는 발견되지 않는 최대 지향적 '진지함'이 놀이에 있다.

노동과 놀이는 다르다. 노동은 하고 싶어 하는 일이 아니라 해야 하기 때문에 하는 일이다. 반면 놀이는 하고 싶어 하는 일이다. 노동의 세계에선 승자독식의 원칙이 통용된다. 노동의 세계에서 결실을 모든 사람이 나눌 수는 없다. 노동의 세계는 일종의 제로섬 게임의 영역이다. 누군가 출세하면 누군가는 출세하지 못한다. 먹고 사는 문제를 해결하는 호구책의 세계, 경제는 일종의 제로섬(zero sum) 게임의 사회이다. 승자와 패자는 명확히 나뉜다. 호구책의 세계에선 '승자독식(Winner-Takes-It-All)'의 법칙이 적용된다. 호구책의 세계에서 승자는 행복하지만 패자는 행복할 수 없다. 호구책의 세계에서는 이긴 사람만 살아남을 수 있다. 그래서 모든 사람들이 살아남기 위해서 치열한 경쟁을 벌이는 그 곳에서 믿음이나 신뢰는 싹틀 수 없다. 경제의 영역에서 사람들은 서로 믿지 않는다. 놀이의 세계는 다르다. 즐거움은 승자독식이라는 냉혹함이 아니라 퍼내고 퍼내도 줄어들지 않는 화수분의 법칙에서 유래한다. 놀이를 통한 즐거움은 혼자 독식하지 않고 그 즐거움을 함께 누리는 사람이 많을수록 커진다.

〈상아투화운룡문투구〉를 만든 장인은 노동하지 않았다. 그는 외부에서 정해진

cloud-and-dragon motifs demonstrates arete itself: it directs at the maximum value. While humans tend to be self-content and believe "enough is enough," humans also affirm the notion that they "are never satisfied." The artisan who made the ivory ball, driven by his desires for quality, did not settle for anything less than the best, and pursued the highest degree of excellence. Huizinga referred to this human activity that pursues arete as "play," and praised the playing human, or the Homo Ludens, the leaders of civilization. From Huizinga's perspective, Homo Ludens is a personified Hephaestus.

No one gets excited about doing what they are forced to do. Therefore, people would pretend to do what they are forced to do, but they would have no attachment, pride, or immersion in what they are doing. But humans change completely when they do what they want. Even those who are slow can move fast, and those who cannot sit still can stay up all night while sitting. And the source of that energy is autonomous, self-driven will.

Play is not an immature activity of a child. We conventionally tend to regard play as a form of entertainment or an act of killing time, but what is found in play is a sense of "seriousness" that is lacking in Homo Fabers who are busy meeting the minimum standards required in a paid occupation.

Labor and play are different, because labor is not something one wants to do but must do. But play is something one wants to do. In the world of labor, the principle of "winner-takes-all" is in effect, and fruition cannot be shared with all people. The world of labor runs by the rules of a zero-sum game, meaning that if someone succeeds, another cannot. The economy of the world of survival is a type of zero-sum game, where winners and losers are

작업지시를 따르는 수동적인 기능인이 아니다. 그는 능동적인 자유인이다. 그는 자신의 목표를 자신이 정한다. 그는 타인의 명령을 따르지 않는다. 그는 자신의 명령을 따른다. 장인이 자신에게 내리는 명령은 최소의 법칙이 아니라 최대의 법칙을 따른다. 장인의 권위(authority)는 명령이 아니라 자신의 자율성(autonomy)으로부터 유래한다.

하위징아는 상(prize), 가격(price) 그리고 칭찬(praise)이 모두 동일한 라틴어 가격(pretium)으로부터 파생되었으면서도 각기 다른 방향으로 전해진 양태는 매우 관심을 끄는 문제라고 말했다. pretium이라는 단어는 원래 교역 및 가치 평가의 영역에서 생겼고 따라서 상대적 가치를 전제로 한다. 그러나 pretium은 동시에 칭찬과 명예를 뜻할 수도 있다. 하위징아의 분석처럼 가격(price)은 경제학과 노동으로 이전했고, 명예와 칭찬은 놀이의 영역으로 옮겨왔다.

보통 우리는 놀이를 일하지 않음과 동일한 것이라 생각하지만, 놀이는 '놀고 있는 것'과는 다르다. 놀이는 경제적 값어치가 아니라 다른 원리를 지향하는 인간의 행위를 뜻한다. 놀이는 '향락'과도 다르다. '향락'은 노동으로부터 도피하는 행위라면, 놀이는 노동으로부터 도피하는 행위가 아니라 노동과 균형을 이루도록 하여 인간을 완성시켜 주는 행위이다.

공부가 직업인 사람은 지식을 판매하고 지식의 대가로 이윤을 얻는다. 반면 공부와 놀이를 하는 학자는 지식을 팔아 이윤을 챙기는 것보다는 공부와의 놀이를 통해 얻은 명예를 소중하게 여긴다. 고대 그리스의 올림픽에 참가했던 선수들은 이윤을 기대하지 않았다. 마라톤에서 우승해도 우승자는 고작 경제적 값어치(price)는 보잘 것 없는 월계관을 받았지만 우승자의 명예는 드높았다. 우승자는 마라톤의 고통과

clearly defined. The "winner-takes-all" principle applies in the world of survival. In such a world the winner is satisfied but the loser is not. Only the winner can survive in this world. Faith and trust cannot be rooted where everyone is in fierce competition with each other in order to survive. Further, in the domain of economy, people do not trust each other. But the world of play is different from this. Pleasure derives not from the coldness of "winner-takes-all," but from the law of the "widow's cruse," or the infinitely bottomless. The joy of play tends to grow not when it is monopolized, but when more people share in it.

The craftsman who made the ivory ball did not toil in labor. He is not a passive person of function who follows external instructions to work. He is an autonomous person working according to his own free and active will. He sets his own goals. He does not follow the orders of another, but only those he directs towards himself. The orders that the craftsman gives himself do not follow the minimum rules but the maximum ones. The authority of the craftsman comes from his autonomy, not from commands.

Huizinga questioned how the words "prize," "price" and "praise" all derive directly from the Latin word *Pretium* but develop in different trajectories. *Pretium* originally arose in the sphere of the exchange and valuation, and presupposes a counter-value. But *Pretium* can also mean praise and honor at the same time. Like Huizinga's analysis, "price" transferred to the realm of economics and labor, and honor and praise moved into the realm of play.

We normally think of play as being equal to "not working," but play is different from "being idle." Play does not signify an economic value but a human activity that pursues a different principle. Play

놀이한 대가로 월계관으로 상징되는 명예를
상(prize)으로 받았다.

*

호모 루덴스는 이윤(price)이 아니라
상(prize)과 칭찬(praise)을 지향한다. 호모
루덴스는 호모 파베르와는 구별되는 가치지향을
통해 역설적으로 이윤만을 추구하는 제로섬
게임에 규정되는 노동중심 사회에 대한
비판자이기도 하다. 우리가 살고 있는 시대에서
놀이하는 인간을 소환하고, 그의 손길이 갖는
의미와 그의 독특한 지향에 주목하고 그 의미를
곱씹어 본다는 것은 우리가 살고 있는 사회의
지배적 경향에 대한 반성적 접근과 동일하다.

돌도끼를 손에 쥔 인류부터 손으로 시금을
하는 중세의 금세공 장인에 이르기까지,
인간은 헤파이스토스가 그랬던 것처럼 재료를
손으로 어루만지고 재료와의 놀이를 통해
재료에 기능적 요소뿐만 아니라 예술적 요소를
부가한다. 재료를 소유물로 장악하기 위해
움켜쥐지(grasp) 않고 시금하는 장인의 손길처럼
재료를 어루만짐으로써 재료와의 친밀한 관계를
구현하려는 사람은 수학적 완벽성에 기초를 둔
공학적 완벽성을 꾀하는 기계가 재료를 대하는
제스추어에 의구심을 표현한다.

우리는 양이 질을 압도하는 낭비의 시대를
살고 있다. 우리가 살고 있는 시대 물건의
내구성은 인위적으로 상업적 목적을 위해
제거되었다. 자본주의가 끊임없이 소비 욕구를
충족시키고 그것을 기반으로 이윤 축적을
확대재생산하려면 내구성은 제거되어야 하는
방해 요소이다. 자본주의는 여전히 내구성을
지닌 물건을 낡은 것처럼 느끼도록 만들어야
번영할 수 있다. 자본주의는 쓸모가 폐기되지
않은 물건을 유행에 뒤떨어졌다는 이유로
폐기되게 만든다.

is also different from entertainment. If
entertainment is an act of escaping from
labor, play is not an act of escaping from
labor, but that which balances with labor to
complete a human being.

Those in the academia world sell their
knowledge and gain profit in return for their
knowledge. On the other hand, scholars
who play with their studies treasure the
honor they earn by playing with their
practice rather than profiting directly from
selling their knowledge. Athletes who
participated in the ancient Greek Olympics
did not expect profits. Even when an
athlete finished the marathon, the winner
received a modest laurel wreath of barely
any economic value. However, the winner
was highly honored for "playing" with the
sufferings of running in the marathon, and
was prized a laurel wreath symbolizing this
honor.

*

Homo Ludens pursue prize and praise, not
price, or economic gain. Homo Ludens
hold different values from Homo Fabers,
and criticize the labor-oriented society that
only seeks profit and abide by the laws
of the zero-sum game. Summoning the
playing human in the era we live in, and
reflecting on the meaning of his touch and
direction, is a reflective approach to the
dominant trend of the society we live in.

From stone axes in the Stone Age to
the hand-assaying of medieval goldsmiths,
humans have always handled their
materials with their hands as Hephaestus
has done, engaging in play with materials
and exploring not only their functional
but also artistic aspects. The person
who embodies an intimate relationship
with the material by touching it, like the
touches of a craftsman who assays
gold without grasping the material as a
possession, expresses skepticism towards

매끈하게 마무리된 제품이 산더미처럼 쌓이고 그 물건은 오래 가지 않아 쓰레기로 산더미를 만든다. 우리 시대의 헤파이스토스는, 완벽한 마무리라는 기계의 이상을 추구하는 시대에 일 자체를 위해 일을 잘해 내려는 장인의 원초적 정체성을 유지함으로써 예외적인 존재로 자신을 구현하고 있다. 오늘날 여전히 손으로 무엇을 만들어내고 있는 사람은 "정밀하고 완벽한 기계의 반대편에서 사람의 개성을 상징"하는 존재이며 "수작업에서 생기는 여러 가지 변이와 결함, 불규칙성"[6]을 보존하고 있는 예외적 존재이다. 모두가 호모 파베르가 된 사회에서 그는 헤파이스토스의 충실한 후계자이자 예외적으로 호모 루덴스이다. 이 사람 호모 루덴스의 손을 보라. 그리고 그 손끝에서 만들어진 이것을 보라.

machines that are based on mathematical faultlessness and pursue technological perfection, and how they deal with material.

We live in an era of waste where quantity prevails quality. The durability of objects in our time has been intentionally eliminated for commercial purposes. Durability is an obstacle that must be removed if capitalism is to constantly meet consumption needs and expand and reproduce profit accumulation based on it. Capitalism can only prosper if it makes objects with durability seem obsolete. Capitalism discards objects that can still be used on the basis of being outdated.

Sleek objects accumulate in a pile, and the products make up a mountain of garbage in no time. In an age that pursues the mechanical ideals of perfect finishing, the Hephaestus of our generation realizes himself as an exceptional being, retaining the original identity of the craftsman who works hard for the work itself. Those who still create things with their hands today are people who *"symbolize the human personality opposite the precise and perfect machines,"* and are exceptional beings that preserve *"the mutations, defects and irregularities that result in manual work."*[6] In a society where everyone has become a Homo Faber, the craftsman is the faithful descendent of Hephaestus and an exceptional Homo Ludens. Look at the hands of a Homo Ludens. And what has been made from those hands.

6 리처드 세넷, 『장인』, 김홍식 옮김 (서울: 21 세기북스, 2010), 143.

6 Richard Sennett, *The Craftsman*, trans. Kim Hongsik (Seoul : Book21, 2010), 143.

예술가의 '놀이하는 사물'
박남희

The Artist's
"Playing Objects"
Park Namhee

예술가의 '놀이하는 사물'

The Artist's "Playing Objects"

박남희
미술비평, 홍익대 대학원 교수

Park Namhee
Art critic and Professor at Hongik University, Graduate School

예술가의 '놀이하는 사물'

The Artist's "Playing Objects"

박남희
미술비평, 홍익대 대학원 교수

Park Namhee
Art critic and Professor at Hongik University, Graduate School

예술(Kunst)과 놀이(Spiel)

"우리가 예술 경험과 연관해서 언급하는 놀이는 창작자 내지 향유자의 태도나 마음 상태가 아니다. 또한 놀이는 결코 놀이에서 작용하고 있는 주관성의 자유가 아니라, 예술작품 그 자체의 존재 방식을 의미한다."[1]

예술(Kunst)과 놀이(Spiel)는 인간의 원초적인 활동이라는 점에서 동근원적(同根源的)이다. 고대의 제의(祭儀)나 주술행위에서 예술의 속성과 놀이의 양태는 상호 밀접하게 연관되어 나타나곤 했다. 시간이 흘러 예술의 자율성, 순수성이 선언되었던 모더니즘에서 예술과 놀이는 서로 거리를 두는 것처럼 보였다. 엄밀히 따져 보면 고대의 제의 형식과 틀거리에서 벗어난 예술과 놀이로 보일 수는 있지만, 본질적으로 양자는 더 친밀한 상황에 있었다. 예술을 위한 예술이 주창되었을 때 종교, 정치, 사회, 역사 등의 예술의 형식과 질료 이외의 것들을 배제함으로써 순수한(?) 예술의 주체적 존립을 꾀하였고, 예술은 정작 충분히 놀이하고 놀아보는 것으로 나아갔기

Art (Kunst) and Play (Spiel)

"When we speak of play in reference to the experience of art, this means neither the orientation nor even the state of mind of the creator or of those enjoying the work of art, nor the freedom of subjectivity engaged in play, but the mode of being of the work of art itself."[1]

Art (Kunst) and play (Spiel) share their origins in that they are both primal human activities. The aspects of art and play appeared closely interrelated in ancient rituals and sorcery. Millennia later, art and play seemed to have distanced themselves from each other in the era of Modernism, a movement that declared the autonomy and purity of art. Strictly speaking, art and play may appear vastly different in form and framework from the ancient rituals, but fundamentally they have always been more closely associated with each other. When advocates of "pure art" called for "art for art's sake," they sought to secure the sovereign autonomy of "pure" (whatever that means) art, stripped of anything that was unrelated to artistic form and material, including religion, social implications, and

1 한스 게오르그 가다머, 『진리와 방법Ⅰ: 철학적 해석학의 기본 특징들』, 이길우, 이선관, 임호일, 한동원 옮김, (파주: 문학동네, 2000[1960]), 189.

1 Hans-Georg Gadamer, *Truth and Method I: The Fundamental Traits of Philosophical Hermeneutics*, trans. Lee Gilwoo, Lee Seongwan, Lim Hoil, Han Dongwon (Paju: Munhak Dongne Publishing, 2000 [1960]), 189.

때문이다. 놀이가 놀이함(das Spielen) 뿐 아니라 진지함을 포함한 것처럼, 예술은 놀이함과 진지함의 심연으로 향했다.[2] 20세기 이후 거의 모든 예술은 그러한 놀이함과 진지함의 형식과 질료, 향유자, 언어, 신체, 개념, 기술, 제도 등 다양한 방식으로 '놀이성(playfulness)'[3]을 만개했다. 이는 한스 게오르그 가다머(Hans-Georg Gadamer, 1900–2002)가 예술이 놀이를 통해 존재론적 사유를 해왔고, 놀이는 창작자의 자유가 아닌 예술작품의 존재 방식이라고 했던 위의 말을 상기시킨다.

가다머의 통찰처럼, 예술은 모방과 표현의 놀이의 속성과 궤를 같이한다. 예술이 자기 표현에 의존하는 것은 '놀이의 놀이함'과 같은 것이다. 이번 국립현대미술관의《놀이하는 사물》전은 이 같은 예술의 표현과 존재가 '놀이의 놀이함'이라는 지평에서 펼쳐지는 경험의 장으로 보인다. 일찍이 놀이를 모든 문화의 원형으로 주장했던 하위징아(Johan Huizinga, 1872–1945)는 "특정 시간과 공간 내에서 벌어지는 자발적 행동 혹은 몰입 행위로서, 자유롭게 받아들여진 규칙을 따르되 그 규칙의 적용은 아주 엄격하며, 놀이 그 자체에 목적이 있고 '일상생활'과는 다른 긴장, 즐거움, 의식을 수반한다"고 놀이의 개념을 요약한

history. Such purist efforts notwithstanding, art continued to play amply and advanced through playing. Just as play encompassed both "playing" (das Spielen) and seriousness, art flourished in the abyss of playing and seriousness.[2] Almost all art since the 20th century bloomed fully in "playfulness,"[3] incorporating the respective elements of materials, viewer, language, body, concepts, techniques, and systems of both "playing" and "seriousness." The above-mentioned quote by Hans-Georg Gadamer (1900–2002) further underpins this notion that the existential unraveling of art has been achieved through play over the years, and that play is the very means by which a work of art comes into existence rather than an activity at the mercy of the creator's whim.

As Gadamer noted, art shares the traits of mimicry and expression that are integral to play. The way art relies on its self-expression to exist is akin to the act of how play "plays." The exhibition *SWITCH THINGS UP* at the National Museum of Modern and Contemporary Art, Korea will provide the audience an opportunity to experience how the expression and the very existence of art unfold in the domain of "the playing play." Johan Huizinga (1872–1945) —the Dutch historian and cultural theorist who was one of the early proponents of the theory that play is the archetype for all forms of culture— explained play as *"a voluntary activity or*

2 "아나카르시스(Anacharsis)의 생각처럼 진지해지기 위해 놀이한다는 것은 옳은 것 같다."라는 아리스토텔레스(Aristotle, 기원전 384–322)의 언급을 상기할 필요가 있다. 즉 놀이함 그 자체에는 어떤 독특하고 신성한 진지성이 존재한다는 것이다. 아리스토텔레스『정치학 Politica』제8권 3, 1337 b 39,『니코마코스 윤리학 Ethica Nicomachea』제10장, 6, 1176 b 33 참조.

3 놀이성에는 신체적 자발성, 사회적 자발성, 인지적 자발성, 즐거움의 표현, 유머 감각이 포함된다.

2 It is worth noting what Aristotle (BC 384 – 322) once said: *"To amuse oneself in order that one may exert oneself, as Anacharsis puts it, seems right."* Aristotle suggests that there is a unique and sacred sincerity inherent to the act of playing (amusement) itself. Aristotle, *Politica*, Vol 8-3, 1337 b 39; Chapter 10, Ethica Nicomachea, 6, 1176 b 33.

3 "Playfulness" encompasses physical spontaneity, social spontaneity, cognitive spontaneity, expression of pleasure, and sense of humor.

바 있다.[4] 이 개념에는 동물, 어린아이, 어른의 놀이 개념이 포함되어 있지만, 실제로 문화마다 다른 입장에 처해 있어 놀이의 개념적 추상화는 비교적 뒤늦게 발달했을 뿐 아니라 놀이를 지칭하는 공통 단어가 없는 지역도 있다고 한다.[5] 어쩌면 추상적 개념으로 정돈되고 동일한 범주로 규정되더라도, 하위징아의 논의에서 드러난 것처럼 시대나 문화에 따라 상이한 놀이의 세계가 있는 것이다. 21세기 지금, 이곳에서 인간의 놀이함, 특히 예술가의 자기표현으로서의 놀이는 어떤 양상으로 존재하는가.

occupation executed within certain fixed limits of time and place, according to rules freely accepted but absolutely binding, having its aim in itself and accompanied by a feeling of tension, joy, and the consciousness that it is 'different' from 'ordinary life.'"[4] While Huizinga's definition encompasses the play of animals, children, and adults, the conceptual abstraction of play is a relatively recent invention for many cultures, so much so that some cultures lack a common, comprehensive word for "play."[5] Even if each aspect of play can be singularly defined as an abstract concept or as part of the same category, the notion of play may manifest differently across cultures and eras as noted in Huizinga's discussions. How, then, does play unravel for humans in the 21st century, especially in the context of an artist's means of self-expression?

4 요한 하위징아 지음, 『호모 루덴스』, 이종인 옮김, (고양:연암서가, 2010[1938]), 78.

5 그리스어의 '아곤(ἀγών)', 산스크리트어의 동사 어근 '크리다티(krīdati)', '디뱌티(divyati)', '라스(las)', '릴라(līlā)', 중국어의 '완(玩)', 알공킨 블랙풋 부족의 코아니(koani), 라틴어의 루데레(ludere), 영어의 '플레가(plega)', 게르만어의 스필(spil,spel) 등의 어원은 하위징아의 놀이 개념의 다양한 의미의 원천이다. 예컨대 산스크리트어에는 놀이를 지칭하는 네 개의 동사 어근만 살펴보아도 흥미로운 지점을 발견할 수 있다. 가장 일반적인 단어인 크리다티(krīdati)는 동물, 어린아이, 어른의 놀이를 가리키고, 바람이나 파도의 움직임, 일반적인 춤추기, 춤과 드라마, 공연의 전 분야를 가리킨다. 또다른 어근으로 디뱌티(divyati)는 도박과 주사위던지기, 농담, 익살, 장난, 흉내내기, 무엇인가를 던지는 것, 번쩍거리면서도 빛난다는 의미도 있음을 일러준다. 세 번째 어근으로 라스(las)는 빛나기, 갑자기 나타나기, 갑자스런 소음, 번쩍거리기, 이리저리 움직이기 등을 의미하며, 마지막으로 릴라(līlā)는 놀이의 가벼운, 공기 같은, 경박한, 힘 안들이는 등으로 사용된다. 같은 책, 83-85.

4 Johan Huizinga, *Homo Ludens*, trans. Lee Jongin (Goyang: Yeonam Seoga, 2010 [1938]), 78.

5 Encompassed in Huizinga's concept of play are more specific, distinct meanings of the word as can be found in various languages including the Greek word "agon" (ἀγών), Sanskrit verb roots (krīdati, divyati, las, līlā), Chinese "wan" (玩), Algonquinian Blackfoot (koani), Latin (ludere), Old English (plega), and Germanic words (spil, spel). For instance, each of the four Sanskrit verb roots interestingly correlates with different aspects of "play." The most generic of the four is krīdati, which refers to the play of animals, children, and adults. The same word is also used to refer to the movements of the wind or waves, generic dancing, dance and drama, and all other types of performance. Meanwhile, divyati refers to gambling, throwing dice, jokes, humor, pranks, imitation, the act of throwing something, shiny, and sparkling. The third root las means to shine, suddenly appear, sudden noise, flashing, or moving about. Lastly, līlā connotes the lightness of playing, airiness, frivolity, or actions that do not require much force. *Ibid*, 83-85.

'놀이함'과 예술가의 사물

자연의 일부로서 인간의 모든 움직임의 결과는 문명이나 예술의 세계로 자리한다. 특히 자기표현으로서의 예술, 사물을 놀이함과 진지함의 극한에서 보여주는 《놀이하는 사물》의 작가들은 각각의 태도와 질료의 사유를 개방한다는 점에서 결을 같이 한다. 동시대 예술에서 장르나 물성 혹은 기법에서의 경계없음을 말하는 것은 부연이거나 사족일 수 있다. 엔오엘(NOL), 서정화, 신혜림, 이광호, 이상민, 이준아, 이헌정, 현광훈 작가의 작업이 하나의 장으로 엮이는 데는 '경계없음' '개방' '혼성'의 시대정신과 '집요함' '반복' '생성' '움직임'의 제작정신이 크로스오버하는 동시대 예술의 한 층에 주목하고자 함이다. 오늘날 마주하는 많은 작업은 사실상 근대기의 범주나 규정으로부터 다소 변형되거나 확장된 양태를 드러내는데, 이는 예술 스스로 자유로운 형식적 넘나듦을 욕망하고 실체화한 것으로 읽힌다. 무엇보다 인간의 감각이라는 토대와 사물의 물성이 만나는 열린 구조가 이를 가능케 한다. 특히 《놀이하는 사물》의 작가들은 사물로 결과하는 물성의 원천과 감각의 여정에 쉼 없이 행위를 축적하여, 칸트(Immanul Kant,1724–1804)가 말했던 "상상력과 지성의 자유로운 놀이에서 나타나는 마음의 상태"에 이르고 있는지도 모른다. 놀이의 속성에도 있는 '우연' '반복' '변형' '구조' '움직임'은 이들 예술가들의 작업에서 가장 기본적인 조형 원리들이자 그들의 세계를 형상화하는 '힘들과 힘의 파동의 놀이'이다. 이러한 근원적인 에너지로부터 그들만의 '사물'이 탄생한다.

"사물의 사물성을 정하기 위해서는 속성들의 보유자에 대한 고찰이나 감각적으로 주어진 것이 그 자신의 통일성 가운데 지니고 있는 다양성에

"Playing" and the Artist's Objects

As part of nature, the consequences of all human movements end up in the domain of civilization or art. In particular, all the artists in *SWITCH THINGS UP* have in common a willingness to openly share their attitudes and contemplation on materials as they present their art and objects in a gamut of expressions that range from the extremities of playfulness and seriousness. Any attempt to remark on the lack of boundaries between genres, material properties, or techniques in contemporary art would be a superfluously redundant endeavor. This is the reason the works of NOL, Seo Jeonghwa, Shin Healim, Lee Kwangho, Lee Sangmin, Lee Joona, Lee Hunchung and Hyun Kwanghun have all been woven into a single site. The eclectic nature of their work sheds light on a particular section of the contemporary art scene wherein the spirit of the era such as "lack of boundaries," "openness," and "hybridity" cross over with the artists' individual work ethics defined by "relentlessness," "repetition," "generation," and "movement." Much of the art created today feature forms that are rather altered or expanded from those defined by modern conventions, which stands as a testimony to how art has manifested its inner intelligence to freely traverse across the rules of formality. More than anything, the open structure wherein the material characteristics of objects meet the foundation of human senses enables such freedom. In particular, the artists in the exhibition have tirelessly accumulated gestures upon gestures in their journey to yield objects born from such alliance of physical materiality and human senses. Perhaps these artists have already reached what Immanuel Kant (1724–1804) described as *the state of mind that is made apparent in the free play between imagination and*

대한 고찰, 심지어는 도구적인 것에서 취해진, 그 자체로 있는 것으로서 표상된 질료 - 형상 결합체에 대한 고찰도 충분하지 못하다. 사물들의 사물성을 해석하는 데 있어서는 사물이 대지에 귀속되어 있다는 것에 대한 선이해가 중요한 척도가 된다. 하지만 아무 것에도 내몰림 없이 보유해주며 동시에 자신을 닫아두는 것으로서의 대지의 본질은 한 세계로의 솟아오름 안에서만, 한 세계와 대지의 마주 - 향해 - 있음 안에서만 드러난다."[6]

예술가의 사물에 어떻게 다가가야 하는가. 하이데거(M. Heidegger, 1889–1976)는 『예술작품의 근원』(1935–1936)에서 사물이 가치나 속성, 도구 등의 현상적 영역에 귀속될 수 없는 고유한 존재의미가 있다는 것을 환기시키고자 했다. 즉 '예술은 예술작품 속에 현실로 있다'는 것이다. 이는 예술의 기능이 존재를 가치로 환원시키는 것이 아니며, 예술작품은 사물성이 근본 특성의 하나임을 함의한다. 그의 말대로 예술작품은 사물이며, 사물의 사물성으로부터 예술가가 몰입하는 감각으로 향할 필요가 있다.

intellect." Traits of play such as "chance," "repetition," "transformation," "structure," and "movement" also constitute the most fundamental elements in the works of artists, serving as the "play of power and the waves of power" that form the domain of such artists. It is from such fundamental energy that the artists' "objects" are born.

"To determine the thingness of the thing, it suffices neither to look at the bearer of properties, nor at the manifold of the sensuously given in its unity, nor indeed at the stuff-form-jointure represented for itself, whereas it is taken from the toollike. The measure-giving and weight-giving fore-sight for the explication of the thingness of the thing must go to the belongingness of thing to earth. The essence of the earth, as the forced-to-nothing bearing and self-occluding, uncovers itself, however, only in her towering up in a world, in the countermovement of both earth and world. This strife is set-fast in the Gestalt of the work and becomes manifest through it. What holds for the tool, that we experience the toolness of the tool first properly through the work, holds also for the thingness of the thing."[6]

How, then, shall we approach the artist's "objects?" In *The Origin of the Work of Art* (1935–1936), Martin Heidegger (1889–1976) attempted to remind the reader

6 M. Heidegger, Der Ursprung des Kunstwerkes, in: ders. Holzwege, a.a.O.,p.57 "Für die Bestimmung der Dingheit des Dinges reicht weder der Hinblick auf den Träger von Eigenschaften zu, noch jener auf die Mannigfaltigkeit des sinnlich Gegebenen in seiner Einheit, noch gar der auf das für sich vorgestellte Stoff-Form-Gefüge, das dem Zeughaften entnommen ist. Der maß-und gewichtsgebende Vorblick für die Auslegung des Dinghaften der Dinge muß auf die Zugehörigkeit des Dinges zur Erde gehen. Das Wesen der Erde als des zu nichts gedrängten TragendenSichverschließenden enthüllt sich jedoch nur im Hineinragen in eine Welt, in der Gegenwendigkeit beider."

6 M. Heidegger, Der Ursprung des Kunstwerkes, in: ders. Holzwege, a.a.O.,p.57 "Für die Bestimmung der Dingheit des Dinges reicht weder der Hinblick auf den Träger von Eigenschaften zu, noch jener auf die Mannigfaltigkeit des sinnlich Gegebenen in seiner Einheit, noch gar der auf das für sich vorgestellte Stoff-Form-Gefüge, das dem Zeughaften entnommen ist. Der maß-und gewichtsgebende Vorblick für die Auslegung des Dinghaften der Dinge muß auf die Zugehörigkeit des Dinges zur Erde gehen. Das Wesen der Erde als des zu nichts gedrängten TragendenSichverschließenden enthüllt sich jedoch nur im Hineinragen in eine Welt, in der Gegenwendigkeit beider."

'공간 안에서의 포괄적 탐구'를 하는 그룹 엔오엘(NOL-남궁교, 오현진, 이광호), '기능적인 형태와 구조 실험을 통한 촉각적 감각과 실용 사물의 형태적 가능성을 연구'하는 서정화, '반복적인 감기와 쌓기 기법에 의한 압축 층위 표현의 집적된 색과 질감으로 시간성을 표현'하는 신혜림, '재료들의 특성과 표현으로 기인한 사물의 시공간적 관계 탐색'의 이광호, '기하학적인 구조와 절제된 선을 강조한 미니멀한 작업'의 이상민, '실에 의한 선과 면, 소재, 배색, 조직의 면적과 두께 등의 변주를 이어오는' 이준아, '매체의 혼합적 사용, 설치적 구성과 조합적 형태를 지속적으로 탐색하는' 이헌정, '정교한 기계 유닛들의 유기적 연결과정을 탐색하고 조형하는' 현광훈 이상 8개팀은 각자의 시선과 물성으로 놀이함을 펼친다. 이들의 놀이는 그들 예술이 탐색부터 제작에 이르는 전 과정에 걸쳐 매우 섬세하게 감각화되어 있다. 다시 말해 놀이를 지칭하는 여러 단어, '아곤(Agôn,경쟁)', '알레아(Alea,요행,우연)', '미미크리(Mimicry,모방,흉내)', '일링크스(Ilinx,소용돌이,현기증)', '파이디아(Paidia,유희,어린애같음)', '루두스(ludus, 놀이, 투기, 시합)'[7] 등이 지닌 의미망이 이들 예술가 각자의 제작 행위 안에 응축되어 있다. 이들은 제작의 개념으로부터 구현에 이를 때까지 각각의 '질료와 형식', '반복과 단절', '친밀과 이질', '구조와 탈구조', '연속과 끊김', '더함과 덜함' 등등 자신만의 대립적 관계항과 끊임없이 경쟁, 우연, 모방, 현기증, 유희, 투기를 지속한다. 그들의 작업이 생동감 넘치고 흥미를 지속시키는 것은 바로 이러한

that objects bear their own meaning in their very existence and that meaning cannot be relegated to phenomenal elements such as value, properties, or utility. In other words, "art exists as reality within the work of art." This implies that the function of art is not to reduce an existence into a value, and that the "thingness" of an artwork is one of the artwork's fundamental characteristics. As Heidegger suggested, an artwork is an object, and artists should strive to go from the "thingness" of the object towards the immersive senses.

This exhibition features the works of eight artists and artist teams, each of which provides their unique perspective and materiality to reveal their idea of play. Namkoong Kyo, Oh Hyunjin, and Lee Kwangho, members of the group NOL, seek to engage in a "comprehensive study in space," while Seo Jeonghwa "studies functional forms, tactile senses through structural experiments, and explores the possibilities of the formal potential of practical objects." On the other hand, Shin Healim "expresses temporality through the compiled color and texture formed by compressed layers generated through repetitive wrapping and stacking techniques," and Lee Kwangho "explores the space-time relationships of objects based on their material traits and expression." Lee Sangmin focuses on "minimalist work that emphasizes geometric structures and composed lines," and Lee Joona "pursues the variations of the lines, planes, material, coloration, and the area and thickness of textiles composed of thread." Lastly, Lee Hunchung "relentlessly explores the use, installation structure, and composition of the material," while Hyun Kwanghun "examines and shapes the organic connection process of precise mechanical units." Their play has been meticulously sensitized throughout the

7 로제 카이와, 『놀이와 인간(LES JEUX LES HOMMES:Le masque et le vertige)』, 이상률 옮김, (서울: 문예출판사, 2004), 35-70.

본능에 귀 기울이고 반응함으로써 스스로 '놀이함'
때문인 것이다.

'놀이하는 사물' 속으로

예술가의 '놀이함'은 '놀이하는 사물'로 귀결한다.
8팀의 예술을 '놀이함'의 사물로 헤아리기
위해 로제 카이와(Roser Caillois)의 몇몇
용어에 기대보자. 그가 『놀이와 인간(LES
JEUX LES HOMMES:Le masque et le
vertige)』의 '놀이의 분류'를 통해서 제시하는
놀이의 언표(言表), 중국 문자에 대한 설명은
《놀이하는 사물》의 예술가들과 유비점을
갖고 있기 때문이다. '유(遊)', '희(戲)', '요(要)',
'도(賭)', '완(玩)'의 다섯 문자가 그것인데,
각각 다음의 의미를 지닌다. 유희를 의미하는
'유(遊)'는 '한가로이 거닒, 공간의 놀이로 특히
연날리기를 가리키며, 혼(魂)이 저승길로 멀리
떠나는 것, 샤먼의 신비적인 여행, 유령의
방황'을 의미한다. '희(戲)'라는 문자는 '변장이나
모의의 놀이를 가리키고 연극 및 거의 모든
무대예술'을 포괄한다. '요(要)'는 '기교와 솜씨의
놀이, 어려운 말싸움이나 검술 등 기술의
연마'를 의미한다. '도(賭)'라는 문자는 '우연
놀이, 위험, 내기, 신명재판(神明裁判), 운(運)을
시험하는 내기' 등의 의미를 갖는다. 마지막으로
'완(玩)'은 '장난치다, 시시덕거리다, 익살부리다
등의 동사에서 연상되는 어린애 같은 놀이와
천진스럽고 하찮은 갖가지 종류의 오락'을
포함한다. 또한 거침없고 비정상적이거나 이상한
성행위에 대해서도 쓰이며, 심사숙고를 요구하며
성급함을 금하는 놀이, 체스, 체커, 퍼즐,
구연환(九蓮環) 같은 놀이에도 사용되고, 요리의
맛이나 술의 향기를 맛보는 즐거움, 예술품을

entire process of exploring and ultimately
producing their artwork. In other words, the
significance of the various words meaning
"play" has been robustly fulfilled within their
artistic performances, to include the ideas of
agôn (compete), *alea* (chance), mimicry, *ilinx*
(vertigo), *paidia* (amusement, childlike-ness),
and *ludus* (games, speculation, contest).[7]
From the conceptualization of their works
to the physical manifestation thereof, each
artist repeats their own internal process
of competition, coincidence, mimicry,
vertigo, games, and gambling oscillating
betwixt conflicting elements of creation,
such as "material vs. form," "repetition vs.
severance," "familiarity vs. strangeness,"
"structure vs. deconstruction," "continuity
vs. disruption," and "more vs. less." The
reason their works are so intriguing and full
of energy is because the artists paid careful
attention to such instincts, as they engaged
in "playing" in the process.

Playing Objects

The "playing" of the eight artists and artist
teams ultimately lead to "playing objects".
Roger Caillois provides a few terms that may
be useful in understanding the eight artists
and artist teams' "playing" in the context of
objects, as it is possible to draw parallels
between those terms and the works featured
in the exhibition. In *Man, Play and Games
(Les jeux et les hommes: le masque et le
vertige)* Caillois refers to Chinese characters
when developing his definitions on the
types of play: *yóu* (遊), *xì* (戲), *yáo* (要), *dǔ*
(賭), and *wán* (玩), which bear the following
meanings. Signifying "amusement," *yóu* (遊)
may also refer to relaxed strolls or spatial
games, particularly kite-flying. It can also
mean the departure of the soul into the

7 Roser Caillois, *Les Jeux Les Hommes: Le
 masque et le vertige,* trans. Lee Sangryul
 (Seoul: Moonye Books, 2004), 35-70.

수집하는 취미, 골동품을 감정하고 감촉을 즐기며 그것을 직접 만드는 취미도 포함한다.[8] 이 같은 5가지 문자 언표의 의미와 8팀의 '놀이함'의 예술과 연계하여 보자면, 이들은 다분히 '유"희"요"도"완'의 놀이 의미를 대체로 다 포함하고 있다. 다만 갖가지 요소가 정도의 차이를 가지고 각각의 양상으로 드러나 보일 뿐이다. 즉 놀이의 언표가 지시하는 세계는 매우 깊고 넓으며, 어느 한 유형으로 구분하기 어렵다. 그럼에도 8팀의 작업에서 보이는 의미 지평은 대략 3갈래로 나누어 살펴볼 수 있다.

먼저 '유(遊)'와 '희(戲)'가 지닌 '공간에서의 노닒'을 보다 두드러지게 나타내는 양상이 한 갈래이다. 엔오엘과 서정화, 이광호, 이준아는 시간과 공간의 긴장과 이완을 통해 노닒에 이르는 무대를 만들고 있다. 엔오엘의 경우 국립현대미술관 과천의 원형전시실이라는 매우 독특한 공간을 둘러싸거나 풀어헤치기의 강약을 조절하며 이들 8명의 작가가 서로 유기적으로 연결되면서도 독립적인 무대인 〈빛의 사물〉 (2021)을 효율적으로 분할하고 배려한다. 원형전시실이 지닌 애초의 공간 정체성을 존중하며, 원형에서 파생되는 원기둥과 직선, 타원과 둥그런 사각의 윤곽 등이 변형되면서도 자연스럽게 작가들의 서사와 명상을 넘나들게 동선을 만들고 있다. 시공간적 안배로부터 반짝이는 은색 마감재로 하여 촉각적인 터치를 가능케 함으로써 감각의 개방, 확장으로 이끈다. 이때 공간은 노닒 그대로 놀이함의 무대이자, 개방과 폐쇄의 호흡을 안내하여 보는 이의 눈과 발 그리고 쉼까지 이끈다.

공간에서 형태와 구조를 통해 탐색하는 놀이는 서정화의 작업에서 포착된다. 판재와

afterlife, the mystical journey of a shaman, or the wandering of phantoms. *Xì* (戲) refers to disguises or roleplaying, inclusive of all performing arts such as theater. *Yáo* (要) alludes to games that require technical mastery, such as a challenging debate or swordcraft. *Dǔ* (賭) refers to game of chance, danger, wagers, trial by ordeal, or other bets that test one's luck. Lastly, *wán* (玩) includes child's play and all kinds of carefree and frivolous diversion such as to "frolic, romp, trifle, etc." It is also used to refer to "casual, abnormal, or strange sex practices… games demanding reflection and forbidding haste, such as chess, checkers, puzzles (tai kiao), and the game of nine rings." Further, it can also include the pleasure of appreciating the savor of good food or the bouquet of a wine, the taste for collecting works of art or even appreciating them, voluptuously handling and even fashioning delicate curious.[8] A comparative look at these five characters and the experience of "playing" inherent in the works by the eight artists and artist teams demonstrates that their work certainly includes the meaning of play nuanced by each of the five characters. The only difference is that each work employs and unveils these elements in varying degrees. The world painted by such words describing "play" is deep and wide, and cannot be captured by a single aspect. This notwithstanding, three distinctive veins can be observed in the works presented through this exhibition.

The first vein would be works that demonstrate a strong element of "frolic in space" in *yóu* (遊), *xì* (戲). NOL, Seo Jeonghwa, Lee Kwangho and Lee Joona create a stage that leads to frolic, by giving tension and relaxation to time and

8 로제 카이와, 『놀이와 인간(LES JEUX LES HOMMES:Le masque et le vertige)』, 이상률 옮김, (서울: 문예출판사, 2004), 68-69.

8 Roser Caillois, *Les Jeux Les Hommes: Le masque et le vertige*, trans. Lee Sangryul (Seoul: Moonye Books, 2004), 68-69.

곡선의 매스를 조합할 때 만들어지는 빈 공간에 주목해, 익숙한 가구의 형태를 벗어나면서도 벤치, 사이드 테이블, 선반 등 다양한 기능을 가진 사물들을 탄생시킨다. 얼핏 유사해 보이는 작품들 안에는 간결한 가구의 구조에서 사물과 사람, 관습과 형태 등 여러 관계를 읽어 내고 재해석한 작가의 치밀한 구성이 숨어 있다. 이번 전시에 선보이는 〈사용을 위한 구조〉(2021) 연작은 알루미늄 주물을 토대로 제한된 형태와 구조를 형상화한다. 다양한 형태와 구조로 응용이 가능한 몇 가지 유닛 형태들로 구축된다. 각각의 구조물들은 나무로 깎인 목형을 알루미늄으로 주물 가공하여 각각의 유닛들이 조립되어 완성된다. 건축적 형태를 공간 안에서 극대화하는 스케일을 통한 '공간으로의 확장', '다중적 구조'라는 조형적 특성을 정돈하는 그런 노닒을 제시한다.

이광호는 관심을 가진 재료에 대한 특성을 탐색하고 형태를 부여하며 독자적 사물로 제작해낸다. 시간성을 담고 있는 사물과 그 사물이 위치하게 되는 공간과의 관계, 자신과 사물 간의 관계를 자문하는 그의 작업은 질료와 패턴의 반복, 구조와 탈구조의 맥락을 재구성하는 양상을 보여왔다. 이번 전시에서는 일련의 압축적이고 조형적인 패턴, 원형의 사물들인 〈집착 연작〉(2020–2021)을 은빛 무대 위에 불규칙하게 흩뿌려놓는다. 말랑말랑한 촉감을 기대케 하면서도 견고한 활용이 순간 떠올려지는 그의 사각, 혹은 비정형의 사물은 스티로폼 선으로 형태를 만든 후 알루미늄 주물을 떠서 완성된다. 한국의 자연 속 어딘가에서 듬성듬성 피어난 풀뿌리나 돌덩어리가 흩어져 있는 것 같은 색색의 사물들은 공간 속의 노닒, 무대 위 사물 풍경이라 하겠다. 즉 세로로 더해지거나 가로로 바닥에 누워있거나 비대칭의 조형적 구조를 획득한

space. As for NOL, the team plays with the very uniquely shaped circular exhibition space in MMCA Gwacheon, wrapping and unwrapping the space in varying intensities. The team's *Objects of Light* (2021) are organically connected yet independent of each other thanks to this efficient but considerate manner of sharing the space. While respecting the original identity of the circular exhibition space, the circular pillars, straight lines, ellipses and round outlines of rectangles that derive from the circular form are transformed. In turn, the diverse outlines of the space meld naturally into the artists' narrative and meditations, guiding the audience's movement throughout the space. In addition to such meticulous allotment of space, the team gave the space a silvery finish to open and expand the viewers' perceptual experience to include tactile sensations. As can be seen, the exhibition space becomes the stage for the frolic aspect of playing, with the rhythm of opening and closing guiding the eyes, feet, and even the breaks the viewers take.

Seo Jeonghwa's works present the type of play enabled by the exploration of spatial form and structure. Seo focuses on the gaps created while connecting the boards and curved masses to create various objects such as benches, side tables, and shelves that are functional yet oddly different from conventional furniture. While these pieces may appear similar at a glance, Seo meticulously designed the simple structures to reflect and reinterpret various relationships between people and objects, as well as conventions and forms. Seo's *Structure for Use* (2021) series featured in this exhibition is composed of cast aluminum structures that are simple yet allow for diverse arrangements to create various forms and structures. Cast using wooden molds, the aluminum units are assembled in various ways to create the final piece. Leveraging such architectural shapes, Seo maximizes the use of scale to

사물들이 자연의 경영위치(經營位置)가 그러하듯 간격을 두거나 밀집하며 유동적이거나 유기적인 풍경의 '놀이함'에 이르고 있다.

공간에서의 놀이함의 다른 양상은 이준아를 통해 만날 수 있다. 실로 선과 면을 만들며 공간을 이어가는 작가는 실의 성질이나 색 또는 면적이나 두께의 변이를 통해 다층적인 편물의 공간을 직조해왔다. 손과 수편기를 이용한 편직은 형태나 크기 등 다양한 제작의 양상을 실험하게 하는 놀이와 같다. 이번 전시에는 〈시간과 흔적〉(2021)이 유기적 생명체 혹은 자연의 순간과도 같은 부정형의 공간으로 드러난다. 실과 편직밴드가 핸드 니팅으로 이루어지는 이 작업은 한코한코 쌓이면서 촘촘해지는 물성과 구조가 궁극에는 공간과 두께를 만들어가는 것임을 보여준다. 즉 유기적 형상으로 드러나는 편물 조직은 공간의 아주 작은 일부였다가 보다 넓은 면적이 되거나 높이가 생겨 새로운 면과 형을 만들며, 서로 겹치고 쌓아, 흔적이 되게 하는 노닒이 있다.

다음으로, '요(要)'의 기교와 솜씨의 놀이함을 드러내는 양상이다. 사실 기교와 솜씨는 8팀 모두 각각의 탁월함을 가지나, 신혜림, 이상민, 현광훈의 작업은 치밀함과 압축적 구조 그리고 정교함에 몰입하고 있다는 점에서 부각된다. 신혜림은 금속을 주재료로 하지만 섬유와의 결합을 통해 장신구에서부터 설치에 이르는 다양한 표현을 선보여 왔는데, 이번 전시에서 〈시간의 비가 내린다-선〉(2021), 〈시간의 비가 내린다-면〉(2021)은 니체(Friedrich Wilhelm Nietzsche,1844–1900)의 '힘들의 파동 놀이'의 그것처럼 응축된 시간성이 만개한다. 그의 무대는 핵이 되는 중추에서부터 길이가 다른 색선이 증폭하는 형상으로 드러나는가 하면, 고요한 선의 면에서 시작되어 공간을

reveal in a frolicking organization of formal characteristics such as "spatial expansion" and "multilayered structure."

Lee Kwangho creates unique objects by exploring the characteristics of his materials and assigning them forms. Over the years, Lee featured works that repeat materiality and patterns or restructured the context of structure and deconstruction, thereby challenging the relationship between objects imbued with temporality and the space wherein the objects lie, as well as his own relationship with the objects. In this exhibition, Lee presents the *Obsession Series* (2020–2021), which features a series of compressed patterns and raw shapes scattered in a seemingly disorganized manner across a silver stage. To create his rectangular or irregular objects that appear soft to touch but also evoke images of sturdy furniture, Lee carved molds from foam and later cast aluminum bodies out of it. Reminiscent of scattered weeds and rocks commonly found outdoors across Korea, the vibrantly colored objects provide a mirthful landscape on the stage. Much like the asymmetric disposition of objects found in raw nature, the vertically or horizontally strewn objects in Lee's series maintain dynamic distance from each other to create an organic scene of "playing."

Lee Joona presents yet another mode of play. By varying the material, color, or girth of her yarn, Lee weaves multilayered textile spaces connected by the lines and planes drawn with strings. Lee's attempts to hand-knit pieces of various shapes and sizes are reminiscent of games that encourage experimentation. In her work *Trace with the Time* (2021) showcased in this exhibition, she presents an irregular space akin to a living organism or a moment from nature. Carefully hand-knitted one stitch at a time, this work reveals how the accumulation of mass and structure can

형성해내기도 한다. 각각의 색선들은 무수히 많은 선들이 반복되어 이룬 색기둥이며, 이들에 의해 확산하는 색선들의 폭발과 조형적 부피는 압도적인 스케일로 다가온다. 기존의 선들의 반복이 표면과 심층의 고리를 만들어냈다면, 이번 작업들은 선들의 연속이 자체로 부피와 두께로 '보이는 심층'에 이르렀다고 하겠다.

금속이라는 속성을 실용적 기물 제작에 활용함으로써 기교와 솜씨의 놀이를 즐기는 이상민의 작업은 신혜림의 밀도있는 반복과 정교한 간격과 다르게 구조적 설계와 실제 사용성을 전제한 치밀함을 장착하고 있다. 대체로 월넛과 황동의 두 질료로 만들어내는 전등, 아이패드 거치대, 스탠드, 조명, 아이폰 음향 증폭기, 향꽂이, 촛대, 와인 렉, 그리고 호두깨는 장치 등의 사물들은 군더더기 없이 최대한 기능에 형태를 맞추는 미니멀한 형식미로 압축된다. 루이스 설리번(Louis H. Sullivan, 1856–1924)의 "형태는 기능을 따른다"는 말이 상기되는 그의 간결한 형태로부터 이번 전시의 〈호두깨는 장치 6〉(2021), 〈호두깨는 장치 7〉(2021)는 기교와 솜씨 놀이라 할만한 유머와 움직임이 있는 실용적 사물의 극한으로 나아갔다.

세 번째 '요'의 작가는 현광훈이다. 실용적 사물이라는 측면에서 이상민의 작업과 접점이 있지만, 톱니바퀴를 이용한 기계장치에 보다 많은 공을 들인다는 점에서 다르다. 카메라와 시계, 오토마타 등 복잡한 기계 장치가 들어가는 그의 작업은 0.001mm 단위의 작은 부품까지도 직접 깎아 제작한다. 정교한 기계 유닛들의 유기적 연결과정이 돋보이는 그의 작업은 이번 전시에서 〈하트비트 III〉(2021)라는 카메라를 선보인다. 기존 〈하트비트〉 시리즈가 시계부품을 변형하여 핀홀 카메라에 접목시킨 셔터의 움직임을 보여준 것이라면, 이번 작품은 작동 구조를 직접 설계하여 만든 것이라는 점에서

ultimately create space and thickness. The knitted fabric begins as an infinitesimal part of the space but grows to acquire new planes and shapes, stacking on top of each other to create traces in a playful manner.

The exhibition also includes works that present the *yáo* (要) aspects of play, which represent mastery of skills and techniques. While all eight artists and artist team boast mastery over their respective form and style, the works of Shin Healim, Lee Sangmin, and Hyun Kwanghun stand out in particular due to the thorough and compressed structure and the attention paid to elaborate details in their works. Although Shin mainly works with metal, she has also incorporated textiles in her works to present a diverse array of pieces ranging from accessories to installation art. In such works *As Time Goes Rain Falls - Line* (2021) and *As Time Goes Rain Falls - Plane* (2021) she features the notion of compressed temporality conceived in Friedrich Nietzsche's (1844–1900) "play of forces and waves of forces." Here, Shin has colored lines of varying lengths radiate from the central core, while in other instances she constructs spaces that begin from tranquil lines and planes. Countless vectors are repeatedly compiled to create colorful pillars, leading to an explosion of colorful lines and sculptural volume of an overwhelming scale. Whereas Shin's previous works featured iterations of lines that linked the visible surface with the underlying layer, her works in *SWITCH THINGS UP* have the lines themselves accomplish a "visible under-layer" through their volume and thickness.

Unlike the elaborate spacing and condensed repetition Shin uses in her works, Lee Sangmin's metal works feature structured design and assume practical utility while also indulging in the play of technique and skillfulness. Minimalist in form, Lee's objects are tailored strictly for their practical purpose without extra

특별하다. 그에 따르면, 시계에서 보여지는 시스루백을 카메라에 적용하여 카메라 셔터가 작동하는 기계장치를 뒷면에 배치하여 사진을 찍는 동안 카메라 내부의 작동을 보이게 함으로써 정밀한 형태미와 기계적 메커니즘을 만끽하게 한다.

세 번째로 '완(玩)'은 천진스럽고도 거침없으며 심사숙고하고 감촉을 즐길뿐 아니라 제작에 이르는 놀이 양상의 갈래이다. 흙의 물성으로부터 평면과 입체, 가구, 설치에 이르는 이헌정의 '여행'으로 대변되는 작업은 구수한 큰 맛이라는 한국적 미감과 매우 잘 맞는다. 그의 일련의 도자 작업은 둥글게 마감된 친근한 형태와 생명력 넘치는 터치 등으로 어느 곳에서나 합을 잘 이룬다. 부드럽게 마무리된 모서리나 흐르다 만 유약 등도 조형적 의도에서 출발하는데, 우연의 개입이 불가피함을 알기에 열어놓는 그의 여백이자 여유는 서정적 추상표현에 이르게 한다. 이번 전시에 선보이는 도판이나 테이블, 스툴 등은 벽면과 공간을 아우르는 다양한 표정으로 조형적 균형을 잡는데, 무엇보다 천정부터 바닥으로 이어진 설치는 원형전시실의 구심점으로 자리한다. 형형색색의 형태들의 구슬이 마법에 걸린 듯 확대되지만 흩어지지 않고 세워진 완의 풍치를 뿜는다.

이렇듯 《놀이하는 사물》전 8팀의 작업은 놀이 문자의 의미 지평 세 갈래로 사색할 수 있다. 앞서 언급했던 놀이의 어원이나 언표는 사실상 하나의 내용으로 규정할 수 없는 넓고도 다양한 속성과 의미망으로 열어 있다. 카이와는 '완'을 설명하면서 '달빛의 고요하고 은은한 감미로움, 맑은 호수에서 뱃놀이하는 즐거움, 시간 가는 줄 모르며 폭포를 바라보는 것'이라 했다. 즉 놀이는 개념적 이해로 다가가는 것이 아니라 감각하는

frills. They include walnut and bronze lamps, iPad stand, lighting fixtures, iPhone speakers, censers, candleholders, wine racks, and nutcrackers. Evoking Louis H. Sullivan's (1856–1924) phrase "form follows function," Lee's minimalist objects in *Nutcracker 6* (2021) and *Nutcracker 7* (2021) presented in this exhibition push our conceptual boundaries, revealing witty and kinetic practical objects in true mastery of technique and skills.

Hyun Kwanghun is the third artist in this exhibition who features the *yáo* aspect of play. Although his objects are similar to Lee Sangmin's works in their practicality, the focus in Hyun's works are on the meticulous arrangement of mechanical cogwheels. From cameras to watches and automata, Hyun hand-crafts each component of his complex machinery, including parts as small as 0.001mm. Featuring the organic connection between such sophisticated mechanical units in this exhibition is a camera titled *Heartbeat III* (2021). Whereas the previous works in the *Heartbeat* series featured pinhole cameras with moving shutters built from watch components, *Heartbeat III* is exceptional in that Hyun designed the entire mechanism from scratch. According to the artist, he applied the see-through-back design of watches on the shutter mechanism placed on the rear so that the inner workings can be observed when taking photos, allowing the viewer to fully appreciate the precise craftsmanship and cogwheel mechanism.

Lastly, *wán* (玩) is a type of play that is innocent, bold, prudent, appreciative of texture, or relating to production. Lee Hunchung's "The Journey" is representative of the *wán* type of play as he elicits planes, sculptural forms, furniture, and installation pieces from clay. It also resonates deeply with the Korean aesthetics of rustic

인간이 마주하는 실재의 현상 또는 사물 안에서의 움직임으로 체험되는 것이다. 이것은 인간이 '놀이함' 그 속에 있어야 하는 이유이다. 가다머가 예술작품의 존재방식으로서 놀이를 강조했던 것은 결과적으로 사물성과 실재성의 횡단을 가능케 하기 때문이었는지도 모른다.

affability. The rounded and vibrant finishing touches in Lee's ceramics pair well with any surroundings. The rounded corners and dripping glaze are deliberate parts of Lee's artistic intent, as he leaves enough room for the inevitable intervention of chance. Such purposeful gaps and down-to-earth attitude enable the poetic abstraction expressed in Lee's works. The plates, tables, and stools presented in SWITCH THINGS UP achieve compositional balance through their diverse expressions juxtaposed across the walls and the exhibition space. In particular, the installation piece connecting the ceiling to the floor serves a pivotal point for the circular exhibition space. Lee's colorful marbles also boast the elegance of wán as they expand yet stand affixed without dispersing.

The works by the eight artists and artist team in SWITCH THINGS UP may be appreciated in the context of three of the Chinese characters representing aspects of play. The aforementioned etymology and lexicons of play are so vast and diverse that it is virtually impossible to distill them into a singular definition. In describing wán, Caillois compared it to "the transitory and relaxing sweetness of moonlight… the pleasure of a boat ride on a limpid lake or the prolonged contemplation of a waterfall." In other words, play is not something to be understood conceptually, but rather something that must be experienced through the contemporaneous exploration of their material reality or the motion of objects. This is precisely the reason why human existence must be continually explored from the perspective of "playing." Perhaps Gadamer emphasized play as art's means of existence because it is such play that ultimately enables the traversal between thingness and reality (Realität).

이광호

Lee Kwangho

이광호의 작업은 유년 시절 주변의 일상 소재들로 다양한 놀이와 도구를 만들었던 순수한 호기심에 맞닿아 있다. 재료가 가진 본연의 특성을 탐구하며, 재료의 고유성과 가능성 사이의 균형을 찾으며 또 다른 사물을 만들어 낸다. 과거를 현재로 소환해 시간이 켜켜이 쌓인 공간 안에서 확장된 오브제를 경험하게 한다. 새롭게 직조된 시공간에선 작품들의 소재와 스케일이 상호 작용하고 서로 유기적으로 헤쳐 모이며 보는 각도에 따라, 움직임에 의해 다르게 보일 수 있는 서사적 구조를 가진다.

Lee Kwangho's works stem from a sense of pure curiosity that drove him to come up with various tools and ideas for play using everyday materials in daily life during his childhood. Lee makes his works in the process of exploring the original characteristics of the material, finding a balance between the inherent properties of the material and the possibilities it presents. Summoning the past to the present, he invites the audience to experience an expanded sense of objects in a space of accumulated layers of time. In the newly woven time and space, the material and scale of the works interact with each other and disassemble and assemble organically. Furthermore, they become charged with a narrative structure that evolves with movement depending on the perspective.

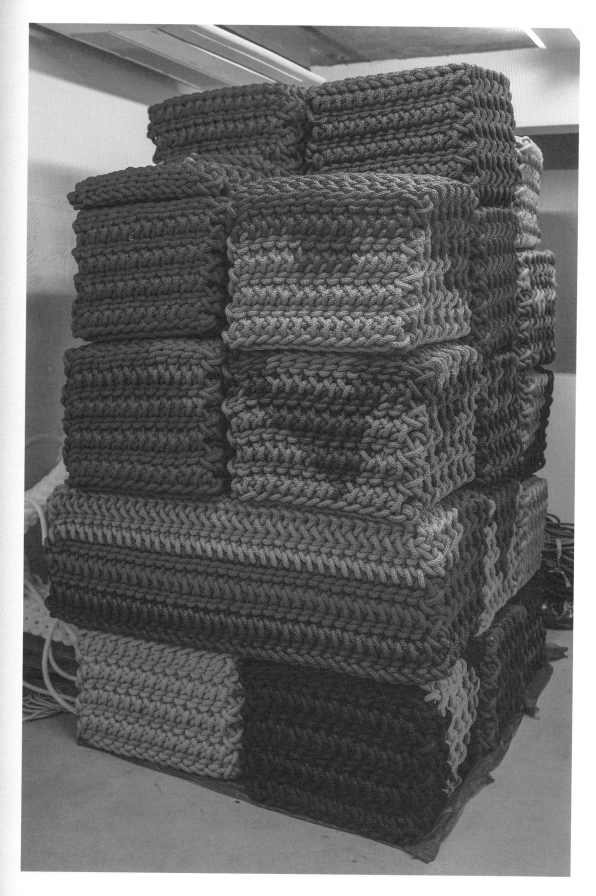

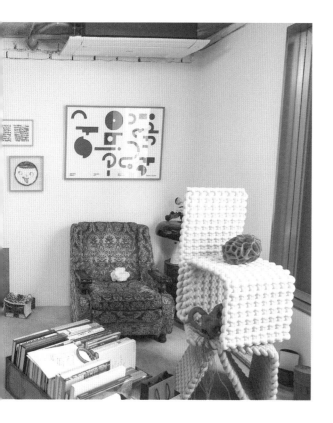

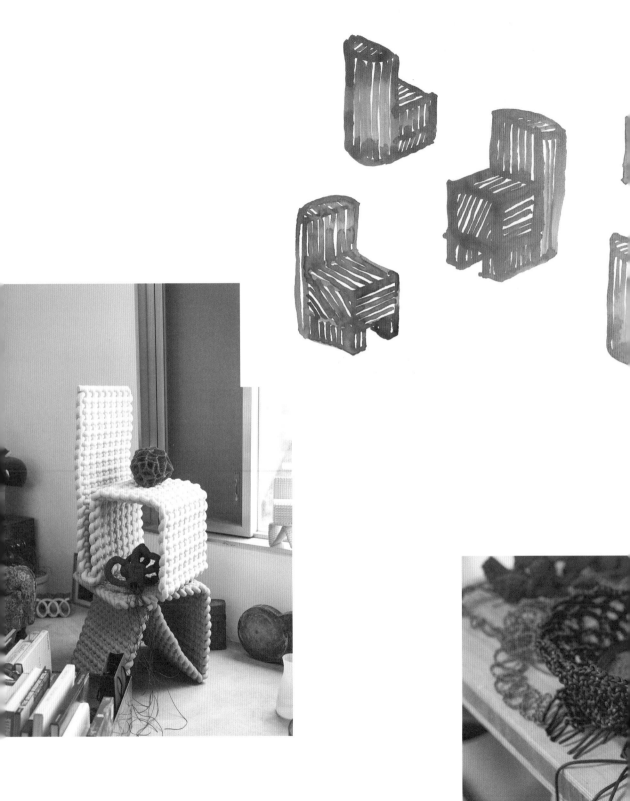

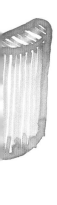

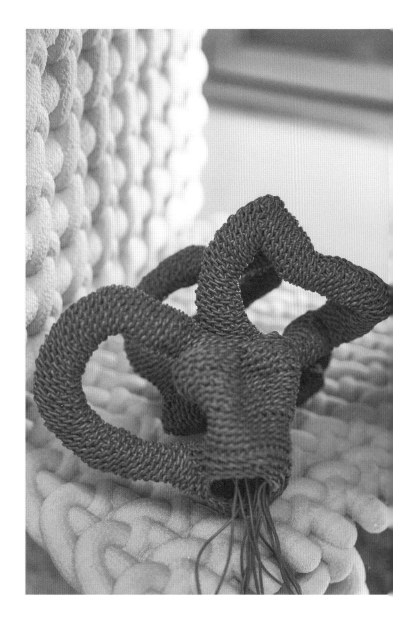

도화진 작가님이 작품을 제작하기에 앞서 행하는 일상의 놀이와 상상의 과정들은 어떤 것들이 있을까요?

이광호 저는 작품을 제작할 때 스케치나 드로잉을 먼저 한다기보다, 어떤 재료를 먼저 정하고 그 다음에 일단 무언가를 만들어 보거든요. 그러면서 자연스럽게 손에서 이루어지는 일들이 상상력을 더 극대화시켜주고 작업 방식의 가능성들을 조금 더 다양하게 만들어 준다고 생각이 들어요.

도화진 작가님이 사용하는 재료들은 익숙함과 새로움이 공존하는데요, 재료를 주로 어떠한 방법으로 채집하고 그 재료에 적합한 기법을 찾으시나요?

이광호 예를 들면 요리처럼, 같은 재료를 이용해서 누군가는 저런 맛을 내고 저 같은 경우에는 이런 맛을 낼 수 있지 않을까 하는 호기심에서 출발을 많이 하는 것 같아요. 그래서 한 재료를 정하게 되면 그 재료를 가지고 이렇게도 만들어보고 저렇게도 만들어보고 하면서 가장 저에게 어울리는 작업 방식 그리고 크기, 형태, 비례라든지 이런 요소들을 찾아내는 과정을 거쳐요. 그래서 저의 작업 같은 경우에는 하나의 결과를 가지고 이야기한다기 보다는 전반적으로 어떤 재료를 찾아내고 저에게 맞는 방법을 찾는 이 과정 자체가 작업이라고 이야기할 수 있는 것 같아요.

Do Hwajin What everyday processes of play and imagination precede the production of your work?

Lee Kwangho I begin my work by choosing certain materials and just making things right away rather than sketching or drawing first. Then what takes place naturally in my hands push my imagination further, and I think this way of working diversifies the possibilities in my work.

Do Hwajin A sense of familiarity and newness coexist in the materials you use. How do you collect your materials and find the right techniques for working with them?

Lee Kwangho To draw an analogy to cooking, I question how the same ingredients can taste differently depending on the person who cooks. My work begins with such curiosity. So when I choose a certain material, I play with it in infinite ways. It's a process of finding out just the right methodology, scale, form, proportion, etc. Instead of focusing on one final outcome, my work is about this overall process of finding a certain material. My practice entails searching for the right methodology that works for me.

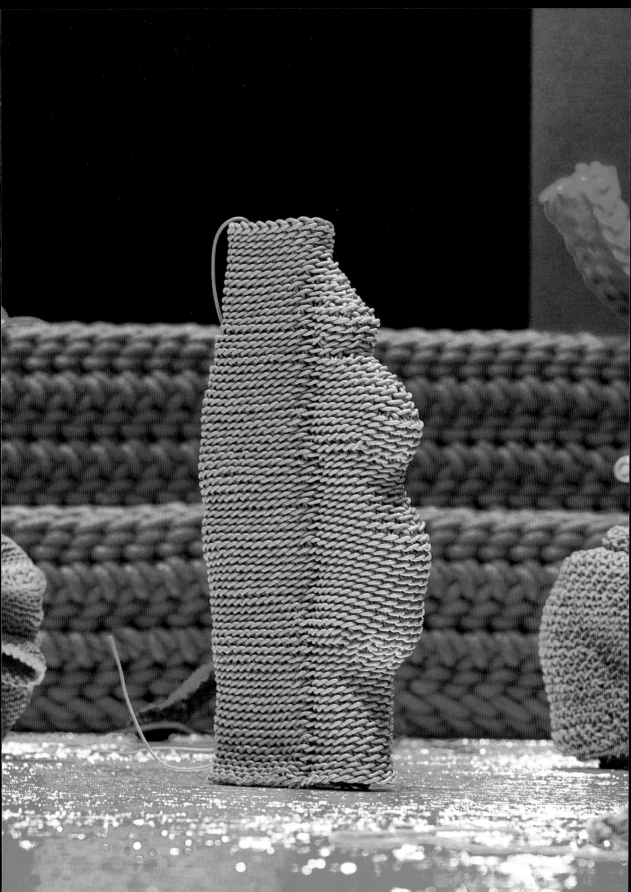

〈집착 연작〉, 2020-2021, 나일론, PVC,
전선, 플라스틱, 알루미늄, 스폰지 폼, 가변크기

Obsession Series, 2020—2021, nylon, PVC,
electric wire, plastic, aluminum, sponge foam,
dimensions variable

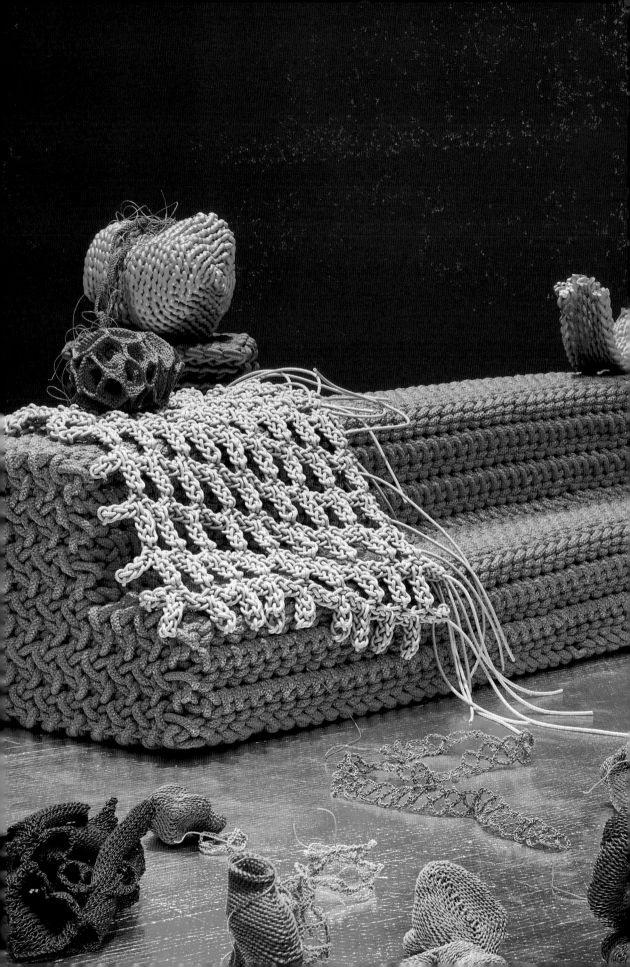

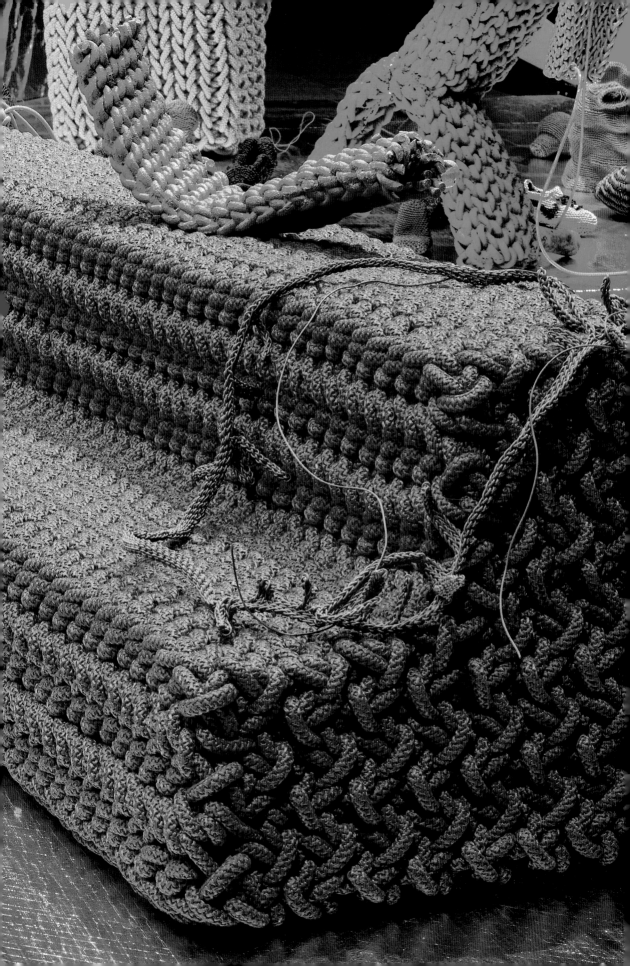

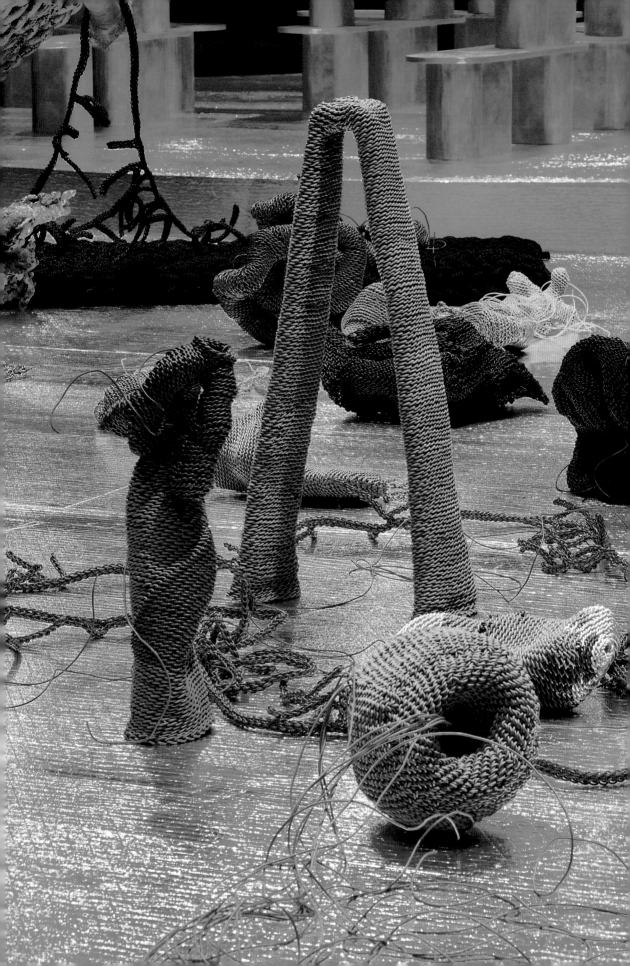

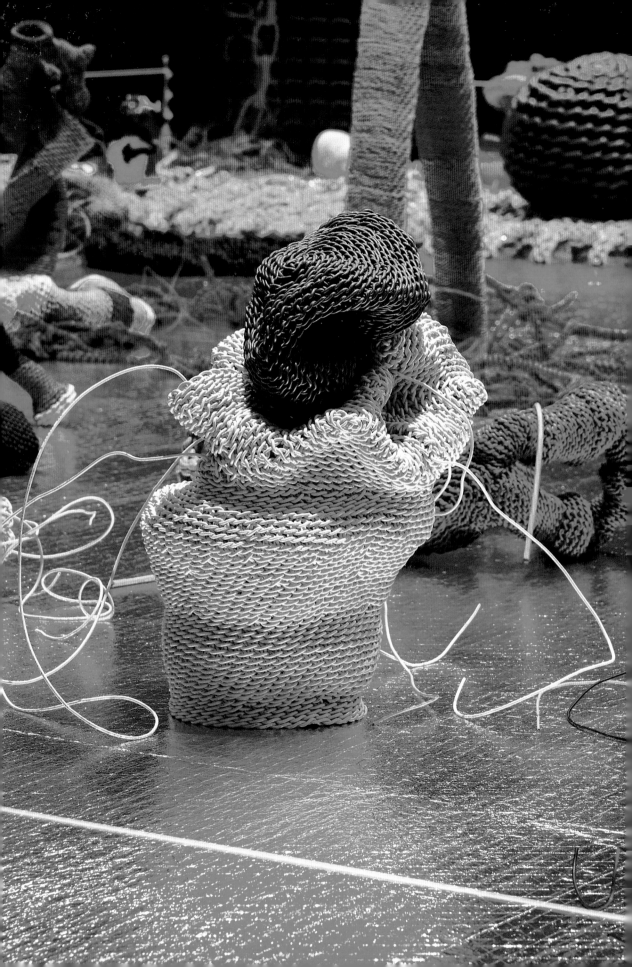

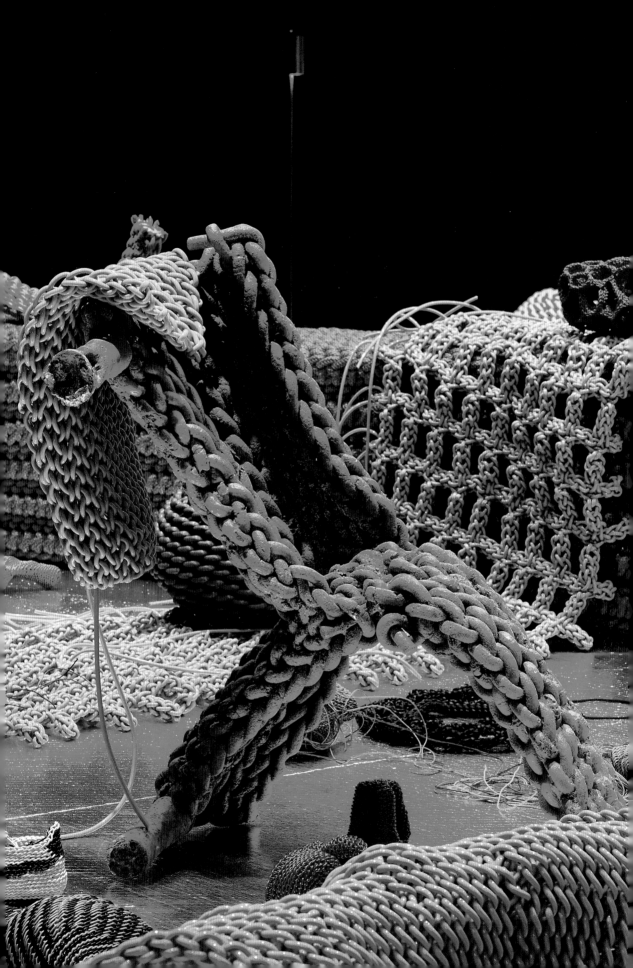

서정화

Seo Jeonghwa

서정화의 작업은 형태와 소재에 대한 깊이 있고 유기적인 이해를 바탕으로 사물을 더욱 단순하고 순수하게 담아낸다. 일상생활 속의 평범한 소재를 선택하고, 다른 재료와 접합하는 다양한 실험을 통해 제한된 형태를 응용하고, 구조적 관계 안의 형태적 가능성을 탐색한다. 곡선과 직선의 반복된 구조를 조합할 때 만들어지는 빈 공간에 주목하고, 열고 닫히는 면적 구성을 이용함으로써 조형 공간에 또 다른 연속성을 부여한다.

Seo Jeonghwa's works capture the simpler and purer aspects of objects based on his deep and organic understanding of form and material. Seo selects ordinary subjects from everyday life and converges them with different materials, making appropriations of limited forms and exploring morphological possibilities within structural relationships. Seo pays attention to the empty spaces produced when combining the repeated structures of curves and straight lines, and adds a sense of continuity to formative space by applying a composition that opens and closes.

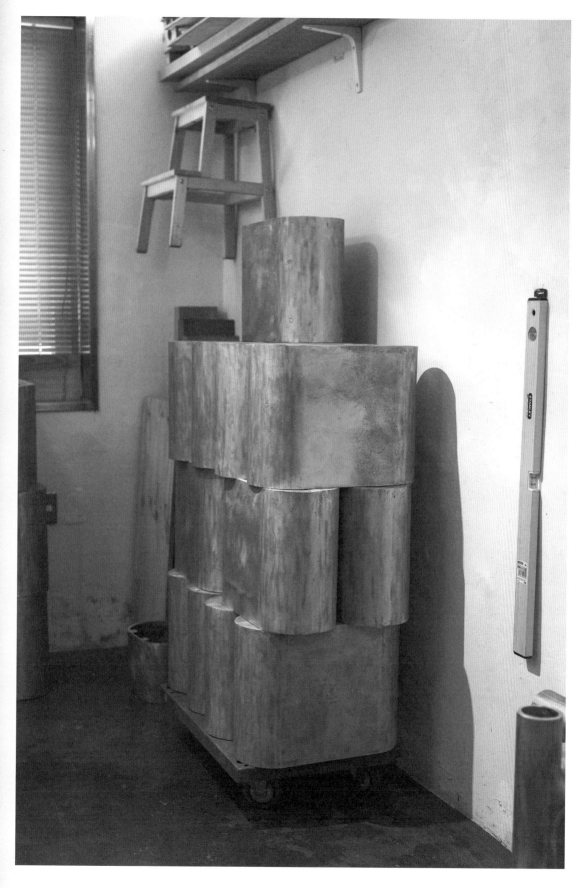

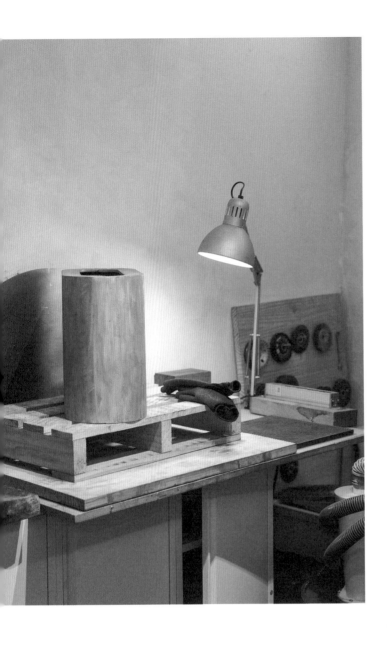

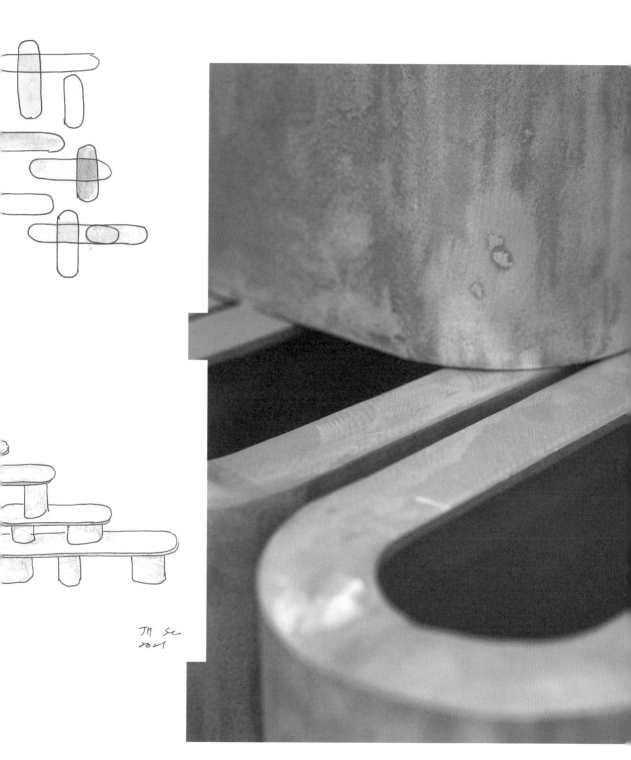

JM Sc
2021

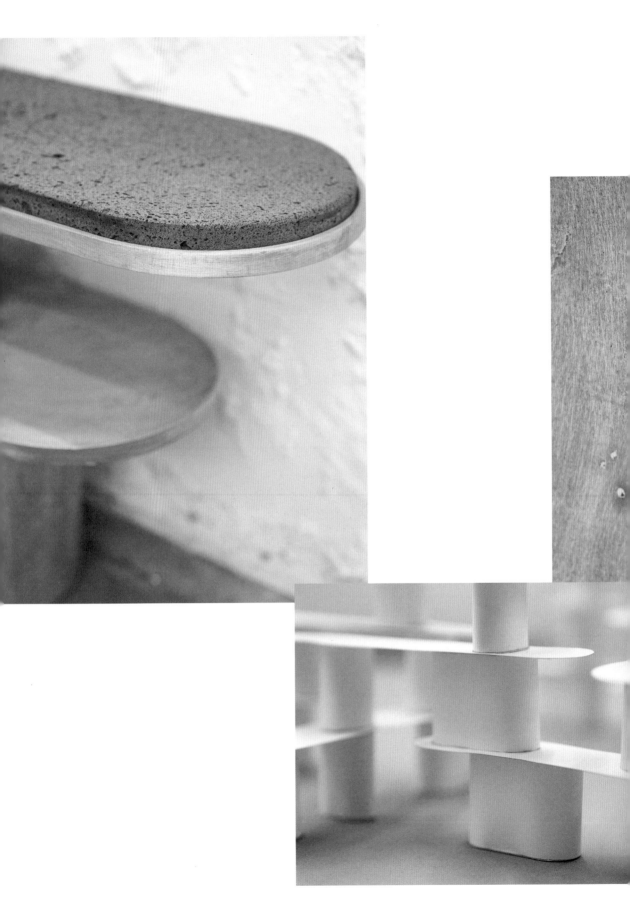

도화진　작가님이 작품을 제작하기에 앞서 행하는 일상의 놀이와 상상의 과정들은 어떤 것들이 있을까요?

서정화　저는 드로잉하는 과정을 정말 중요하게 생각해요. 그래서 드로잉으로 나오는 형태들을 10분의 1 스케일 목업으로 종이와 같은 재료로 실제 입체물을 제작을 해서 관찰하는 과정을 또 거치게 되고요, 그런 것이 주된 작업 과정인 것 같아요. 그리고, 무언가를 정렬한다든지 정리한다든지 그런 행동을 좀 많이 하는 편이거든요. 그런 것에서 또 영감이 오기도 해서, 집에 있는 가구를 옮긴다든지 물건들을 배열했을 때 간격 같은 것을 본다든지 일상생활 속에서 사물들을 가지고 관찰하는 행위를 하는 것 같아요.

도화진　작가님이 사용하는 재료들은 익숙함과 새로움이 공존하는데요, 재료를 주로 어떠한 방법으로 채집하고 그 재료에 적합한 기법을 찾으시나요?

서정화　평소에 재료 같은 것을 보러 다니는 것을 좋아하고 재료를 수집하는 행위들을 좋아해요. 어디 가서 새로운 재료가 나온다든지 혹은 질감들이 마음에 드는 재료가 있으면 그것을 작업실에 가져다 놓고 선반 위에 올려놨던 것들을 다시 재조합해 보기도 하고, 새로운 소재에 대한 조합을 실험해보기도 하고요. 그런 과정들을 통해서 작업이 연계되어 나오기도 하는 것 같아요.

Do Hwajin　What everyday processes of play and imagination precede the production of your work?

Seo Jeonghwa　The process of drawing is very important in my work. The drawing would be transferred as a 1:10 scale mockup in paper or an actual 3-dimensional model. Such processes of drawing, making and observing are the key aspects of my work. I often find myself arranging or organizing objects. This process inspires me, so I'd move around furniture in the house or line objects up and observe the spaces in between. It's fascinating to observe objects in my everyday life.

Do Hwajin　A sense of familiarity and newness coexist in the materials you use. How do you collect your materials and find the right techniques for working with them?

Seo Jeonghwa　I always like going out to look for materials or collecting them. So if I come across a new material or find matters with textures that I like, I'd take them to my studio, put them on a shelf and assemble them in different ways. These processes would then lead to other experimentations combining new materials.

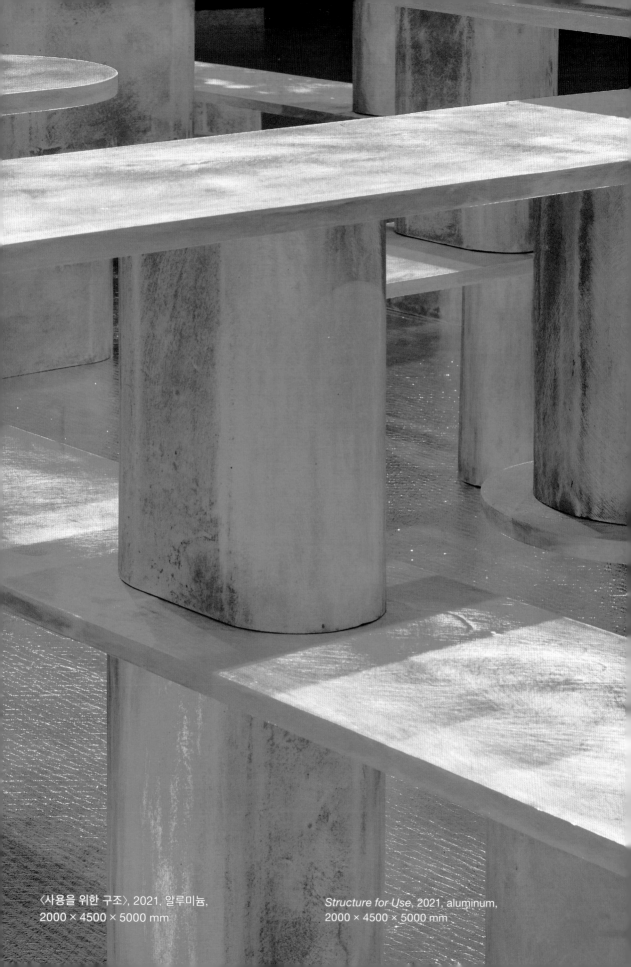

〈사용을 위한 구조〉, 2021, 알루미늄,
2000 × 4500 × 5000 mm

Structure for Use, 2021, aluminum,
2000 × 4500 × 5000 mm

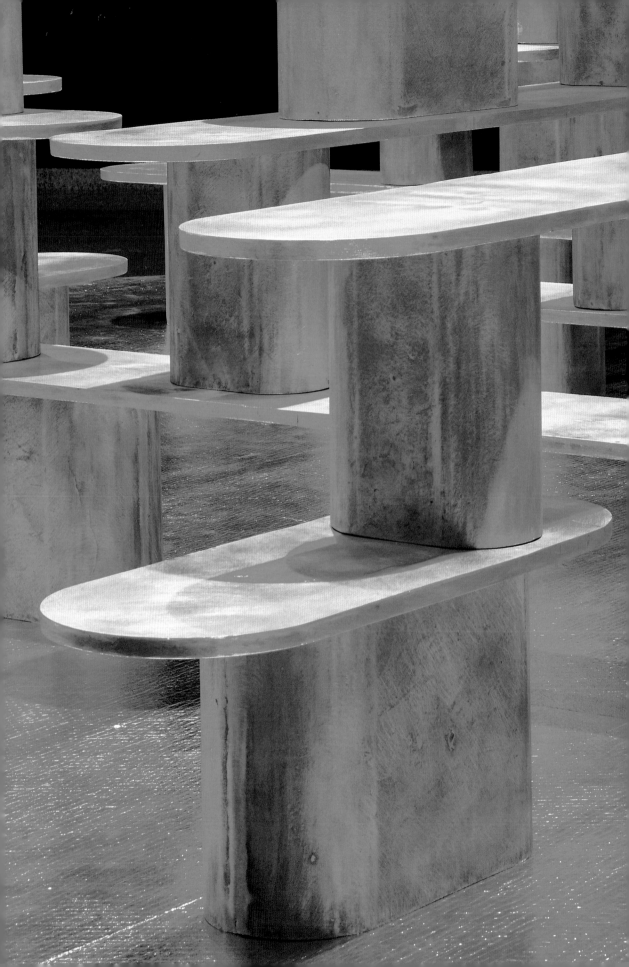

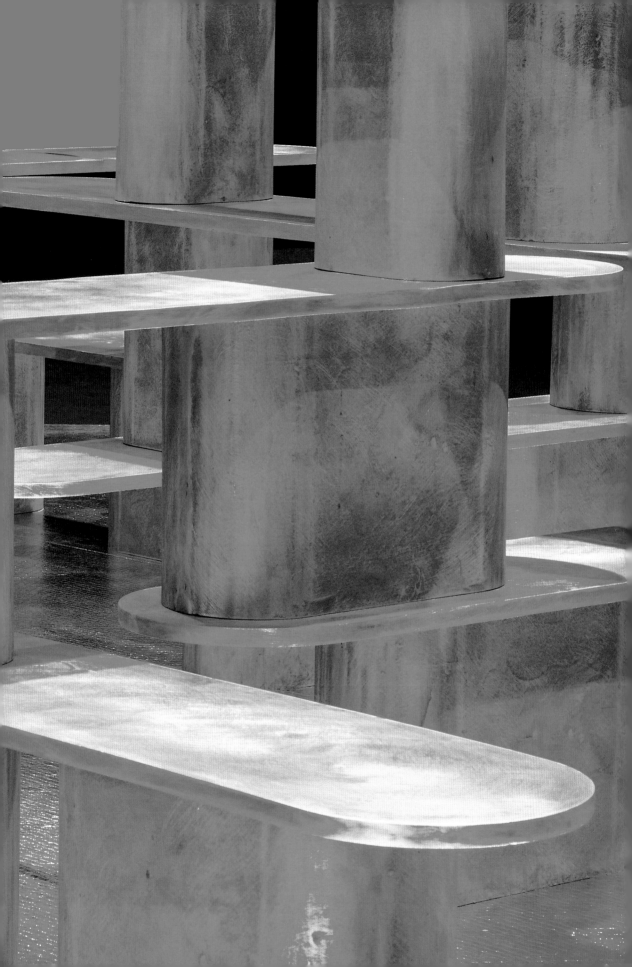

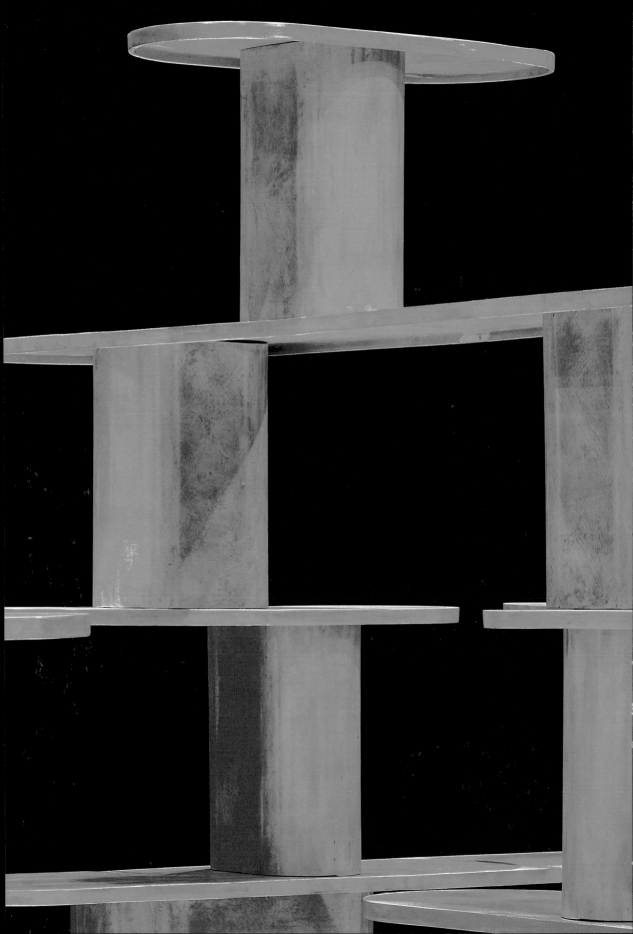

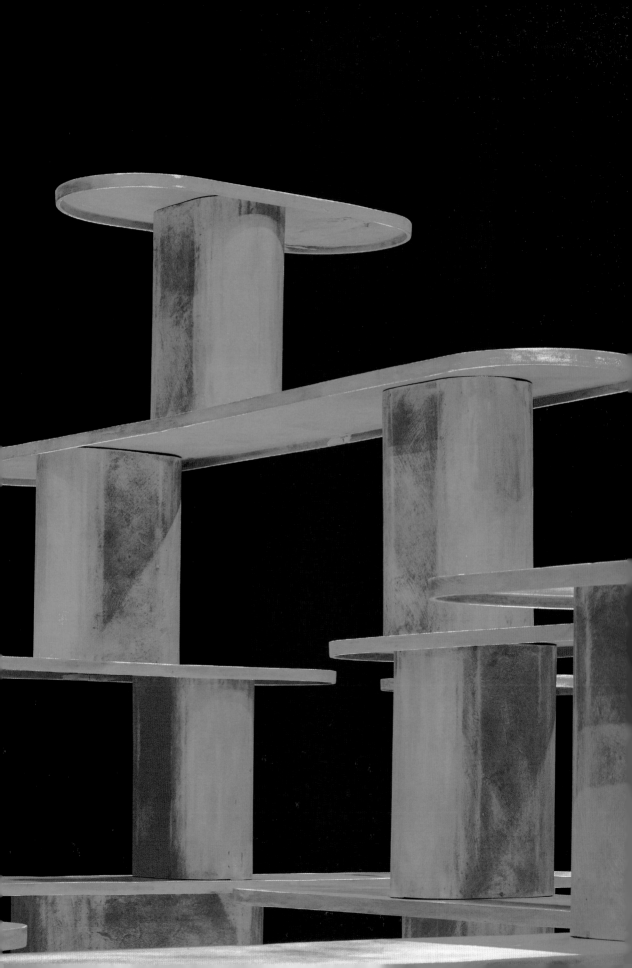

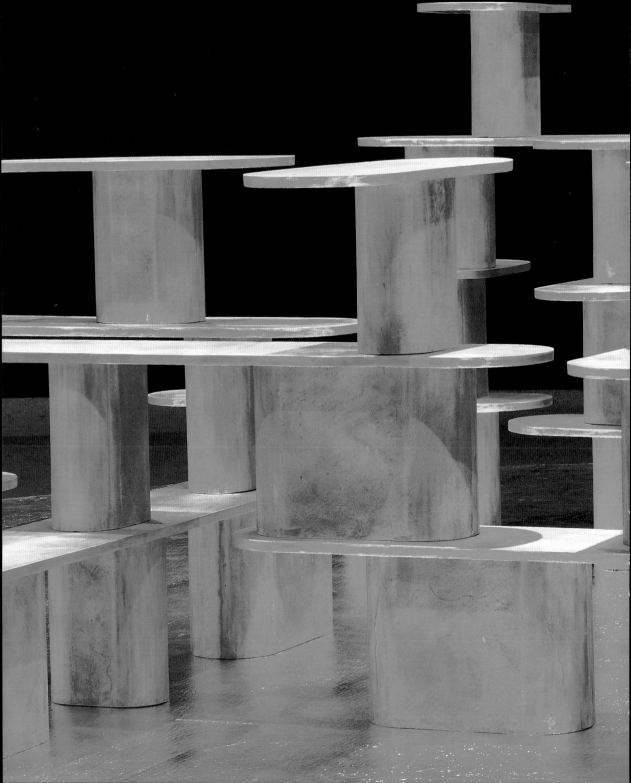

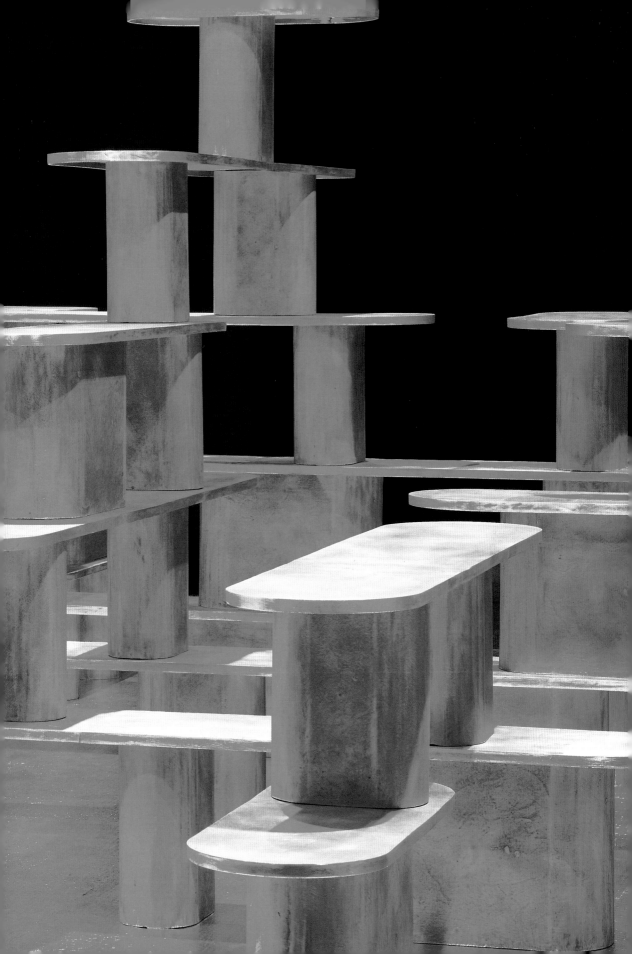

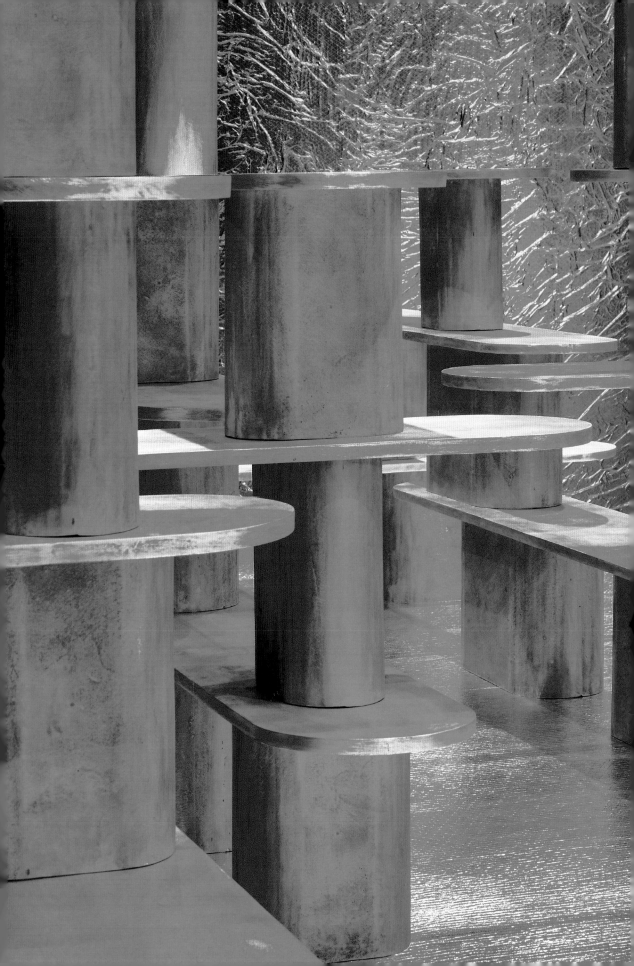

신혜림

Shin Healim

신혜림은 개인의 서사와 감정, 기억이 유기적으로 관계하며, 감고 쌓는 반복적인 행위를 통해 자신만의 시간을 끊임없이 기록한다. 각가지 개체를 모으고 압축하는 과정과 그 쌓임은 또 다른 깊이와 입체적인 공간감을 만들며, 우리의 상상력을 자극하고 시각적 즐거움을 불러일으킨다. 작업에 주로 사용되는 가죽 끈, 실과 같은 소재는 색채와 재료를 서로 연결시키며 또 하나의 조형을 만들어 내는 선택이자 작가의 일상을 차곡차곡 엮어 주는 기억으로부터 건져 올린 재료이다.

Shin Healim's work is an organic relationship of personal narratives, emotions and memories. Through her work that involves repeated gestures of wrapping and layering, Shin constantly records her own time. The process of gathering and compressing each unit and the accumulation of such processes create a difference in depth and a sense of three-dimensional space, stimulating our imagination and arousing visual pleasure. The subjects often employed in her works, such as leather strings and threads, are selected such that they reflect a sense of connection with each other in terms of color and material. In addition, the subjects are materials taken from Shin's memories, which neatly tie together the artist's everyday life.

85

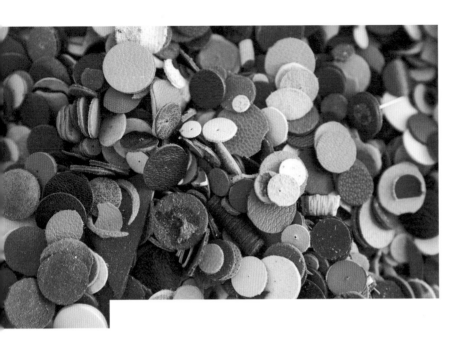

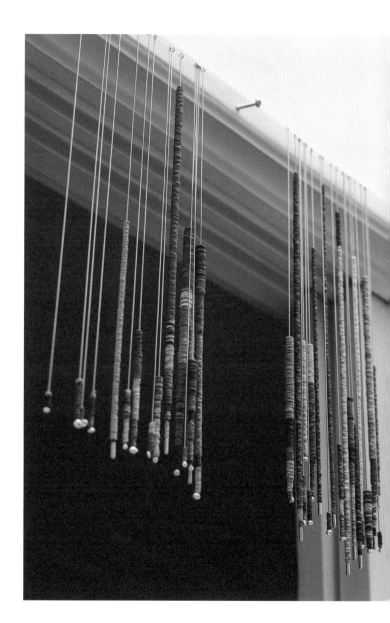

87

도화진 작가님이 작품을 제작하기에 앞서 행하는 일상의 놀이와 상상의 과정들은 어떤 것들이 있을까요?

신혜림 저는 제 생활 공간 안에서 유심히 재료를 살펴요. 살피고 재료를 선택하고 대상화해서 이 재료가 나랑 어떻게 놀 수 있을까, 같이 놀아질 수 있을까 그런 부분들을 계속 생각해요. 그 다음에는 어느 적정선에서 선택된 재료와 함께 손으로 계속 대화하듯이 풀어나가요. 주로 부족한 시간에 언제든지 손을 통해서 놀 수 있는 재료가 선택의 기준점이 되고 있어요.

도화진 작가님이 사용하는 재료들은 익숙함과 새로움이 공존하는데요, 재료를 주로 어떠한 방법으로 채집하고 그 재료에 적합한 기법을 찾으시나요?

신혜림 때로는 이 단순 반복 과정이 굉장히 무디고 더디고 답답할 수도 있지만 저한테 또 원동력이 되어서 자극을 주는 것은 '색'이에요. 실이라든지 가죽, 타이벡, 종이 등 우리 주변 일상에서 색이 계속 존재하는 것을 느끼게 해 주는 재료를 구입하거나 모으는 과정이 또 하나의 작업 과정이 되기도 해요. 재료의 선택 과정이면서 그것을 가지고 제가 짬짬이 노는 행위를 하고 있는 것이죠.

Do Hwajin What everyday processes of play and imagination precede the production of your work?

Shin Healim I carefully observe materials within my living space. I thoroughly examine what materials I can select as the subject of my work and how I can engage in a play with them. Then I select the materials at some point, and explore them with my hands as if to converse with them. I choose my materials based on whether I can explore them with my hands at any time, even in short periods of time.

Do Hwajin A sense of familiarity and newness coexist in the materials you use. How do you collect your materials and find the right techniques for working with them?

Shin Healim While this simple repetitive process can be slow and frustrating at times, 'color' is another element that gives impetus to my work. Colors can always be found around us in our everyday life, in things like thread, leather, Tyvek, paper, etc. The process of buying or collecting materials also becomes a process of my artmaking. The selection of materials itself becomes intermittent acts of play for me.

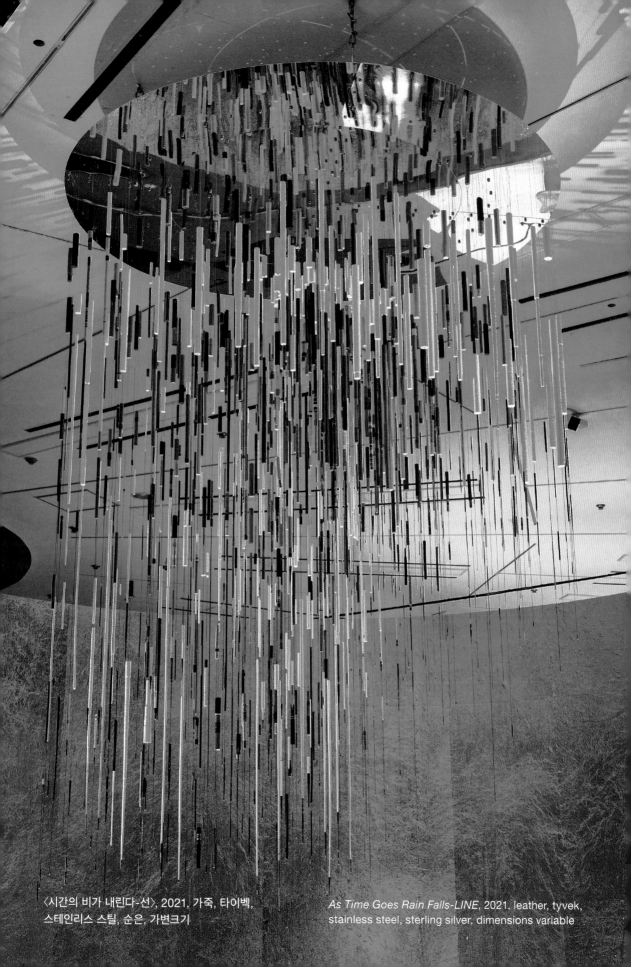

〈시간의 비가 내린다-선〉, 2021, 가죽, 타이벡,
스테인리스 스틸, 순은, 가변크기

As Time Goes Rain Falls-LINE, 2021, leather, tyvek,
stainless steel, sterling silver, dimensions variable

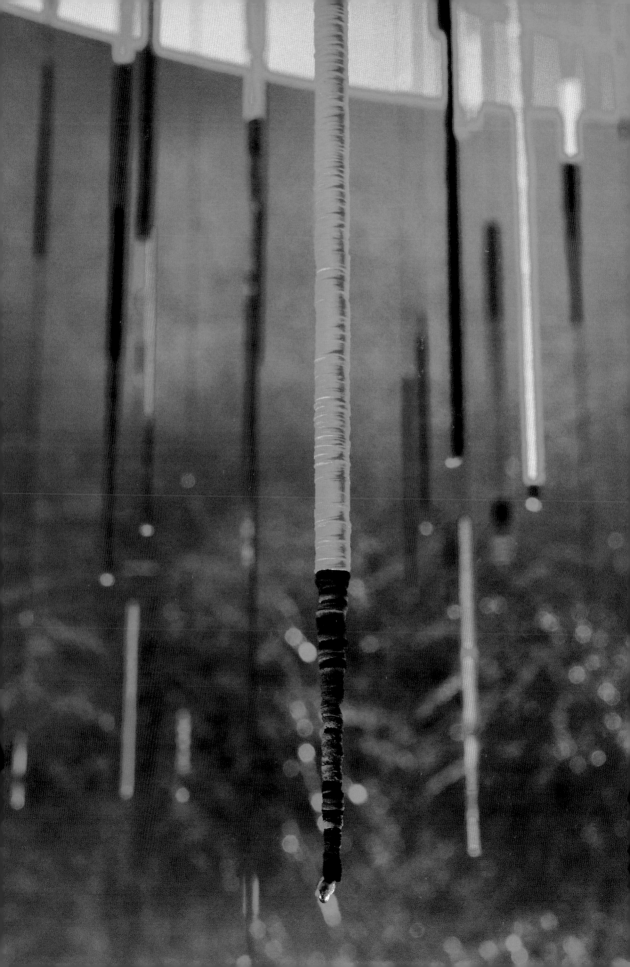

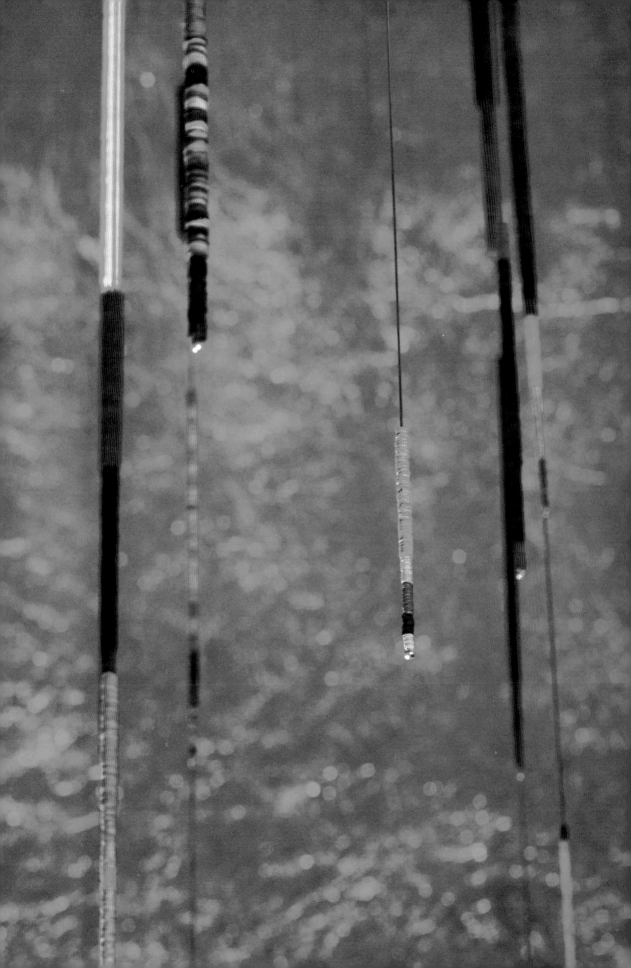

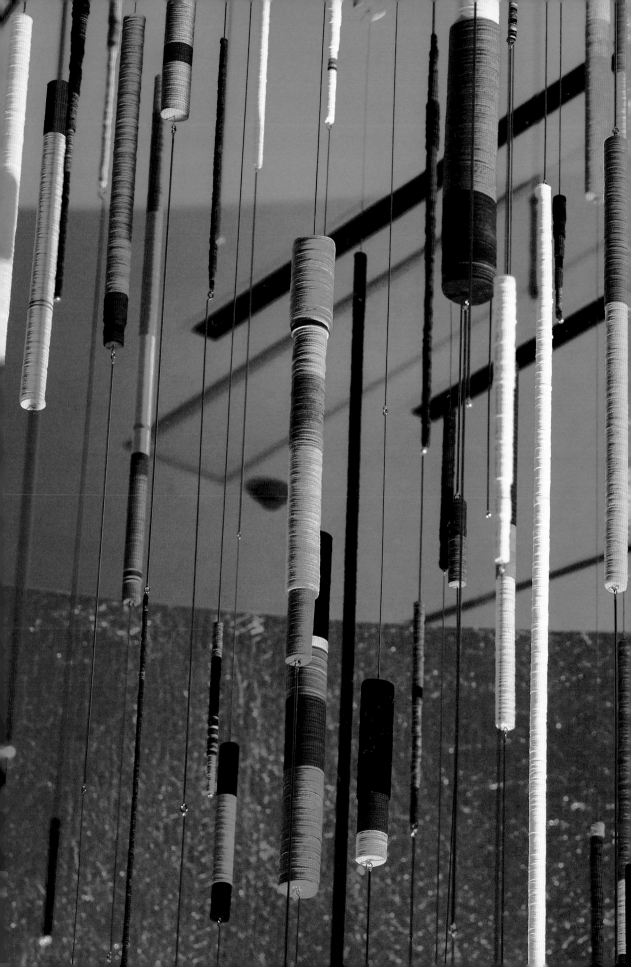

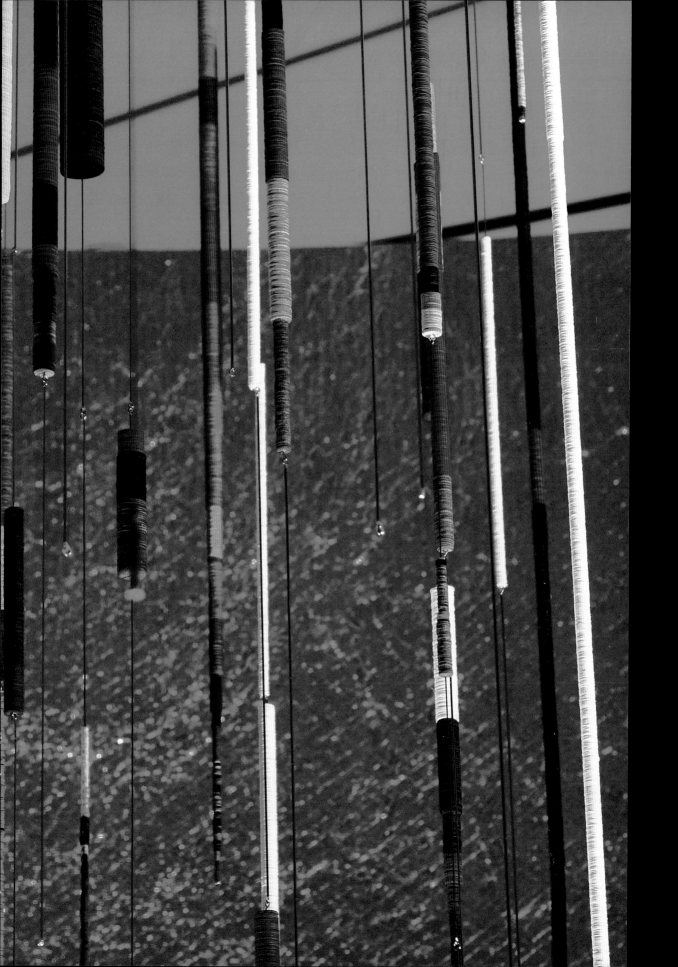

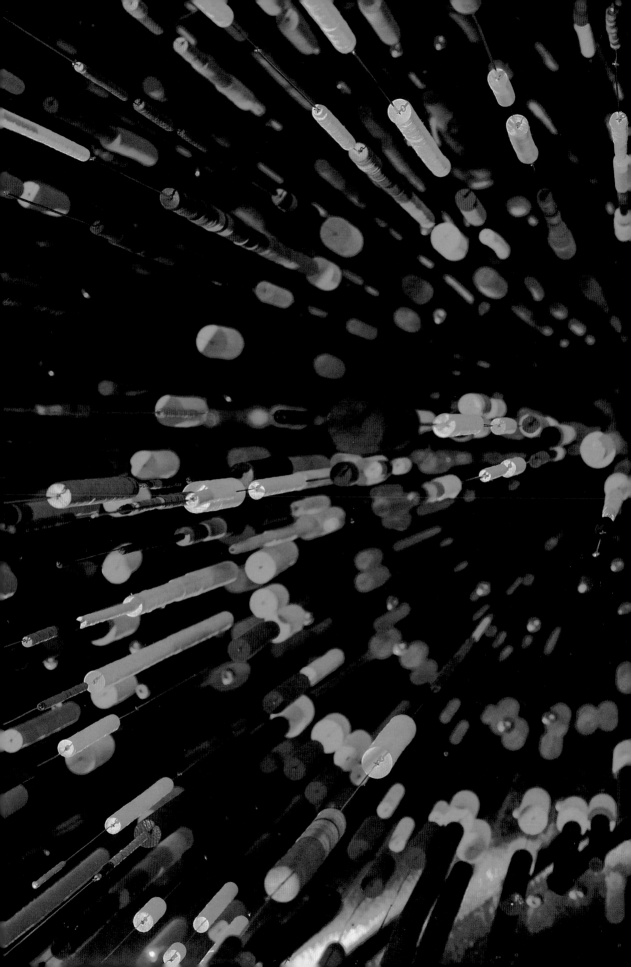

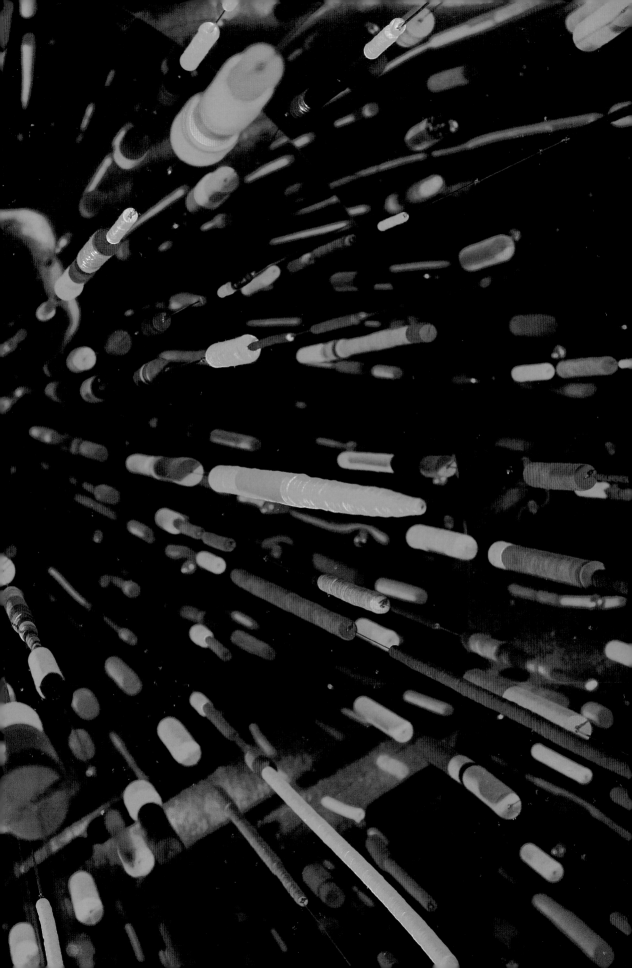

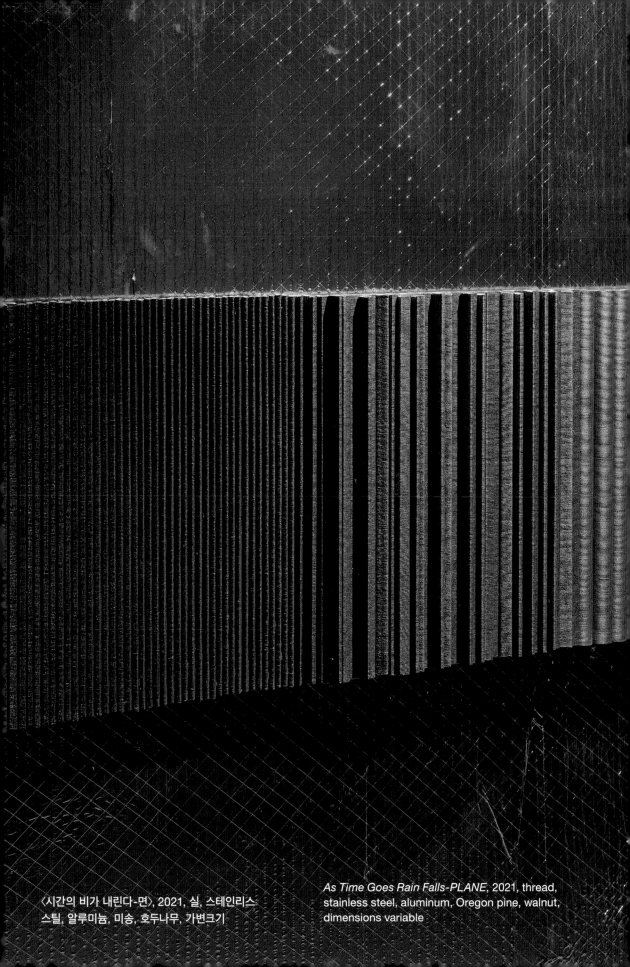

〈시간의 비가 내린다-면〉, 2021, 실, 스테인리스
스틸, 알루미늄, 미송, 호두나무, 가변크기

As Time Goes Rain Falls-PLANE, 2021, thread,
stainless steel, aluminum, Oregon pine, walnut,
dimensions variable

현광훈

Hyun Kwanghun

현광훈은 자연스러운 움직임 속에 담긴 기계의 본질을 전한다. 세상을 가장 작게 집중해서 관찰하고, 맞물려 돌아가며 기능하고, 기다림과 시간을 고스란히 담아내는 사물을 보여 준다. 카메라 렌즈를 통해 작은 대상에 머물면서, 복잡하게 얽혀 있는 톱니바퀴의 움직임을 본인만의 질서와 규칙으로 내부의 형태와 구조를 파악하고 설계한다. 기능하는 유닛들은 각각의 역할에 맞게 정직하게 배열되고 맞물림으로써 아날로그적 감성을 스며들게 한다.

Hyun Kwanghun conveys the essence of the machine in natural movement. His works demonstrate objects that observe the world from the smallest, most concentrated perspective, function in conjunction with the world, and capture a sense of time and anticipation. Focusing on small subjects through the camera lens, Hyun applies his unique element of order and rules to interpret and design inner form and structure in the movement of the complex entanglement of cogwheels. The straightforward layout and workings of the functioning units in his works reflect an analogue sensibility.

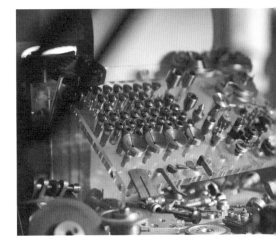

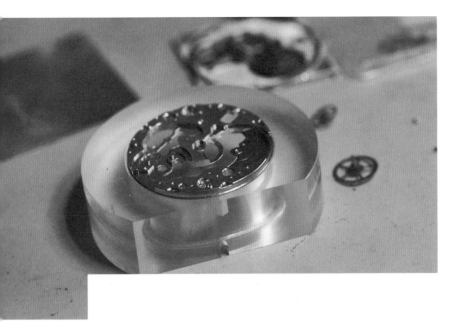

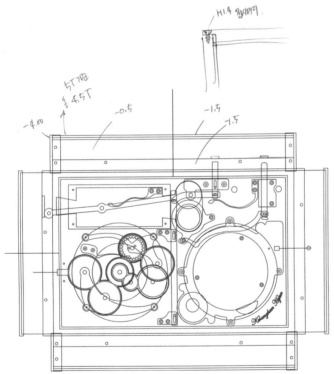

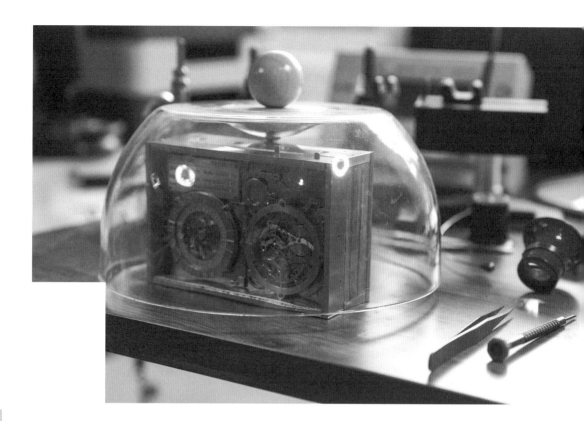

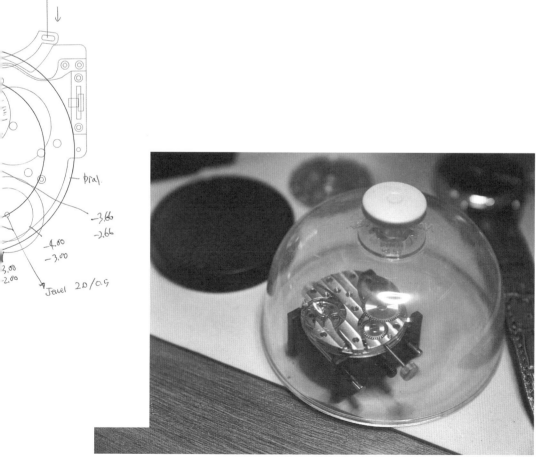

Dial.

−3,66
−2,66

−4,00
−3,00

3,00
2,00

Jewel 2,0/0,5

103

도화진 작가님이 작품을 제작하기에 앞서 행하는 일상의 놀이와 상상의 과정들은 어떤 것들이 있을까요?

현광훈 항상 저에게 스스로 문제를 내고 그것을 풀어가는 과정이 제 작업이라고 생각을 해요. 그래서 항상 궁금증을 찾아 다니죠. 어떤 아이템이나 구조적인 부분이라든가, 메카닉적으로 풀어낼 수 있는 방법들을 자면서도 생각하고 버스 타고 이동하면서도 머리 속에서 항상 그런 생각들을 하죠. 작업실에 오고 나면, 그런 문제들을 이제 풀어나가는 과정, 그것이 작업의 일부인 것 같아요.

도화진 작가님이 사용하는 재료들은 익숙함과 새로움이 공존하는데요, 재료를 주로 어떠한 방법으로 채집하고 그 재료에 적합한 기법을 찾으시나요?

현광훈 저도 처음에는 다른 재료에 대해서도 호기심을 가지고 접근해 볼 요량으로 도자기로 카메라도 만들어봤어요. 다시 금속으로 돌아오게 된 계기는 '아, 내가 금속에 대해서 많이 안다고 생각했는데 사실 그렇지가 않았구나'라는 것을 깨달았기 때문이죠. 더 연구하고 깊이 팔수록 모르는 것이 많더라구요. 제가 주로 사용하는 것이 황동이라든가 철과 같은 소재들인데 특히 철 같은 경우에는 열처리 등의 과정을 통해서 특성이 변화하는 재미가 있더라구요. 황동 같은 경우에도 색이 변색되는 부분들은 도금을 통해서 해결하고 있고, 또 황동이 가지고 있는 절삭성이 메커니즘을 구현하는데 최적의 재료가 아닐까라고 생각을 해서 황동과 탄소강, 이 두 가지를 주로 많이 사용을 하고 있어요. 앞으로는 금속을 위주로 하되 나무도 같이 사용해보고 싶고, 조금씩 주변에 더 받쳐줄 수 있는 새로운 재료가 없을지 찾아보고 있는 중입니다.

Do Hwajin What everyday processes of play and imagination precede the production of your work?

Hyun Kwanghun I always think that my work entails the process of raising my own questions and answers. I'm always driven by curiosity. I'm usually thinking about mechanical solutions like certain structural parts. My head is always full of these thoughts, whether I'm on the bus or sleeping. Then the process of unraveling these thoughts when I get to my studio becomes a part of my work.

Do Hwajin A sense of familiarity and newness coexist in the materials you use. How do you collect your materials and find the right techniques for working with them?

Hyun Kwanghun At first, I approached other materials with curiosity, making objects like porcelain camera. Then I came back to working with metal because I realized that I actually didn't know as much about metals as I thought I did. The deeper I delved and researched, the more I didn't know. So I ended up mainly using brass and iron. What fascinated me about iron is how its properties change with heat. When there's discoloration in brass, I'd treat it with plating. I mainly use brass and carbon steel in my work. I think the machinability of brass makes it the best material for constructing mechanisms. While still working with metal, I'm gradually expanding my works to incorporate other materials to support the metal medium, such as wood.

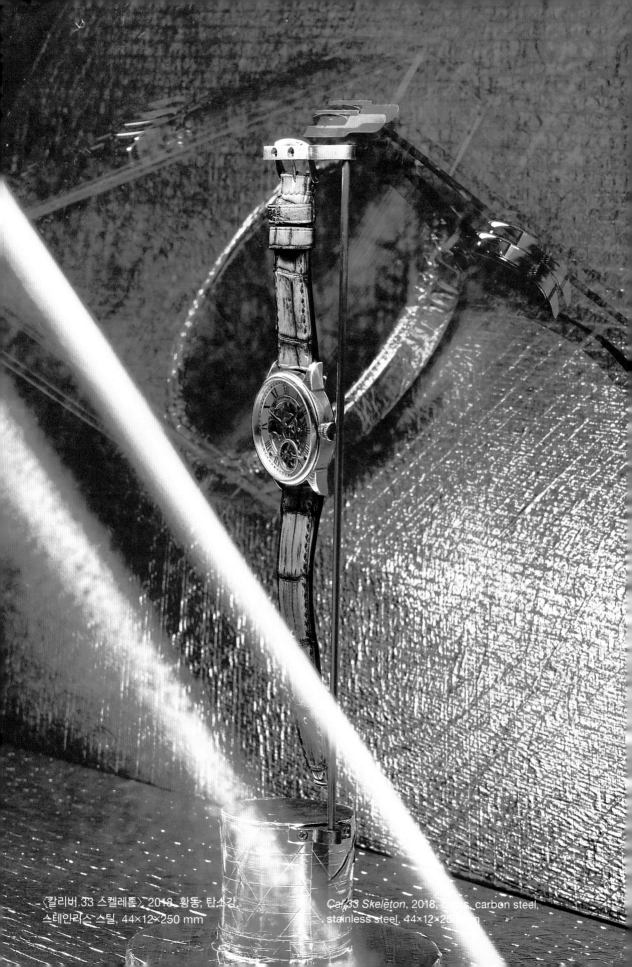

〈칼리버.33 스켈레톤〉, 2018, 황동, 탄소강, 스테인리스 스틸, 44×12×250 mm　　Cal.33 Skeleton, 2018, brass, carbon steel, stainless steel, 44×12×250 mm

〈하트비트 1〉, 2014, 황동, 95×66×33 mm
〈하트비트 3〉, 2021, 황동, 호두나무, 120×100×55 mm
〈하트비트 2〉, 2012, 황동, 102×67×33 mm

Heartbeat 1, 2014, brass, 95×66×33 mm
Heartbeat 3, 2021, brass, walnut, 120×100×55 mm
Heartbeat 2, 2012, brass, 102×67×33 mm

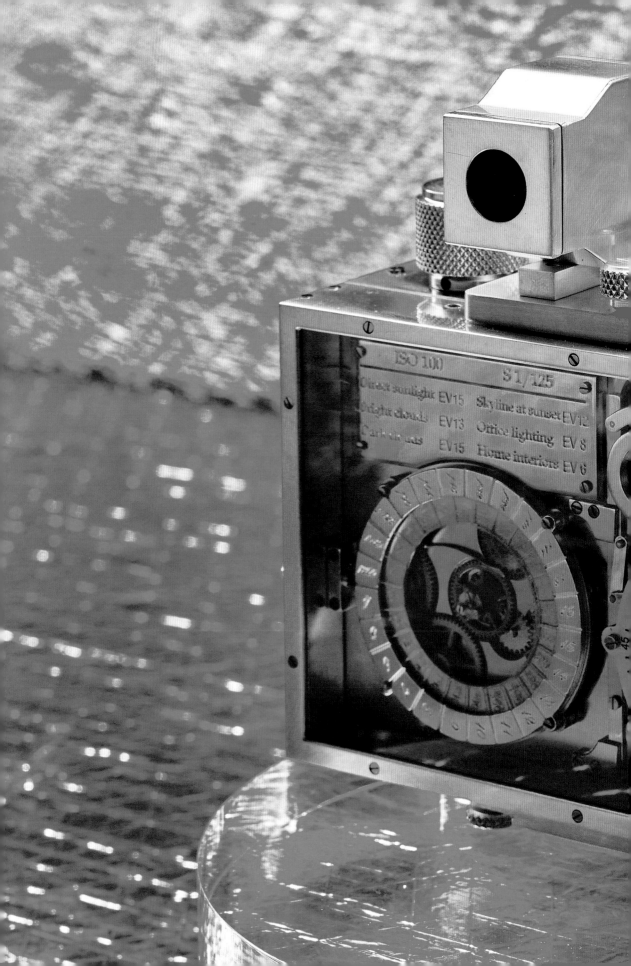

ISO 100 S 1/125

Sunset sunlight EV15 Skyline at sunset EV12
Bright clouds EV13 Office lighting EV 8
Dark clouds EV15 Home interiors EV 6

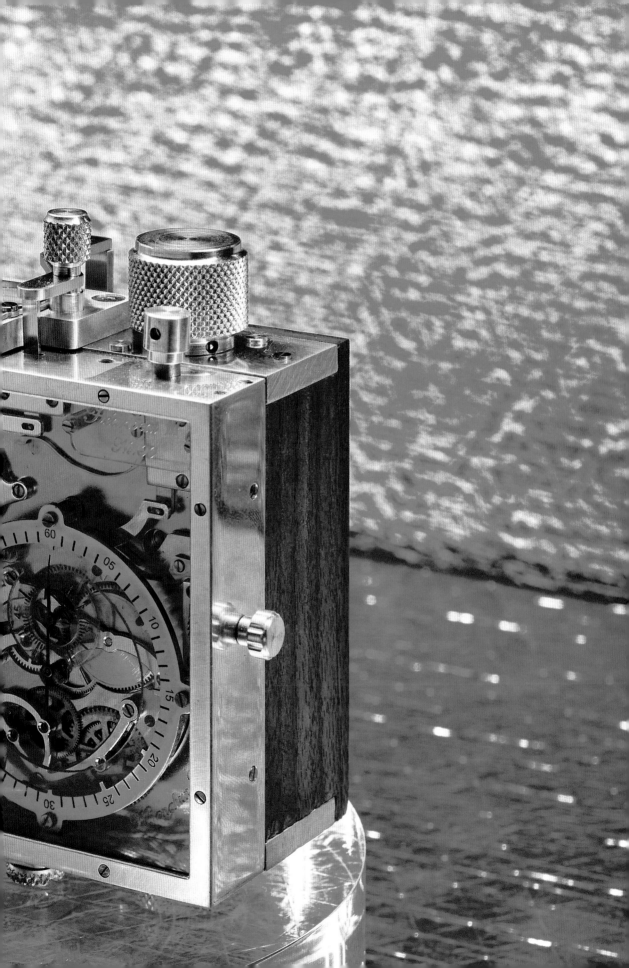

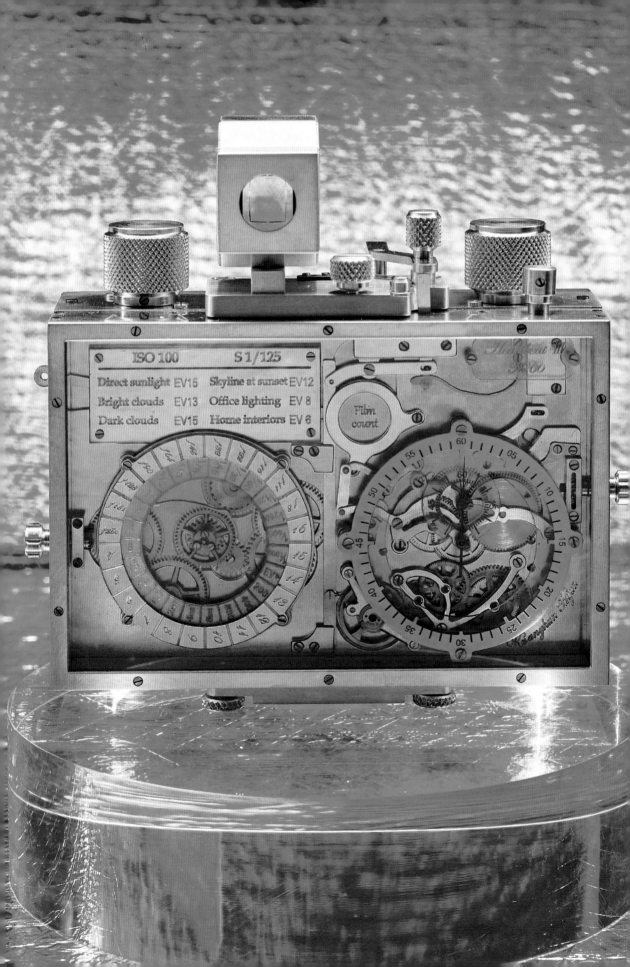

ISO 100 S 1/125

Direct sunlight EV15 Skyline at sunset EV12
Bright clouds EV13 Office lighting EV 8
Dark clouds EV15 Home interiors EV 6

Film
count

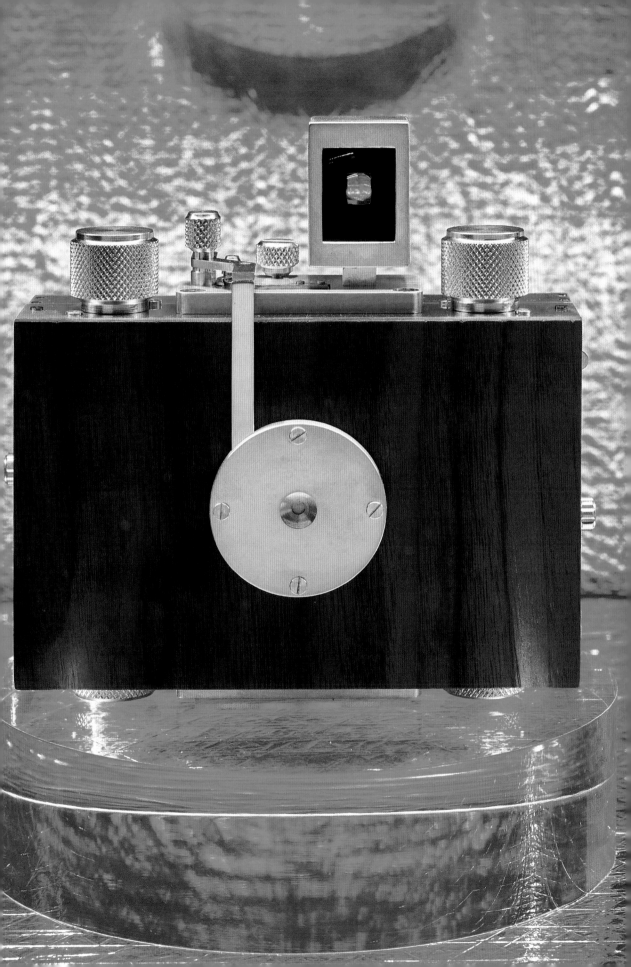

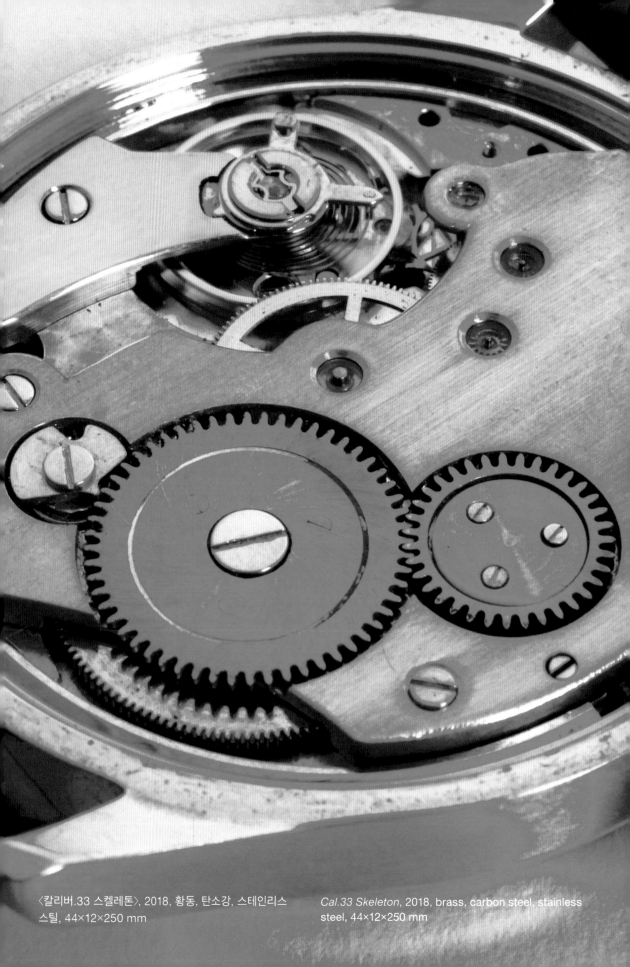

〈칼리버.33 스켈레톤〉, 2018, 황동, 탄소강, 스테인리스 스틸, 44×12×250 mm

Cal.33 Skeleton, 2018, brass, carbon steel, stainless steel, 44×12×250 mm

이상민

Lee Sangmin

이상민은 유년 시절의 움직이는 사물에 대한 호기심과 놀이를 통해 손에 남아 있는 익숙함이 작업의 원동력이 된다. 재료와 형태, 무게에 따라 동작의 미묘한 변화를 가져오는 사물의 유닛들은 기능에 부합하도록 정교하게 구성되었다. 이는 블록처럼 분해하고 조립할 수 있는 구조로, 재미있는 형태와 기능을 가진 사물로 조합되며 유희를 경험하게 한다. 또한, 보이지 않았던 것들을 물리적으로 연결하고 움직이는 요소를 삽입하여 변화의 구조를 가지게 하고, 보는 이의 반응을 유도하고 상상력을 증폭시킨다.

Lee Sangmin's childhood curiosity about moving objects and the familiar memories they left in his hands through play are the driving forces behind his work. The aspects of objects such as material, shape and weight, which bring subtle changes in motion, are elaborately configured to fit the function. As a structure that can be disassembled and assembled like blocks, Lee's works give rise to objects with fun forms and functions and present the audience with experiences of play. He also visualizes the connection amongst the invisible and inserts moving elements so as to give them a framework of change, encouraging response from the audience and amplifying their imagination.

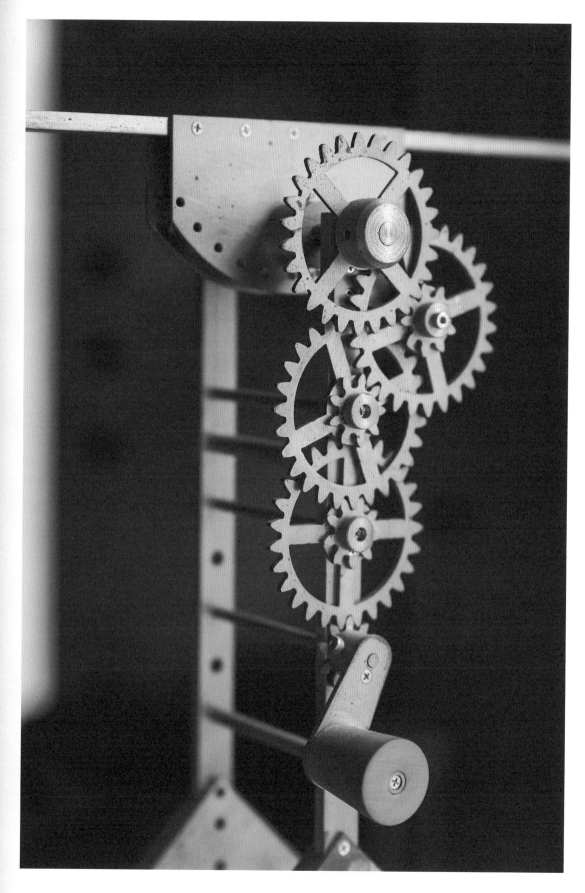

450

10

6

18

440

300

53

135

1/3 desk lamp

70

18

brass, walnut

116

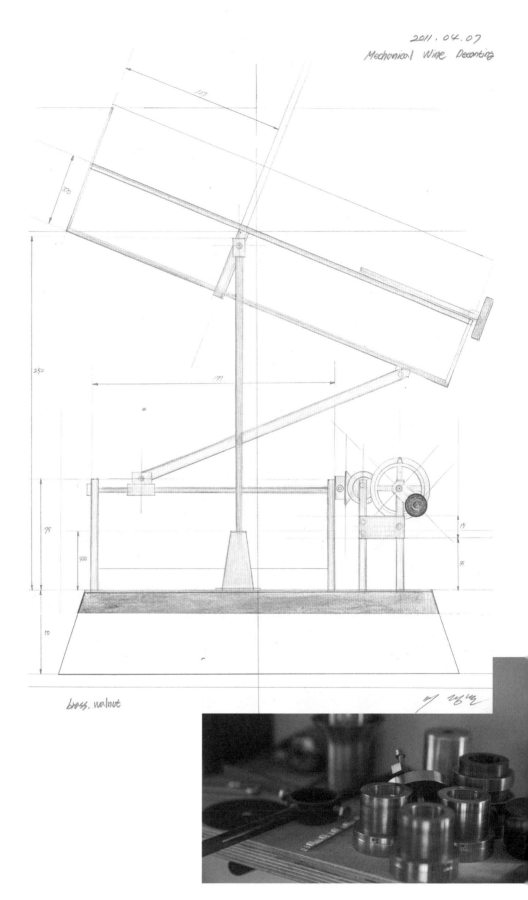

brass. walnut

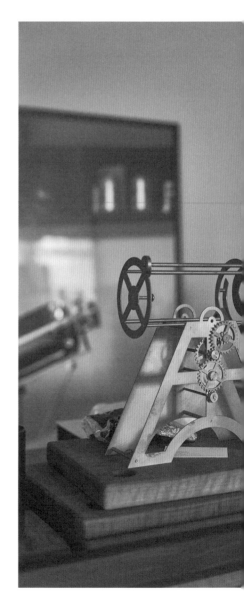

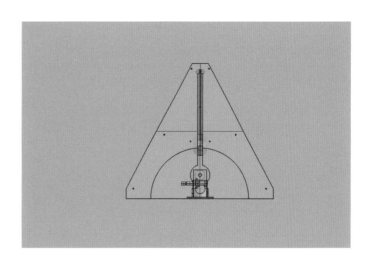

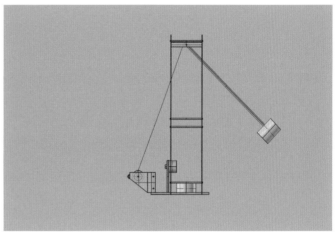

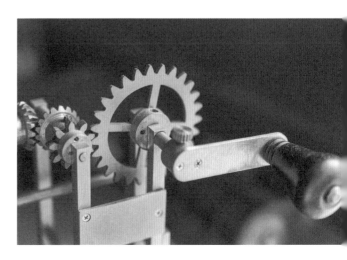

도화진 작가님이 작품을 제작하기에 앞서 행하는 일상의 놀이와 상상의 과정들은 어떤 것들이 있을까요?

이상민 저는 보통 일상에서 주변에 있는 사물들을 가지고 많이 상상하고 혼자 노는 편이에요. 지금도 제 작업대 위에는 항상 레고, 장난감 조각들이나 기타 작업을 하다 남은 자투리 블록들, 황동 부속, 부품들과 같은 것들이 항상 일정한 규칙을 띄지 않고 널브러져 있습니다. 그것들을 가지고 어떤 작품을 구상하거나 제작할 때 조합도 해보고 구조도 생각해 보고 형태나 비율을 정해보는 방식으로 노는 경우들이 있고, 종이접기 같은 것도 많이 하고요. 아직까지 사실 레고를 정말 좋아해서 많이 가지고 놀아요.

도화진 작가님이 사용하는 재료들은 익숙함과 새로움이 공존하는데요, 재료를 주로 어떠한 방법으로 채집하고 그 재료에 적합한 기법을 찾으시나요?

이상민 어릴 때 집에 부모님들이 여행 갔다 오셔서 벼룩시장 같은 곳에서 사가지고 왔던, 그 당시의 유럽 주물 제품들이나 아니면 황동으로 된 어떤 소재의 소품들, 그런 것들을 많이 봤었어요.
　　사실 금속은 그 단어만으로도 눈으로 확인하기 전에는 상당히 차가운 생각이 드는 소재이긴 해요. 그런데 저는 어릴 때부터 봤던, 시간이 변해가면서 조금씩 변하는 황동의 톤들과 가구나 공간에 녹아 들었을 때의 그 따뜻한 느낌이 기억 속에 있었어요. 가공성도 정말 좋고 우드와의 조합에 있어서 다른 적동이나 백동보다 매칭이 훨씬 좋다고 생각해요.

Do Hwajin What everyday processes of play and imagination precede the production of your work?

Lee Sangmin I often take objects I find around me in daily life, and spend time alone playing with them and letting my imagination roam free. Still, there's always Lego blocks or pieces of toys or left-over fragments from my other works lying around on my table. There are also brass components all scattered out in my studio without a certain order. I take these fragments and think about how I can assemble and structure them together in conceptualizing certain works, or how I can decide on certain forms or ratios. I also do a lot of paper folding. I love Lego, so I still play with it today.

Do Hwajin A sense of familiarity and newness coexist in the materials you use. How do you collect your materials and find the right techniques for working with them?

Lee Sangmin When I was young, my parents would come back from their travels and bring home things they bought from flea markets. So I saw a lot of bronze castings or brass objects and figures from Europe.
　　When I imagine metal without seeing it, it feels like a very cold material. The word itself sounds cold. However, the tone of brass in my childhood gradually started to change, and I remember the warmth of metal when it's melted into furniture or certain spaces. I think brass has excellent processability, and goes well with wood or other combinations, much better than copper or nickel does.

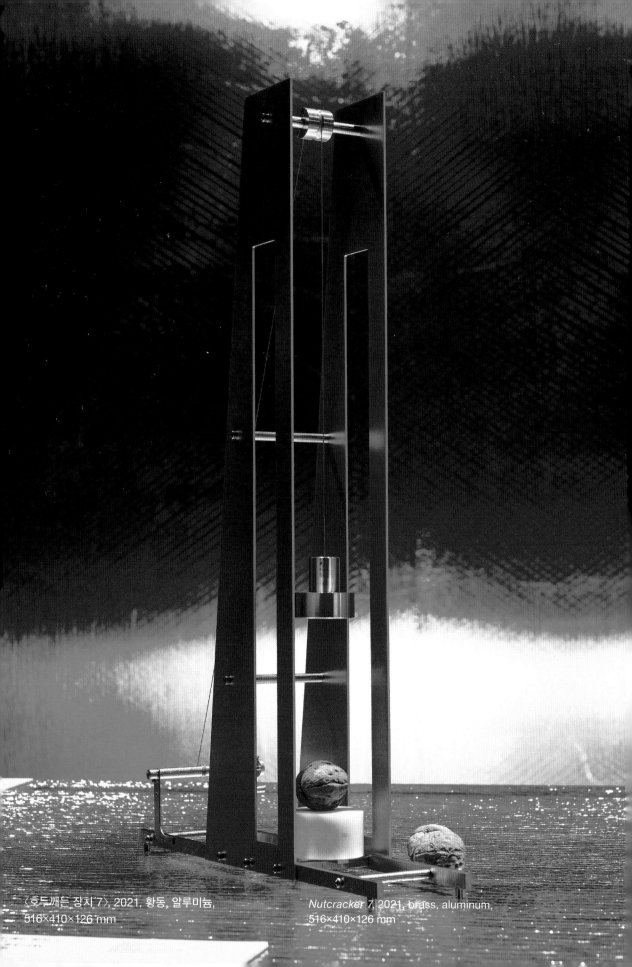

〈호두깨는 장치 7〉, 2021, 황동, 알루미늄,
516×410×126 mm

Nutcracker 7, 2021, brass, aluminum,
516×410×126 mm

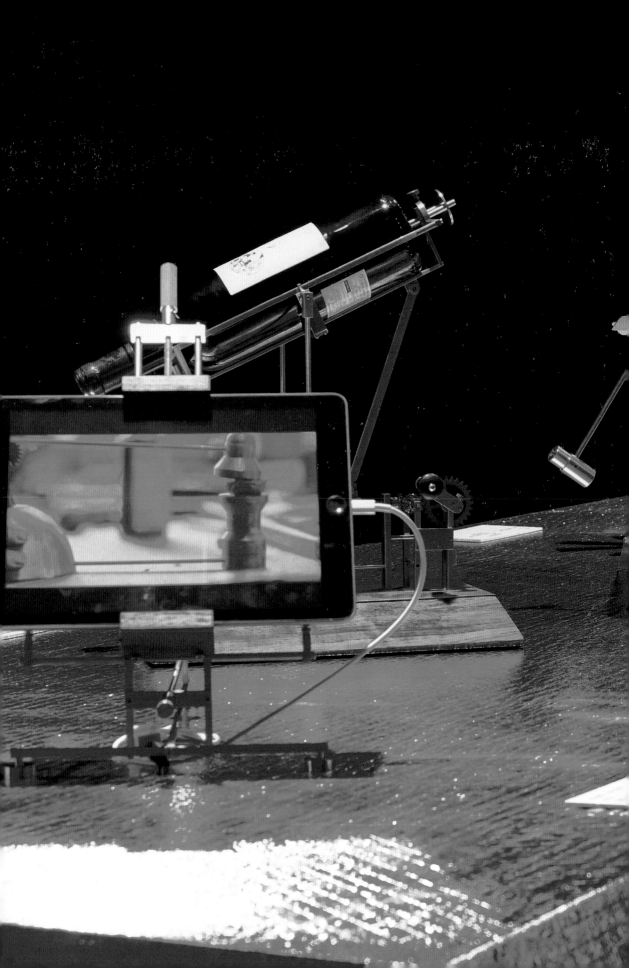

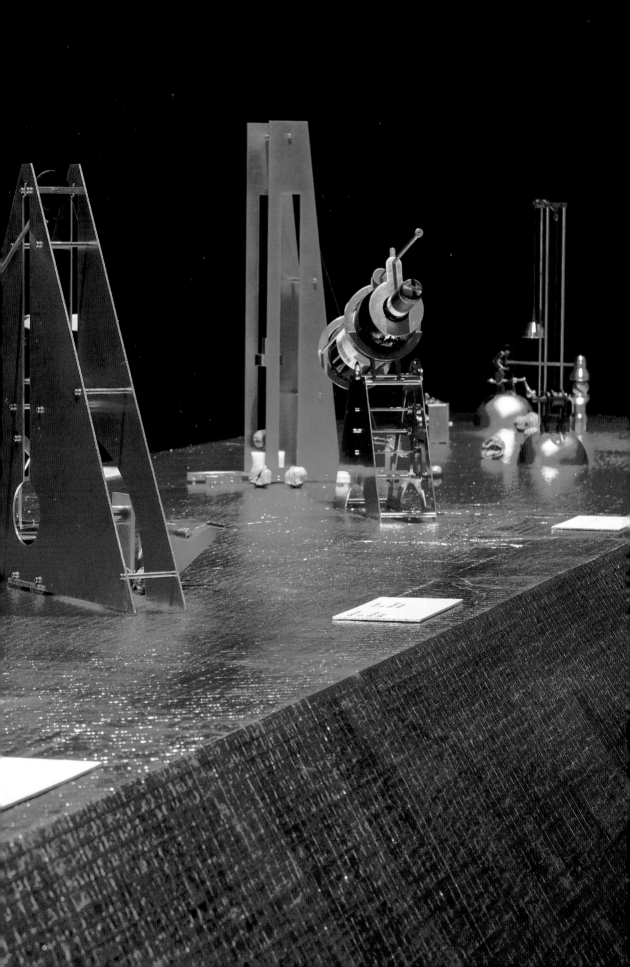

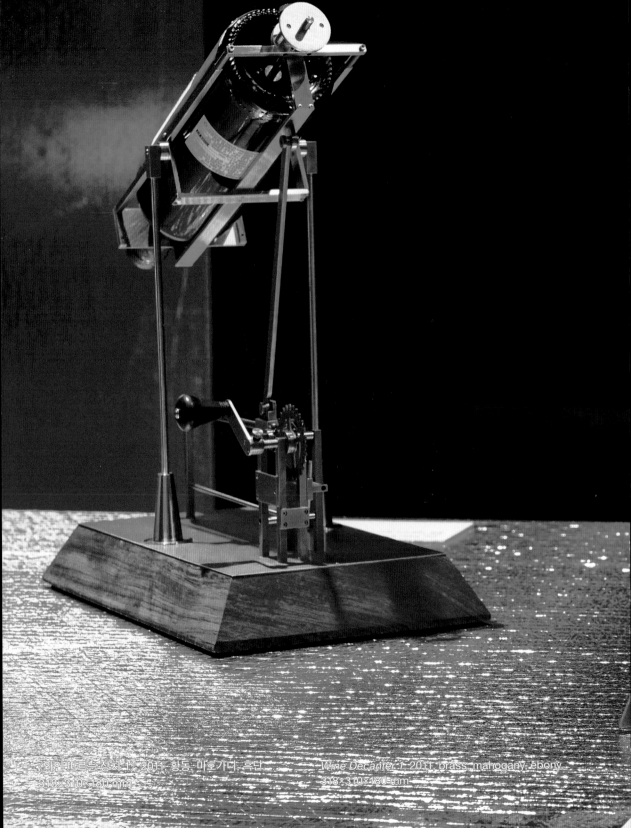

〈와인따르는장치1〉 2011, 황동, 마호가니, 흑단
318×310×180 mm

Wine Decanter 1 2011, brass, mahogany, ebony
318×310×180 mm

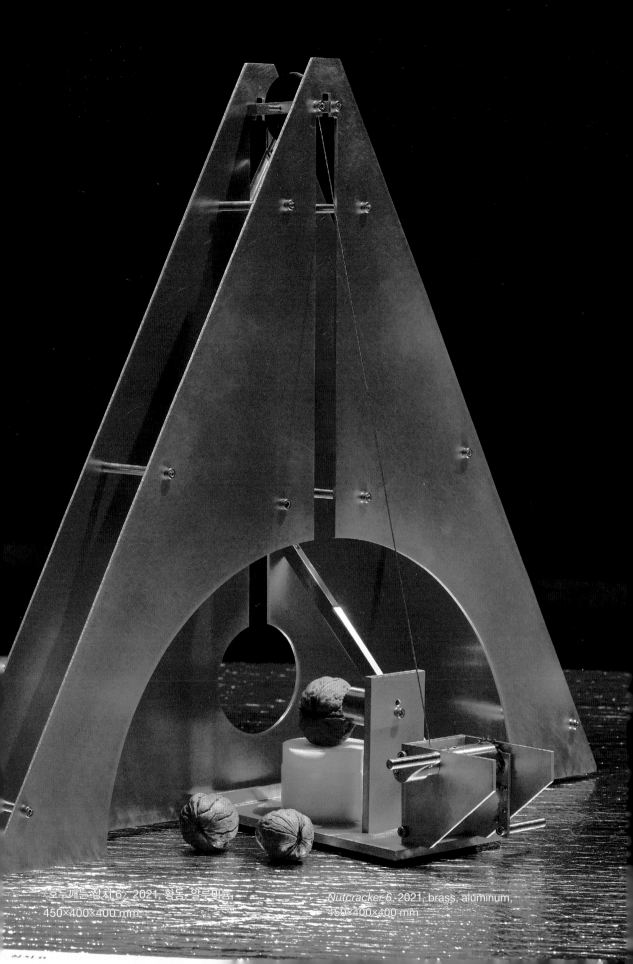

〈호두 깨는 장치 6〉, 2021, 황동, 알루미늄,
450×400×400 mm

Nutcracker 6, 2021, brass, aluminum,
450×400×400 mm

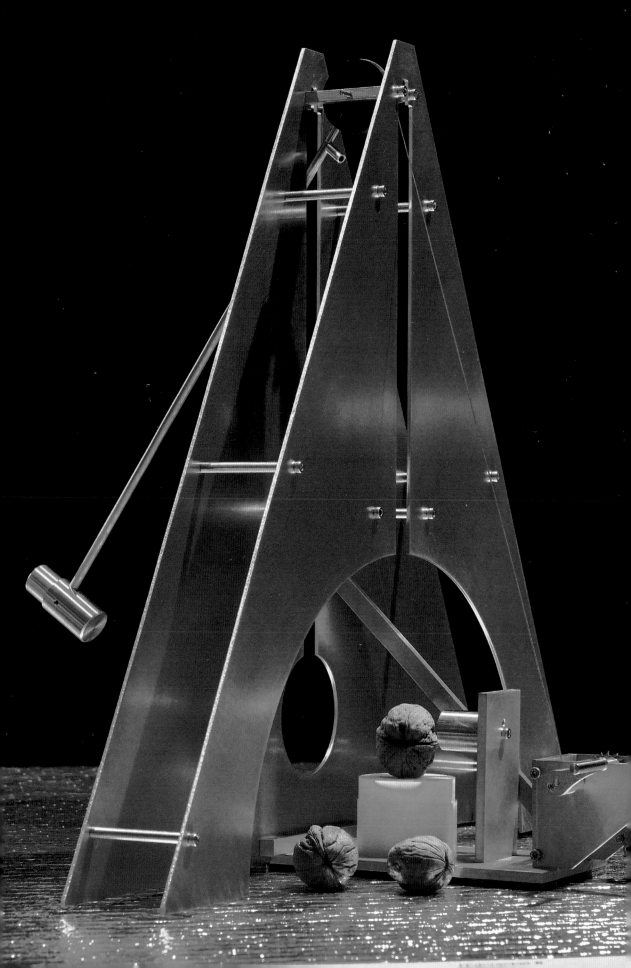

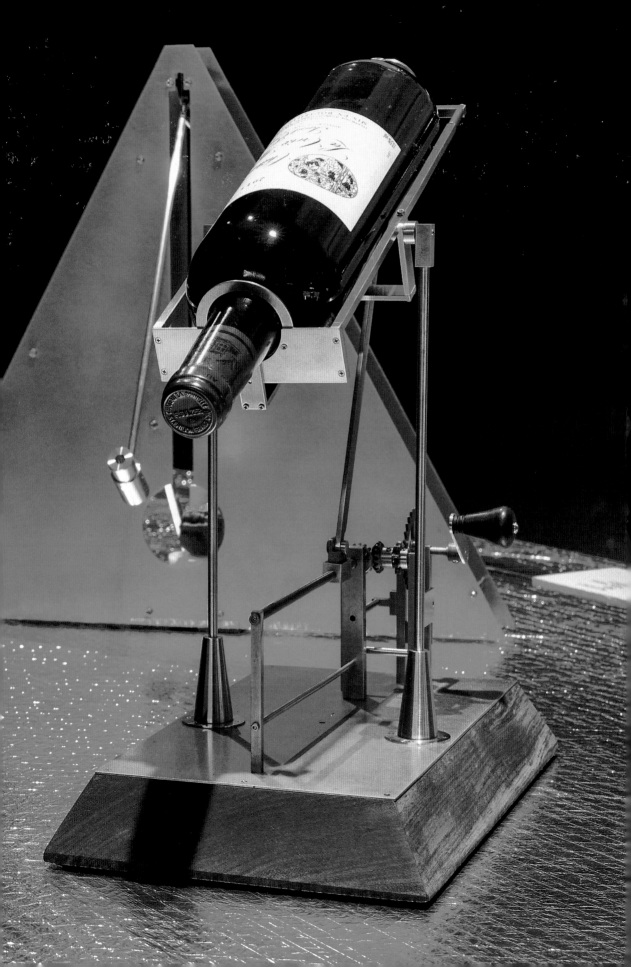

〈촛대 2〉 2011, 황동, 체리목, 정은.
250×215×215 mm

Candlestick 2, 2011, brass, cherry tree. pure silver.
250×215×215 mm

이헌정

Lee Hunchung

이헌정은 도예, 건축, 조각, 드로잉, 설치 등 다양한 매체를 이용해 자신의 언어를 확장해 간다. 작가에게 만듦이란 행위는 계획을 변경시키기도 하고, 계획하지 않았던 효과를 만들어 내며, 또 다른 영감을 얻는 하나의 과정이다. 흙이 가진 물성을 바탕으로 하나의 서사와 무대를 상정하여 풀어냄으로써 특정 장르에 국한되지 않는 자신만의 언어를 구축해 나아간다. 형태의 배열과 감각적인 색채, 그 사이의 쉼과 비움은 적당한 리듬감을 부여하며 한 곡의 음악적 구성을 보는 듯하다. 불과의 상호 작용에서 발생하는 우연성은 지난한 노동의 집적을 통한 경험을 바탕으로 완성된 작품에서 미적 가치를 추구하기보다 과정과 행위를 통한 표면의 변화와 가능성에 가치를 둔다.

Lee Hunchung expands his language through various mediums such as ceramics, architecture, sculpture, drawing, and installation. For Lee, making is a process that involves changing plans, creating unexpected effects, and stirring up the imagination. Setting up a stage and working with on narratives based on the physical properties of clay, Lee constructs his unique language that's not limited to a specific genre. The arrangement of forms, sensuous colors, and the pauses and emptiness in between imbue the work with just the right sense of rhythm, making it look like a musical composition. The coincidences that arise from the interaction signify value placed on the changes and possibilities that rise up to the surface through processes and gestures, rather than a pursuit of aesthetic values in works completed through intense labor and direct experiences.

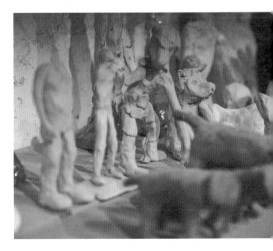

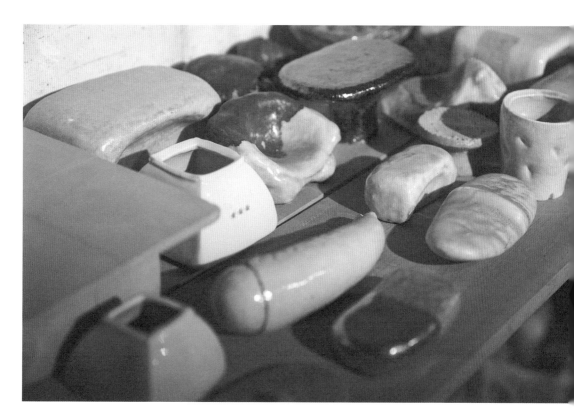

도화진　　작가님이 작품을 제작하기에 앞서 행하는 일상의 놀이와 상상의 과정들은 어떤 것들이 있을까요?

이헌정　　저는 작업할 적에 계획은 세우기는 하는데 꼭 계획이라기보다는 그냥 실마리를 찾는 것이라고 생각을 해요. 계획에 맞춰서 결과물이 만들어지게 되면 그 과정에서 내가 즐길 수 있는 부분이 많이 줄어들어요. 즐기면서 하려면, 제작하는 과정에서의 즉흥적인 변화와 유도가 가장 중요하다고 생각해요. 앞으로의 계획이자 목표는 지금보다 조금 더 자유롭고 싶다는 생각을 가지고 있어요. 그래서 그것이 나한테는 작업이 되었든 삶이 되었든 무엇이 되었든 간에 조금 더 자유로울 수 있을 적에 어쩌면 제가 좋은 작업, 더 진지한 작업을 할 수 있지 않을까 하는 그런 생각을 하고 있어요.

도화진　　작가님이 사용하는 재료들은 익숙함과 새로움이 공존하는데요, 재료를 주로 어떠한 방법으로 채집하고 그 재료에 적합한 기법을 찾으시나요?

이헌정　　도예에서 얻은 그런 어떤 지식들, 그리고 조그만 깨달음이면 깨달음, 그런 것들이 굉장히 중요한 부분을 차지하는 것 같아요. 어쩌면 제가 가지고 있는 코어(core)가 도예에 있다는, 굉장히 강한 생각을 가지고 있어요. 제가 다른 재료를 다루는 것들은 어쩌면 여행을 하는 것 같아요. 집에서 나와서 다른 곳으로 여행을 했다가 다시 집으로 귀환하는 과정이, 다시 도예로 돌아오는 과정 같은 생각이 들어요. 도예, 흙, 불이라는 매체들을 객관적으로 보기 위해서 잠깐 떠나는 것 같은 느낌이 들어요.

Do Hwajin　　What everyday processes of play and imagination precede the production of your work?

Lee Hunchung　　While I plan my work, I think of it more as an attempt to find clues rather than planning. When I arrive at an outcome according to a plan, I miss out on aspects that please me in the process. In order for me to enjoy my work, what's important is the changes that take place in me in the process of making. I may seem unrestrained in my everyday life but my plans and goals for the future is to become even more free than I am now. I think that I would be able to produce better and more genuine works when I become more liberated, whether it's my work or anything else in my life.

Do Hwajin　　A sense of familiarity and newness coexist in the materials you use. How do you collect your materials and find the right techniques for working with them?

Lee Hunchung　　Certain knowledges and moments of enlightenment I acquire from ceramics are an important part of my work. I believe that ceramics lies at the core of my practice. For me, working with other materials is kind of like traveling. The process of leaving home, traveling somewhere, then returning home, is like reverting to working with ceramics. So working with other materials is like taking a little trip in order to look at the components of ceramics, like clay and fire, in a more objective way.

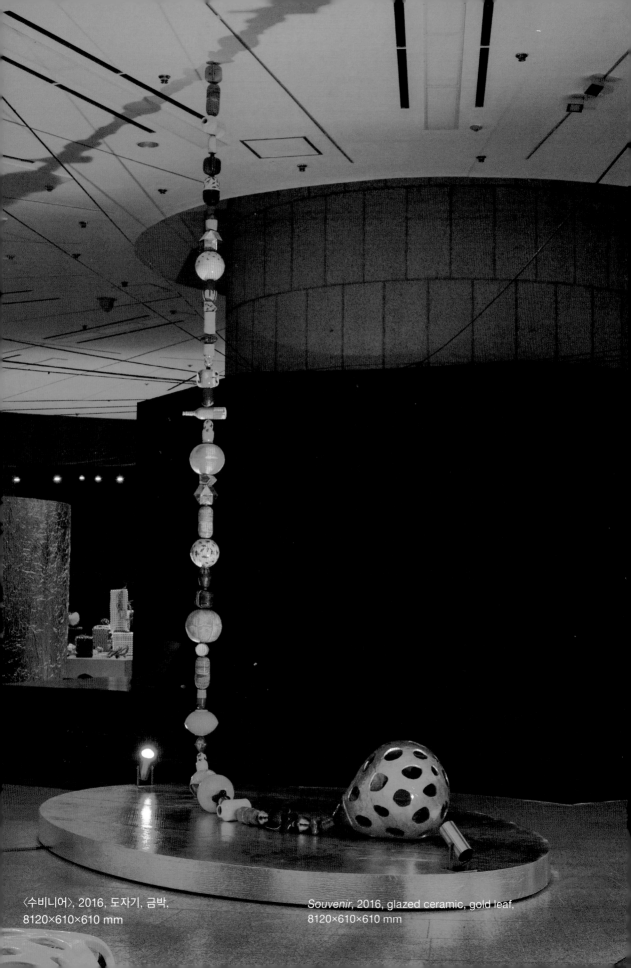

〈수비니어〉, 2016, 도자기, 금박,
8120×610×610 mm

Souvenir, 2016, glazed ceramic, gold leaf,
8120×610×610 mm

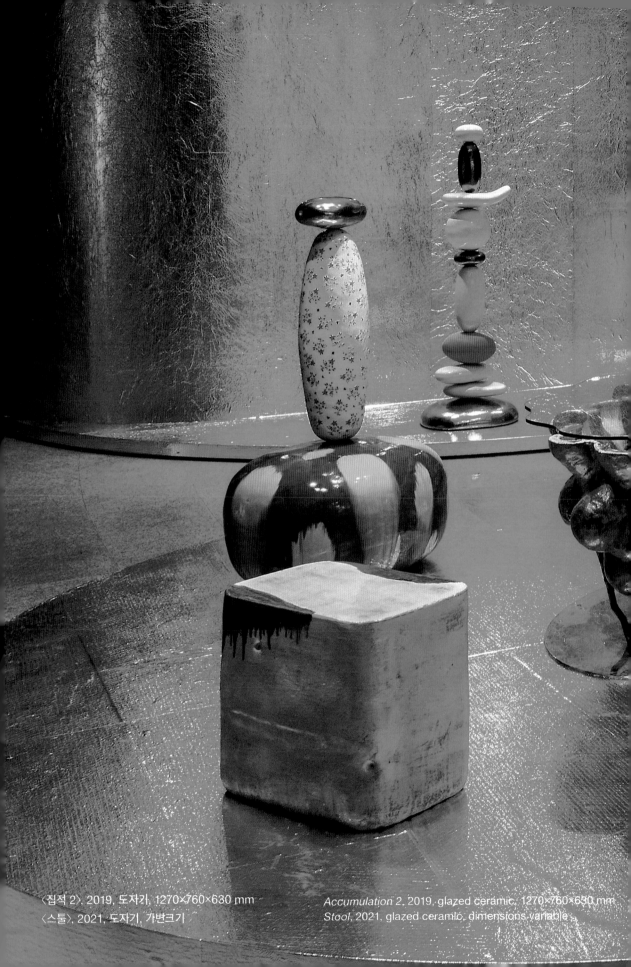

〈집적 2〉, 2019, 도자기, 1270×760×630 mm
〈스툴〉, 2021, 도자기, 가변크기

Accumulation 2, 2019, glazed ceramic, 1270×760×630 mm
Stool, 2021, glazed ceramic, dimensions variable

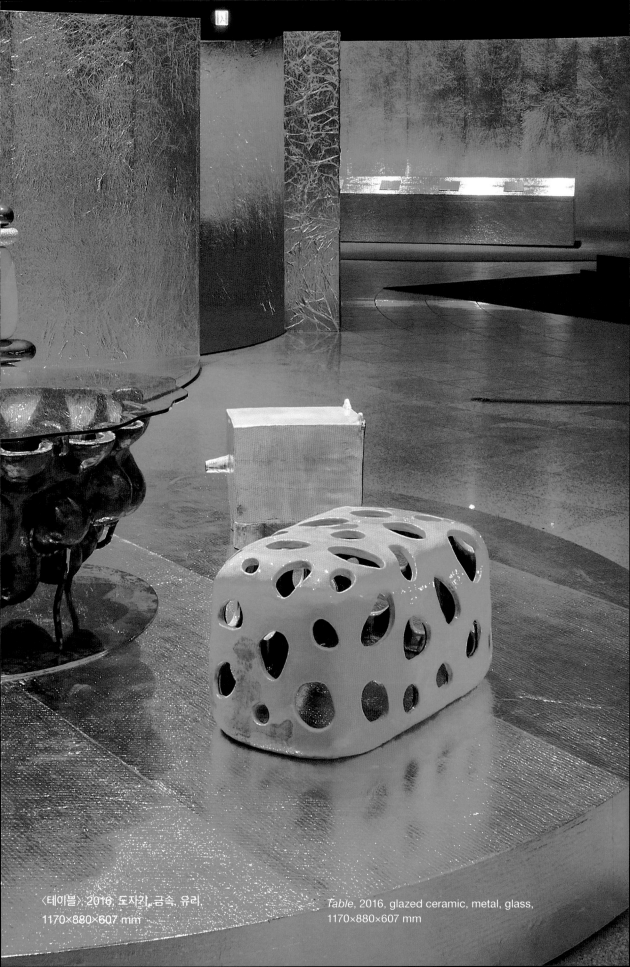

⟨테이블⟩ 2016, 도자기, 금속, 유리,
1170×880×607 mm

Table, 2016, glazed ceramic, metal, glass,
1170×880×607 mm

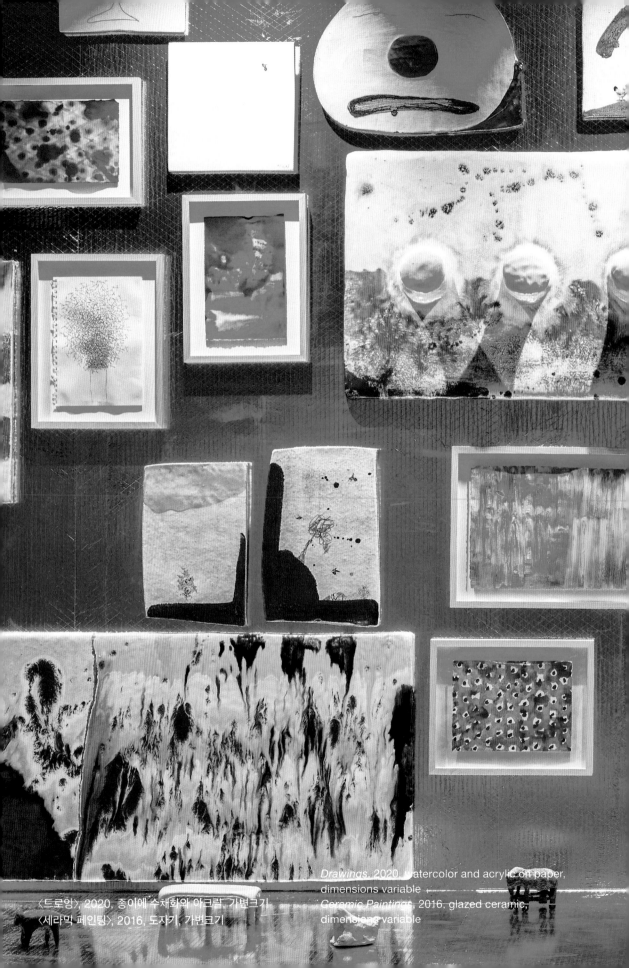

Drawings, 2020, watercolor and acrylic on paper,
dimensions variable
Ceramic Paintings, 2016, glazed ceramic,
dimensions variable

〈드로잉〉, 2020, 종이에 수채화와 아크릴, 가변크기
〈세라믹 페인팅〉, 2016, 도자기, 가변크기

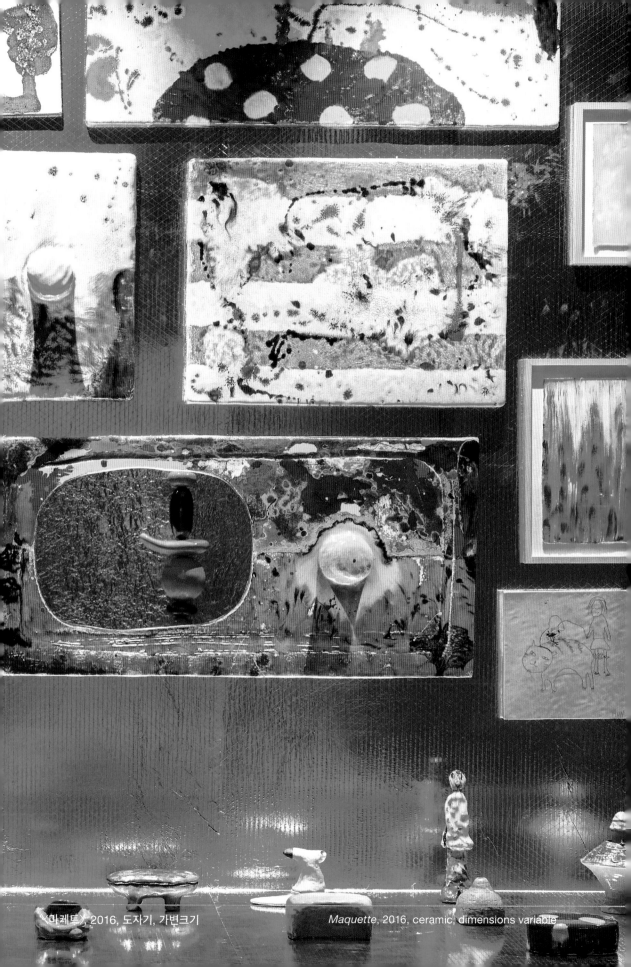

〈마케트〉, 2016, 도자기, 가변크기　　　　　　*Maquette*, 2016, ceramic, dimensions variable

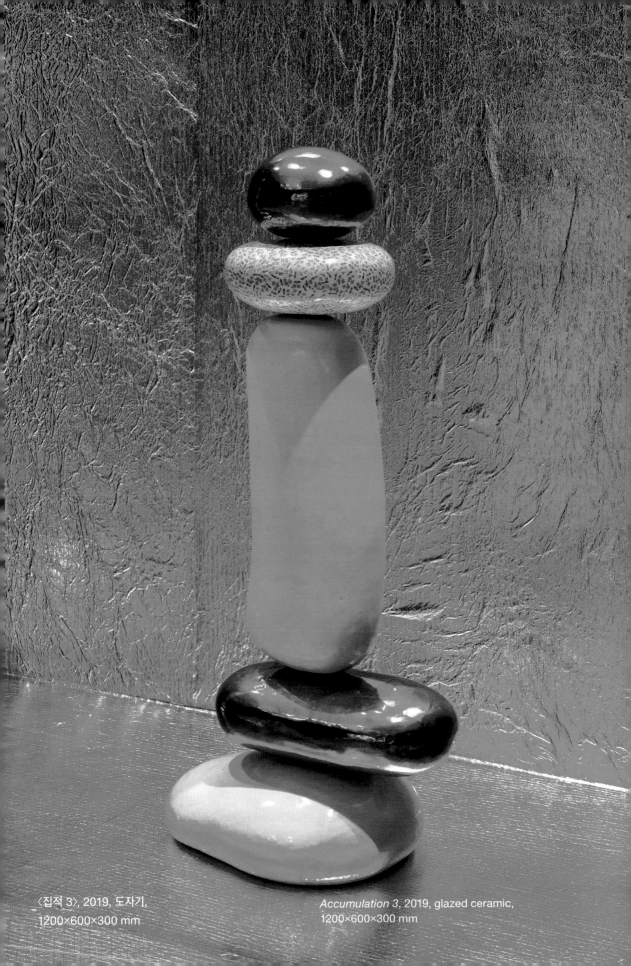

〈집적 3〉, 2019, 도자기,
1200×600×300 mm

Accumulation 3, 2019, glazed ceramic,
1200×600×300 mm

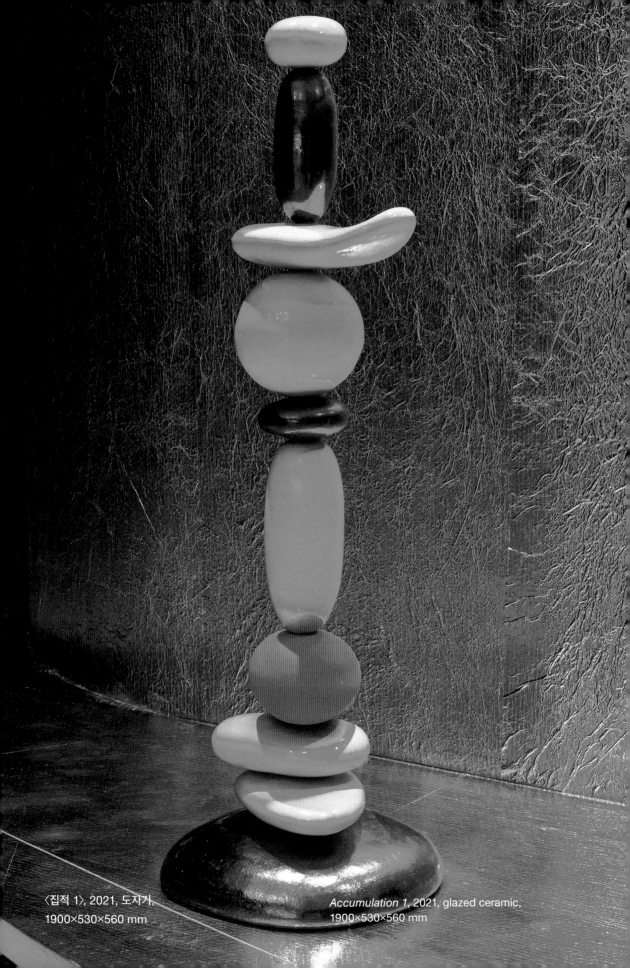

〈집적 1〉, 2021, 도자기,
1900×530×560 mm

Accumulation 1, 2021, glazed ceramic,
1900×530×560 mm

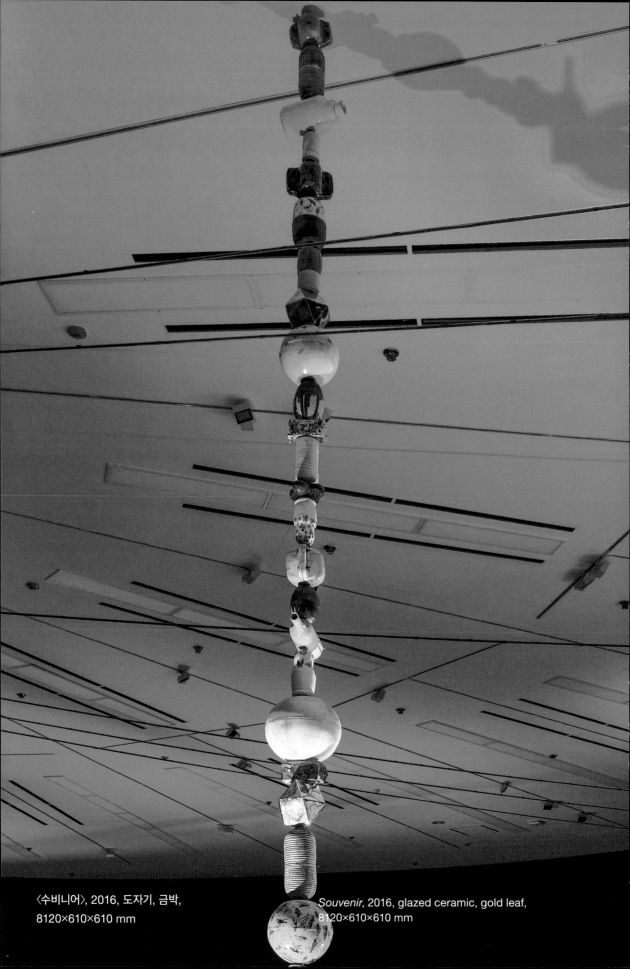

〈수비니어〉, 2016, 도자기, 금박,
8120×610×610 mm

Souvenir, 2016, glazed ceramic, gold leaf,
8120×610×610 mm

이준아

Lee Joona

이준아는 경험과 감정, 섬세함을 녹여낸 텍스타일을 선보인다. 작가는 우리의 경험을 형성하는 온갖 색깔들이 모여 진동하는 듯 미묘하고 깊이 있게 공간 전체를 직조해간다. 손과 수편기를 이용한 편직 작업은 색의 배색, 소재의 변화, 조직의 두께 등 재료 그 자체의 구체성을 지키는 동시에, 우리의 기억에 남아 있는 분위기, 냄새, 소리를 떠올리게 하는 시간성이 담긴 압축물과 같다. 중첩된 선들은 리듬감을 주며 서로의 다른 색을 만나고 하나의 촉각과도 같은 색채 언어로 표출된다. 색은 관객과의 소통, 공유하는 또 하나의 시각적 언어로서 가장 근원적인 감정에 호소하여 내면의 기억들을 이 자리에 소환한다.

Lee Joona presents textile works that weave together experiences, emotions and delicacy. Lee creates the entire space subtly and deeply, as if to bring to reverberation all the colors that shape our experiences. Woven works employing the hands and hand-knitting machine maintain the specificity of the material itself—such as the scheme of colors, changes in the materials, and the thickness of the knitted structure—while at the same time connoting a compressed aspect of temporality reminiscent of the ambience, scent and sounds buried within our memory. The overlapping lines form a sense of rhythm, meet different colors, and are expressed in a color vocabulary that's almost tactile. As another visual expression of language that communicates and bonds with the audience, colors appeal to the most fundamental emotions and summon up one's deepest memories.

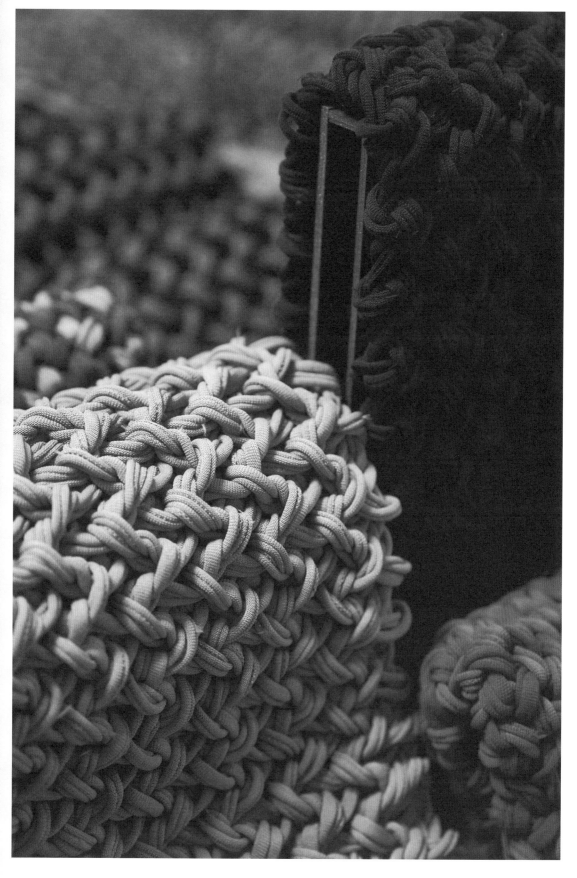

gray

dark blue

green
dark green

vert olive

gray

gray

pocket.

vert olive

dark blue

dark blue.

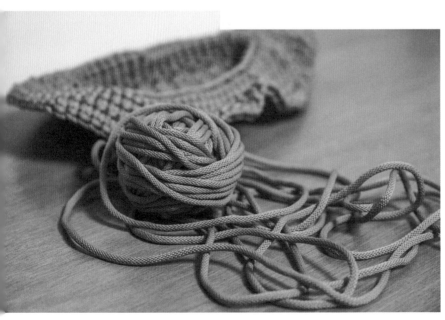

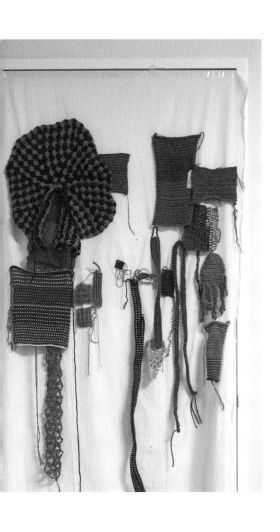

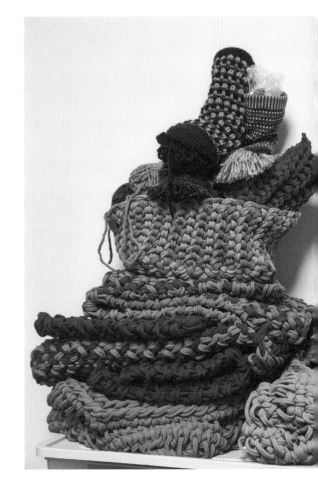

도화진 작가님이 작품을 제작하기에 앞서
행하는 일상의 놀이와 상상의 과정들은 어떤
것들이 있을까요?

이준아 제가 하고 있는 일을 취미처럼 하고
있어서, 사실 일과 취미가 분리가 되어 있지 않기
때문에 놀 때도 일을 하고 일할 때도 놀아요.
'오늘 내가 뭐가 필요한데 한 번 내가 만들어볼까,
아니면 이런 재료가 있던데 그걸로 뭘 한 번
해보면 좋을까. 이게 수편기에 먹힐까? 코바늘로
해야 될까, 대바늘로 풀어야 될까' 이런 것들을
끄적이면서 시간을 많이 보내요. 항상 일을
가까이 하고 어떤 새로운 형상, 새로운 소재에
대해서 궁금해 하면서 어떻게 이것을 접목할 수
있을지를 많이 고민해보는 것 같아요.

도화진 작가님이 사용하는 재료들은 익숙함과
새로움이 공존하는데요, 재료를 주로 어떠한
방법으로 채집하고 그 재료에 적합한 기법을
찾으시나요?

이준아 감각이라는 것은 갑자기 생기는 것은
아닌 것 같고 어렸을 때부터 주변에서 무엇을 더
가까이 보고 관심을 가지는지가 중요한 것 같아요.
저는 색 이외에도 항상 새로운 재료에 대해
호기심을 갖고 있어요. 직접 착용하는 옷이라든가,
피부에 닿아야 되는 물건 같은 경우에는 촉감이나
기능적인 면을 고려해서 면이나 캐시미어, 울
쪽으로 많이 사용하는 편이에요. 미국유학 당시
철물점과 화방 같은 새로운 재료를 찾을 수 있는
공간들을 매우 좋아했고, 코르크 원단, 지퍼,
글루건 등의 재료에서 부터 길거리 쓰레기까지
다양한 소재에 대해서 항상 관심을 가졌어요.
그런 것들이 지금까지도 제가 새로운 색깔, 재료
등을 계속 찾고 있는 계기이자 동기가 되었던 것이
아닌가 생각해요.

Do Hwajin What everyday processes
of play and imagination precede the
production of your work?

Lee Joona My work is like my hobby.
Work and hobby are inseparable for me,
so when I'm working I'm playing, and vice
versa. I spend a lot of time playing with
different ideas like if I should try making
what I need, or what I should make with
a new material. I'd explore different tools
like the hand-knitting machine, crochet
needles or bamboo needles. My work
and life are inseparable, as I'm always
wondering about new forms and materials,
and how I can integrate them.

Do Hwajin A sense of familiarity and
newness coexist in the materials you
use. How do you collect your materials
and find the right techniques for working
with them?

Lee Joona I think color sensibility
isn't something that's just given. What
one observes closely around them in
their childhood is really important. In
addition to colors, I'm always curious
about new materials. So when I work with
things that touch the skin, like clothes
we can wear, I think more about tactile
or functional aspects and use cotton,
cashmere or wool. When I was in the
United States, I looked for new materials
like cork fabric, zippers and glue gun. My
favorite places back then were hardware
stores and art supply stores, and I
became interested in various materials,
even things like garbage on the streets.
These experiences fueled my practice,
motivating me to always search for new
colors and materials.

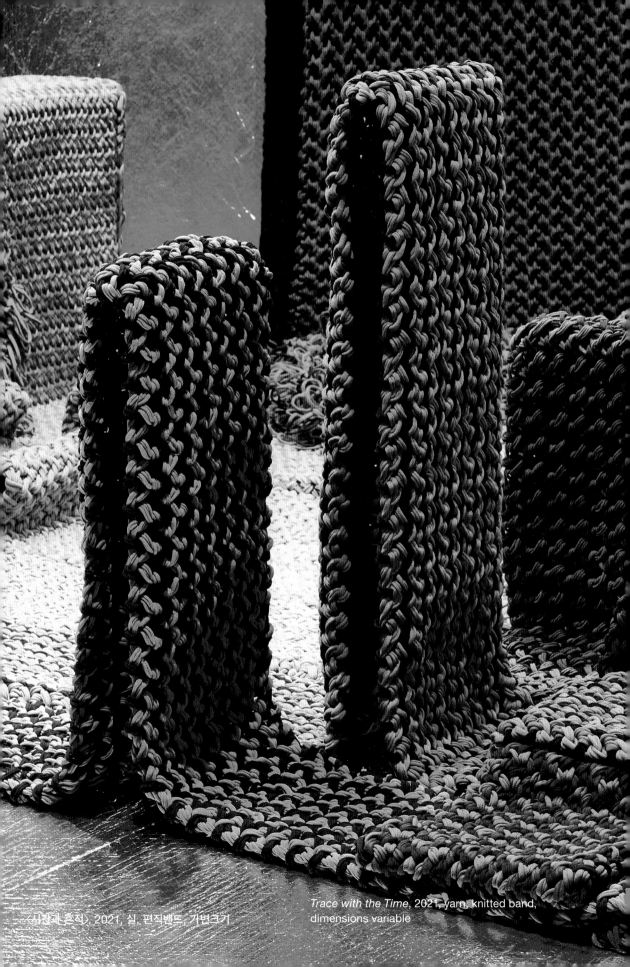

〈시간과 흔적〉, 2021, 실, 편직밴드, 가변크기

Trace with the Time, 2021, yarn, knitted band, dimensions variable

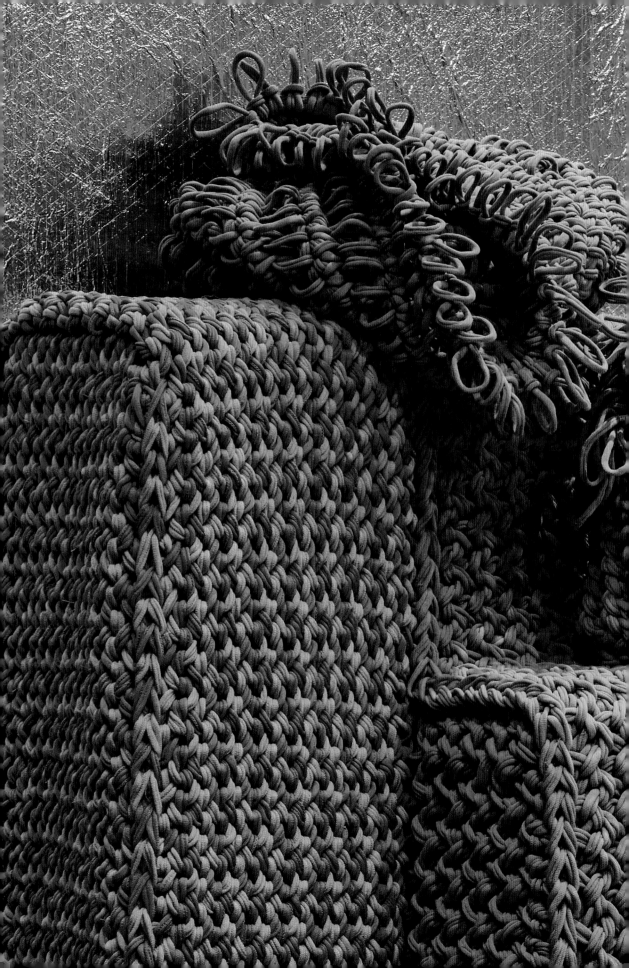

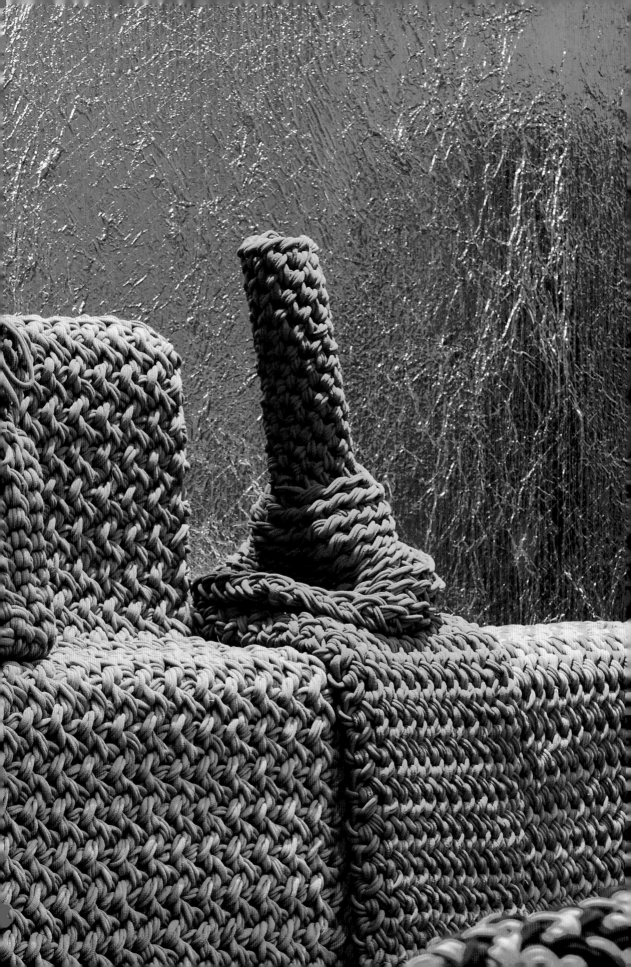

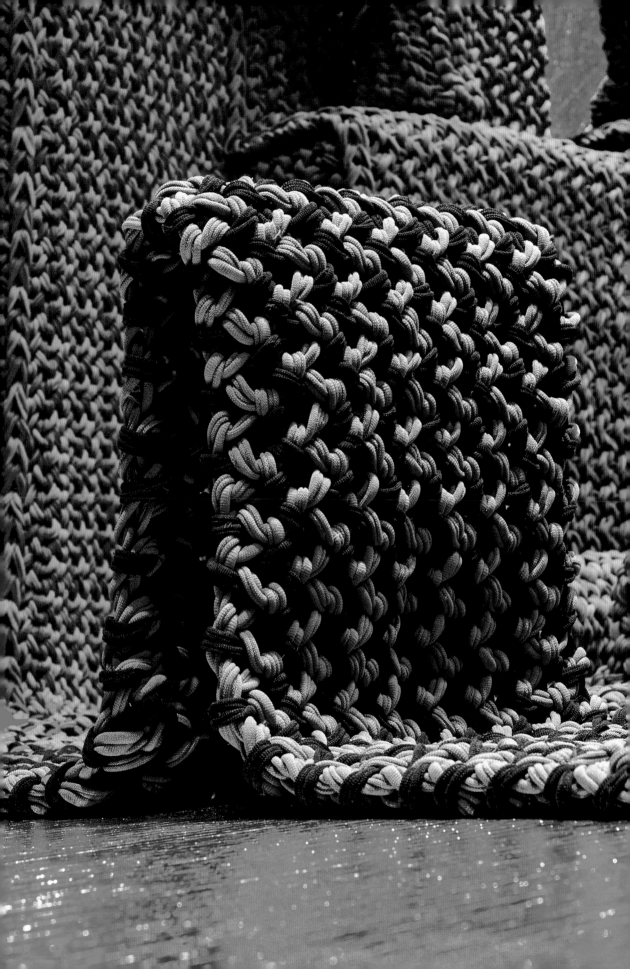

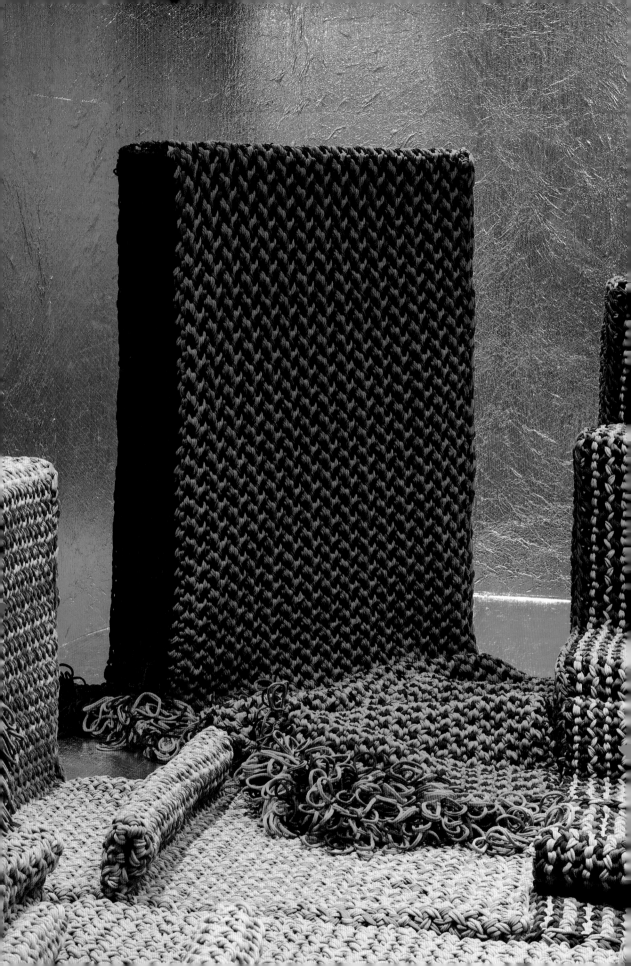

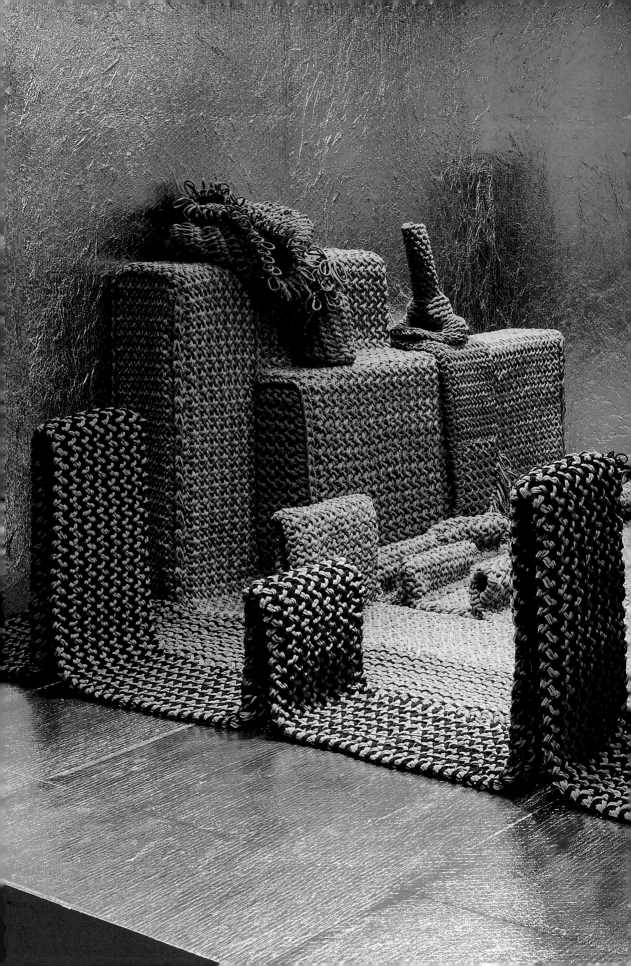

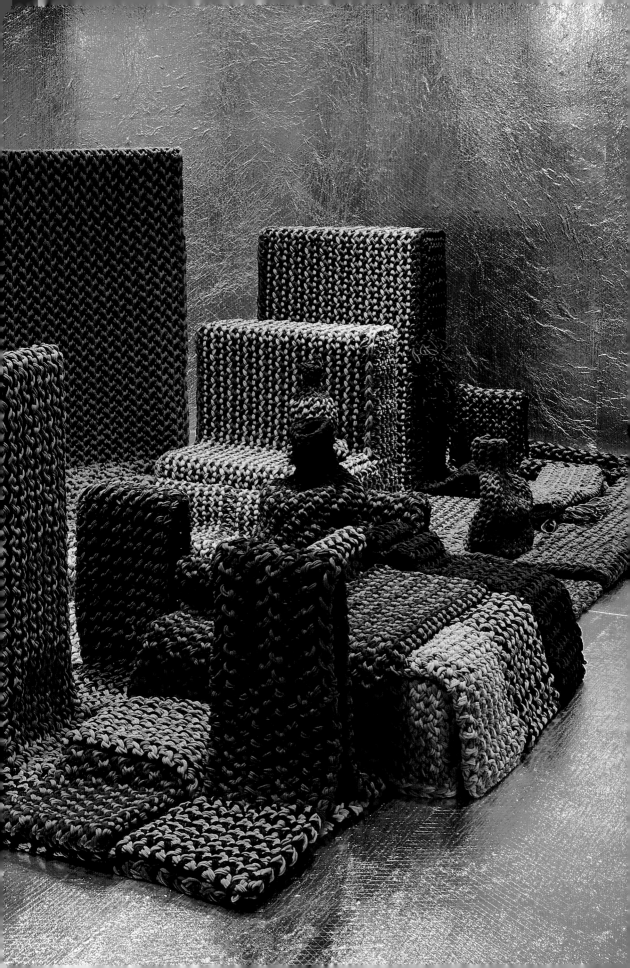

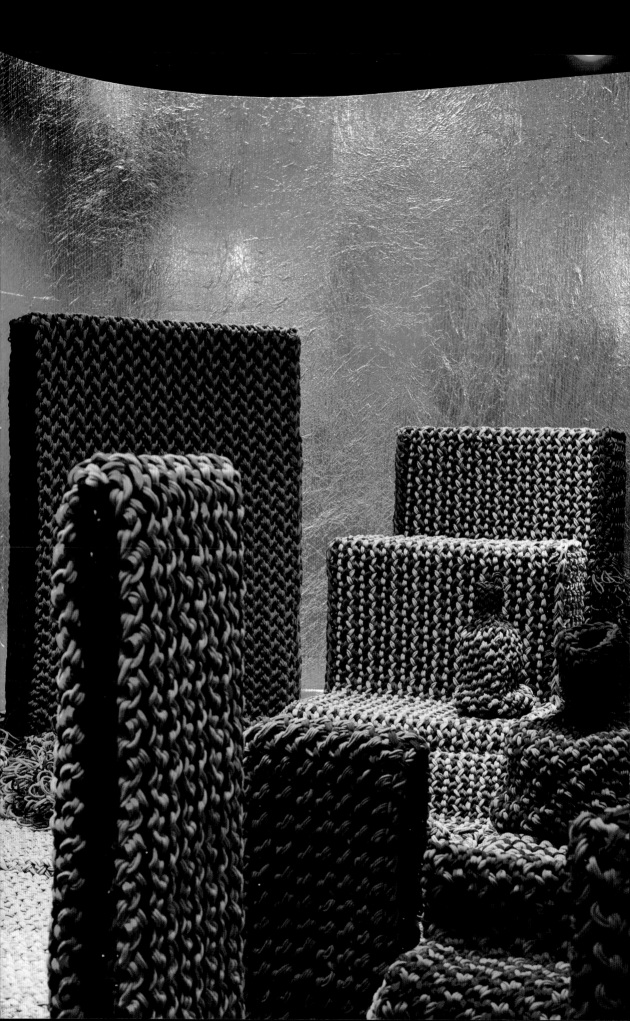

엔오엘

NOL

엔오엘은 KLO의 이광호와 ARR의 남궁교, 오현진으로 이루어진 공간 프로젝트 그룹이다. 재료를 탐구하고 재료가 가진 이야기를 담은, '공간 안에서의 포괄적 탐구'라는 공감대에서 출발해 다양한 공간들을 만들어 왔다. 유연한 곡선을 따라 이어지는 명확한 공간적 분할과 은박 소재의 반사와 흡수에 따른 다채로운 색감은 공간에서 발생할 수 있는 모든 사물들을 아우르며 공간의 생기와 활력을 풍만하게 한다. 또한, 독특한 재료의 잠재력을 바탕으로 우리에게 부여한 비일상적 경험은 소통의 장벽을 낮추고, 전복적인 상상이 가능하도록 한다.

NOL is a space project group formed by Lee Kwangho from KLO and Namkoong Kyo and Oh Hyunjin from ARR. Exploring materials and capturing the narratives held within the materials, the collective has been giving shape to various spaces that take off from the consensus of "comprehensive exploration within space." The clear spatial division along the flexible curve and the vibrant colors resulting from the reflection and absorption of silver materials encompass all the things that can be generated in a space, and enhance the vigor and vitality of the space. In addition, the unusual experiences presented to the audience based on the potential of unique materials bring down the usual barriers to communication and enable subversive imagination.

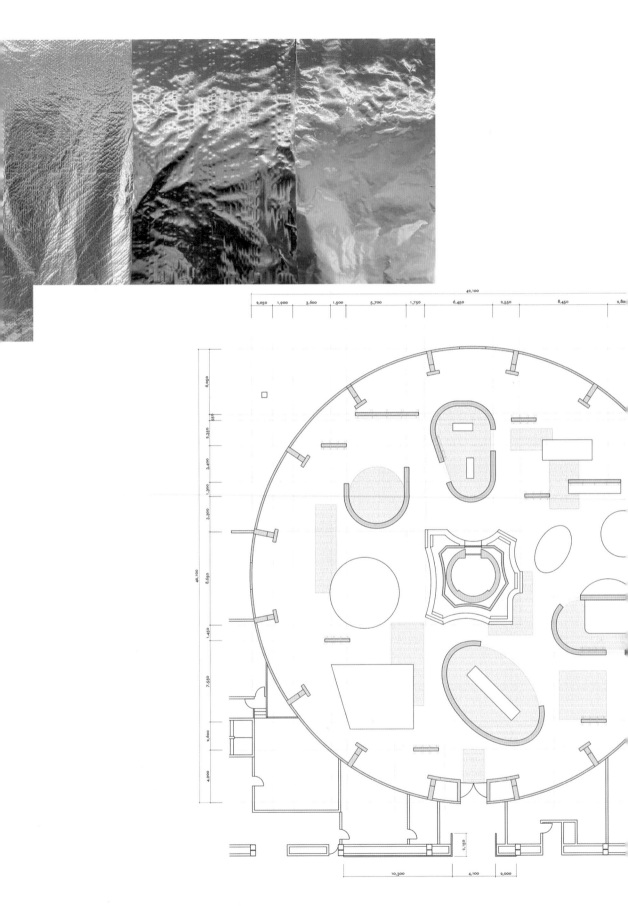

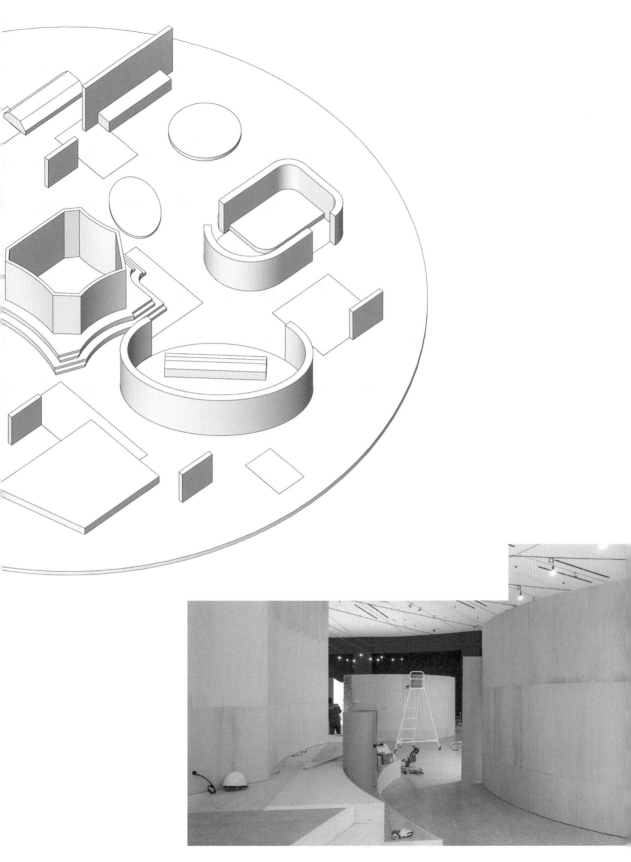

도화진 　이번 전시 공간 디자인 컨셉과 은박이라는 독특한 소재를 선정하게 된 이유가 있을까요?

NOL (남궁교, 오현진, 이광호) 　저희가 전시장에서 하나하나의 작품을 보고 느끼듯이 공간 자체가 작품과 잘 어우러져 하나의 공간적 경험이나 풍경으로서 느낄 수 있는 전시공간을 디자인하고자 했어요. 그리고 간결하지만 조형미를 갖춘 벽체들과 좌대를 이용해서 작가별로 공간을 구획해서 기존의 밍밍한 동선과 시선을 정리하고 싶었어요. 특히 전시공간의 벽체는 반드시 작품을 위해서 배경으로만 존재해야 할까, 무언가 시너지를 만들어 낼 수 없는지 등 다양한 의문점을 갖고 시작한 작업이에요.

　벽체의 표현 방식을 다양하게 연출하기 위해 연질 성질의 은박을 구겨 바르거나 펴 바르는 단순한 방법으로 은박의 텍스쳐를 표현했어요. 원형 공간 안에 은박 벽체들은 주변의 빛을 흡수하고 반사하게 되는데요, 빛과 그림자, 그리고 사람들의 움직임을 벽체를 통해 경험하도록 유도해요. 또한 작품의 물성이나 형태, 재료의 색감에 따라 작품을 보고 공간을 체험하는 느낌도 달라지지 않을까 생각해요. 동시에 공간의 조명도 중요했는데요, 와이어를 이용해서 적절한 조명의 높이를 테스트 하면서 공간과 작품이 모두 잘 어울릴 수 있는, 약간 모호한 조도를 보여주고자 했어요.

Do Hwajin 　What is the reason you chose this concept of space design as well as the unique material of silver foil for this exhibition?

NOL (Namkoong Kyo, Oh Hyunjin, Lee Kwangho) 　Just as we see and feel each individual works in the exhibition space, we wanted to design an exhibition space that harmonizes with the works and the space can be felt as an experience or a landscape. Dividing the space by each artist using simple but structurally beautiful walls and pedestals, we wanted to construct an organized sense of perspective and movement. We started questioning if the walls in an exhibition space must exist only as the background for the works, and if some synergy couldn't be created.

　The tinfoil was simply crumpled or smoothed out to express its texture and to create various ways of conveying the wall. The tinfoil walls in the cylindrical space absorb and reflect the surrounding light, allowing the audience to experience light, shadows and human movements. The walls help you to experience the space and see the works according to the properties, forms, colors and materials of the works. Lighting design was also important. Testing the appropriate height of lighting using wire, we wanted an ambiguous intensity of illumination that supports both the space and the works.

〈물결 시리즈〉, 2021, 스테인리스 스틸,
800×1000×400 mm

Wave Series, 2021, stainless steel,
800×1000×400 mm

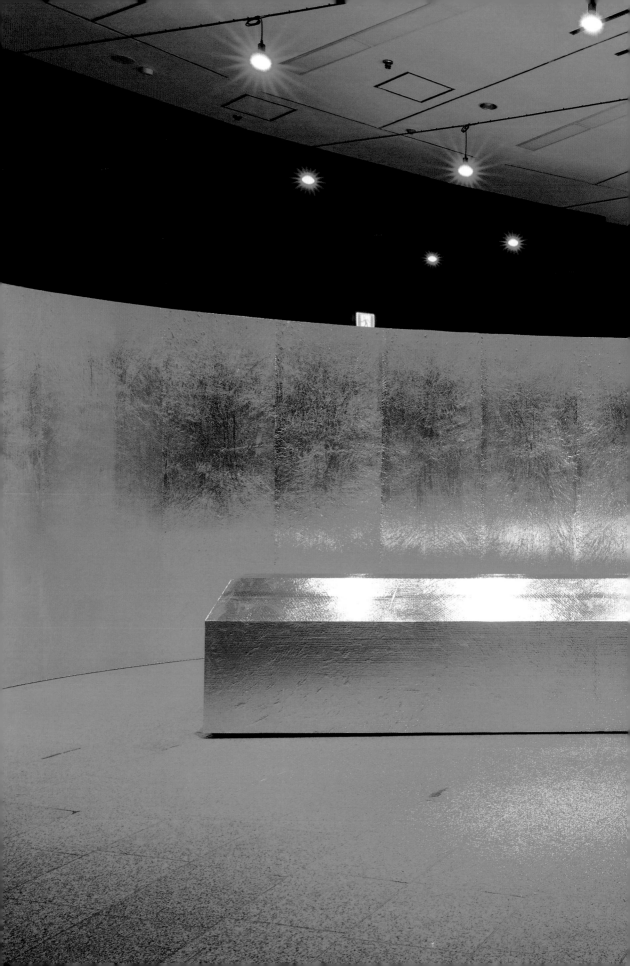

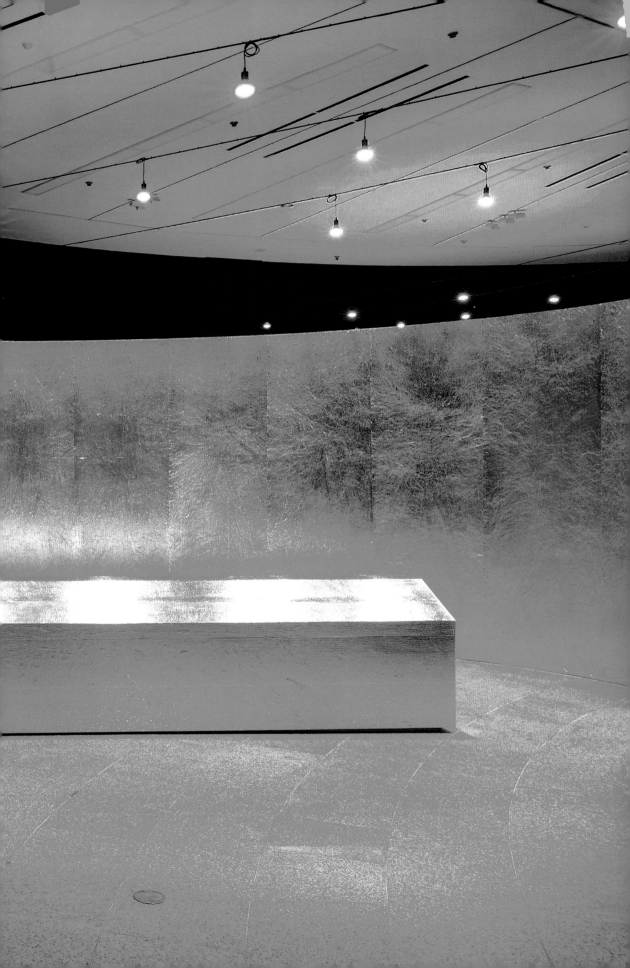

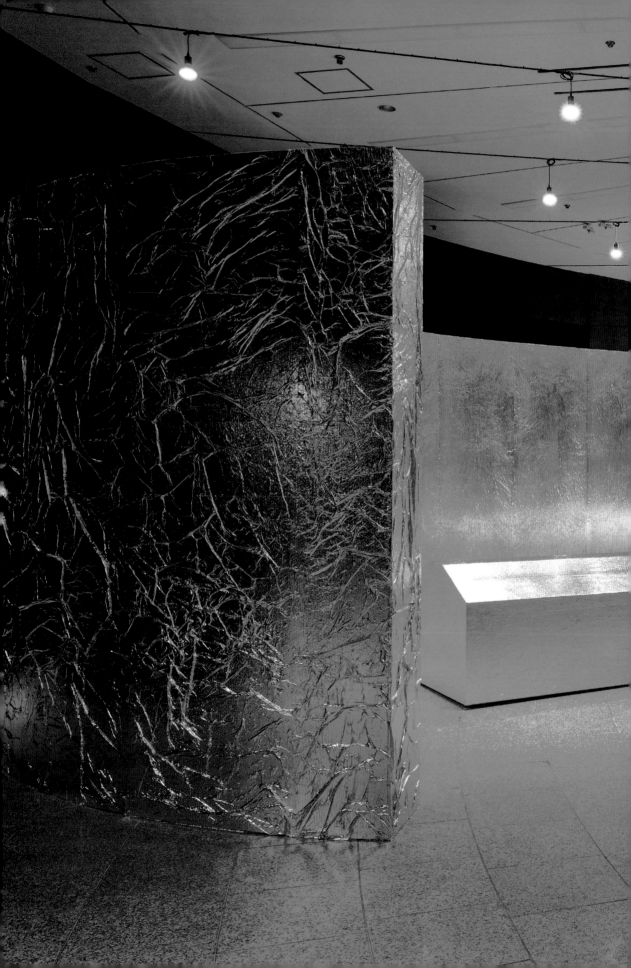

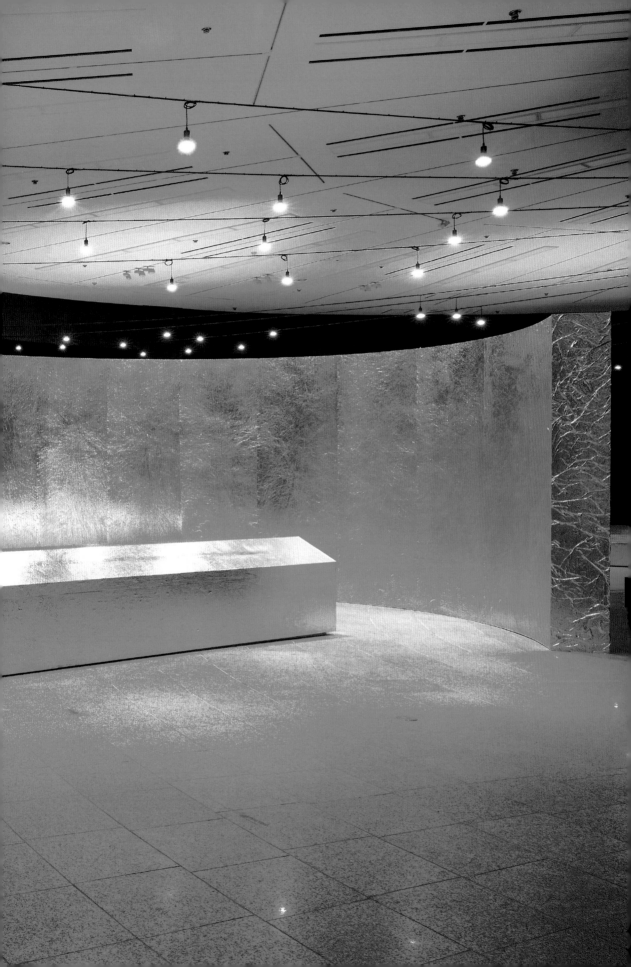

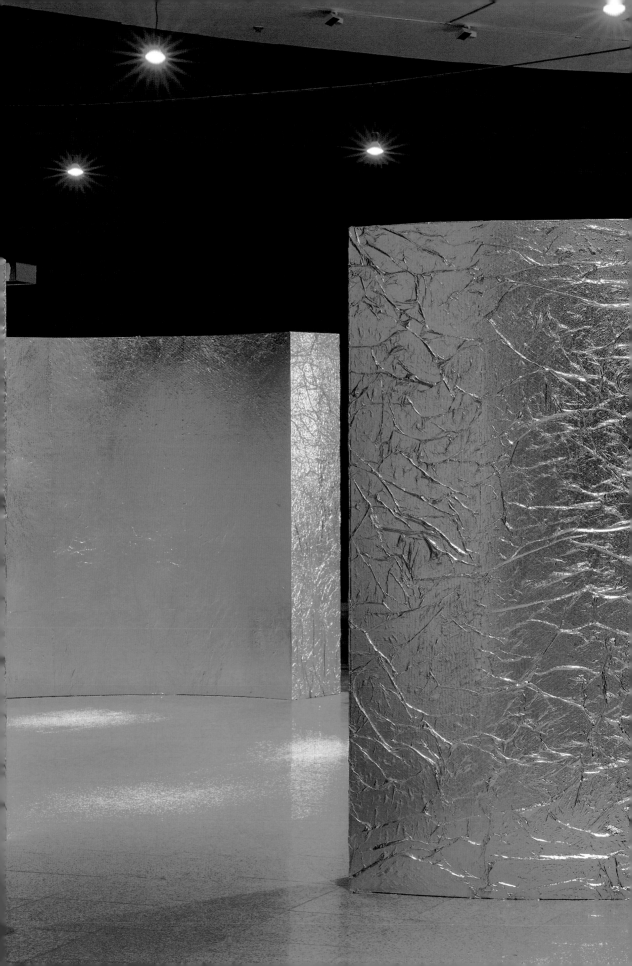

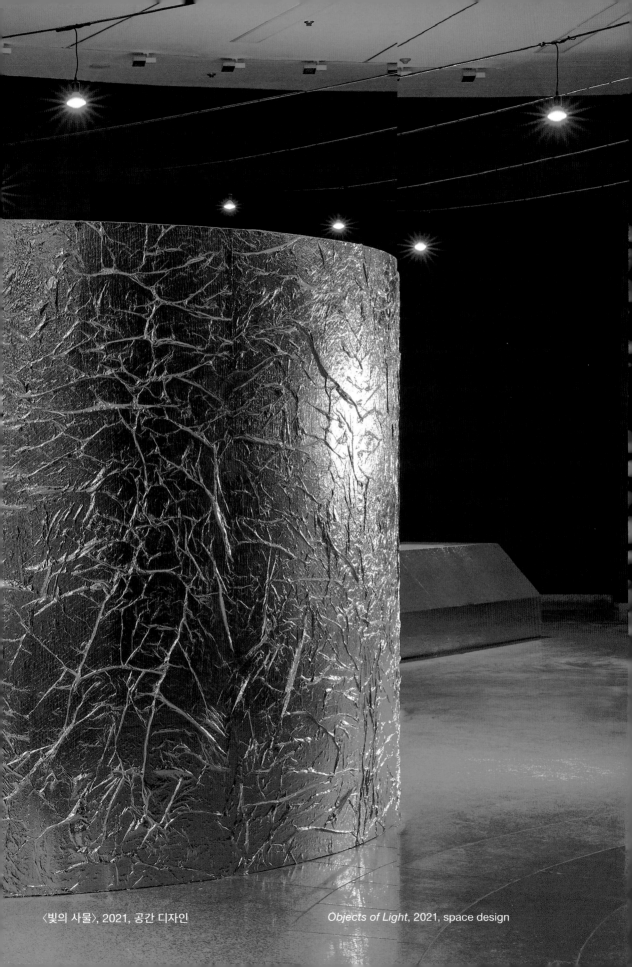

〈빛의 사물〉, 2021, 공간 디자인　　　　　　　　　　　　　　　　*Objects of Light*, 2021, space design

이광호 (b.1981)

학력
2007 홍익대학교, 금속조형디자인, 학사, 서울

주요 개인전
2020 《푸른 구성》, 리안갤러리, 서울
2016 《10년》, 빅터 헌트 갤러리, 브뤼셀, 벨기에
2014 《모호한 사물》, 원앤제이 갤러리, 서울
2012 《매체》, 클리어 갤러리, 롯폰기, 도쿄, 일본
2010 《확장》, 서미 갤러리, 서울
2008 《선으로 된 숲》, 커미세어 갤러리,
 몬트리올, 캐나다

주요 단체전
2021 《아트부산 2021》, 리안갤러리, 부산
2021 《대구아트페어》, 리안갤러리, 대구
2020 《레비고비 X 살롱 94 디자인》, 레비고비,
 마이애미, 미국
2019 광주 디자인 비엔날레
 《휴머니티 HUMANITY
 (HUMAN+COMMUNITY)》, 광주
2019 밀라노 디자인 위크, TIDES, 밀라노, 이탈리아
2018 Poeme-brut, 디자인 뮤지엄 겐트, 겐트, 벨기에

작품 소장
M+ 미술관, 홍콩
대구미술관, 대구
샌프란시스코 미술관, 샌프란시스코, 미국
몬트리올 현대미술관, 몬트리올, 캐나다
리움, 서울
시드니 응용예술_과학 미술관, 시드니, 호주
스와로브스키 크리스탈 미술관, 바텐스, 오스트리아

Lee Kwangho

Education
2007 BFA, Metal Art & Design, Hongik
 University, Seoul, Korea

Selected Solo Exhibitions
2020 *Composition in blue*, Leeahn Gallery,
 Seoul, Korea
2016 *10 years*, Victor Hunt Gallery, Brussels,
 Belgium
2014 *Indefinite objects*, ONE AND J. Gallery,
 seoul, Korea
2012 *Medium*, Clear gallery, Roppongi,
 Tokyo, Japan
2010 *Extension*, Gallery Seomi, Seoul, Korea
2008 *Like a forest of wire*, Commissaires
 Gallery, Montreal, Canada

Selected Group Exhibitions
2021 *ART BUSAN 2021*, Leeahn galley,
 Busan, Korea
2021 *Daegu Art Fair*, Leeahn gallery, Daegu,
 Korea
2020 *Levy Gorvy X Salon 94 design*, Levy
 Gorvy, Miami, USA
2019 *Gwangju Design Biennale, HUMANITY
 (HUMAN+COMMUNITY)*, Gwangju, Korea
2019 *TIDES*, Milan Design Week, Milan, Italy
2018 *Poeme-brut*, Design Museum Gent,
 Belgium

Collections
M + Museum, Hongkong
Daegu Art Museum, Daegu, Korea
San Francisco Museum of Modern Art, San
 Francisco, USA
The Montreal Museum of Fine Arts, Montreal,
 Canada
Leeum, Seoul, Korea
MAAS Museum, Sydney, Australia
Swarovski Crystal Museum, Wattens, Austria

서정화 (b.1982)

학력
2010 네덜란드 디자인 아카데미 아인트호벤,
 컨텍스츄얼 디자인(Contextual Design),
 석사, 아인트호벤, 네덜란드
2007 홍익대학교, 금속조형디자인, 학사, 서울

주요 개인전
2019 *Volume*, 가나아트 한남, 서울

주요 단체전
2020 《집들이 ; 공예》, 청주시 한국공예관, 청주
2019 제3회 한글실험 프로젝트 《한글디자인:
 형태의 전환》, 국립한글박물관, 서울
2018 *UNSIGHTED*, House of Demons,
 밀라노, 이탈리아
2016 《코리아 나우_2016 한국공예디자인
 뮌헨전》, 바이에른 국립박물관, 뮌헨, 독일
2016 *Making is Thinking is Making*, 트리엔날레
 디자인 뮤지엄, 밀라노, 이탈리아
2016 *Harmony of Materials*, 소피스 갤러리, 서울
2015 《지금, 한국!》, 파리 장식미술관, 프랑스
2015 《손의 축제》, 서울시립 북서울미술관, 서울

작품 소장
국립중앙박물관
국립한글박물관

Seo Jeonghwa

Education
2010 MA, IM(contextual design), Design
 Academy Eindhoven, Netherlands
2007 BFA, Metal Art & Design, Hongik
 University, Seoul, Korea

Selected Solo Exhibitions
2019 *Volume*, Gana Art Hannam, Seoul, Korea

Selected Group Exhibitions
2020 *HOUSE OF CRAFT*, Cheongju City
 Korean Craft Museum, Cheongju, Korea
2019 *The 3rd Hangeul Design Project
 -Transformations: Experiment in
 Hangeul design*, National Hangeul
 Museum, Seoul, Korea
2018 *UNSIGHTED*, House of Demons,
 Milano, Italy
2016 *KOREA NOW in Munich 2016
 Contemporary Korean Crafts &
 Design*, Bavarian National Museum,
 Munich, Germany
2016 *Making is Thinking is Making*, Triennale
 Design Museum, Milano, Italy
2016 *Harmony of Materials*, Sophis Gallery,
 Seoul, Korea
2015 *Korea Now!*, Musée des arts décoratifs
 de Paris, France
2015 *Festival of Hands*, Buk-Seoul Museum
 of Art, Seoul, Korea

Collections
National Museum of Korea, Korea
National Hangeul Museum, Korea

신혜림 (b.1971)

학력
2004 국민대학교, 금속공예, 석사, 서울
1995 국민대학교, 공예미술, 학사, 서울

주요 개인전
2017 《태양과 달, 사람을 잇다》, 갤러리일상, 서울
2016 《비를 그리니 빗방울이 만들어졌습니다》,
 갤러리아원, 서울
2010 Mind Map Revisited, 갤러리HL, 서울
2009 《Mind Map_마음의 지도》,
 가나아트스페이스, 서울
2004 《보여주는 이야기》, 크라프트하우스, 서울

주요 단체전
2021 《한국의 색, 어제와 오늘》, 카자흐스탄
 대통령 박물관, 누르술탄, 카자흐스탄
2019 SOFA CHICAGO 2019, Navy Pier
 Festival Hall, 시카고, 미국
2018 《시간의 여정》, 스페인 국립장식박물관,
 마드리드, 스페인
2017 Schmuck 2017, 뮌헨 메쎄 전시장, 뮌헨, 독일
2016 《코리아 나우_2016 한국공예디자인
 뮌헨전》, 바이에른 국립박물관, 뮌헨, 독일
2015 COLLECT 2015, 사치 갤러리, 런던, 영국

작품 소장
국립현대미술관
서울공예박물관, 서울
RIAN Design Museum, 팔켄베리, 스웨덴

Shin Healim

Education
2004 MFA, Metal Craft, Kookmin University,
 Seoul, Korea
1995 BFA, Metal Craft, Kookmin University,
 Seoul, Korea

Selected Solo Exhibitions
2017 *Sun and moon, Connecting peoples*,
 Gallery Ilsang, Seoul, Korea
2016 *I painted rain, which became raindrops*,
 Gallery Ahwon, Seoul, Korea
2010 *Mind Map Revisited*, Gallery HL,
 Seoul, Korea
2009 *Mind Map*, Gana Art Space, Seoul, Korea
2004 *The Visual Story*, Craft House, Seoul, Korea

Selected Group Exhibitions
2021 *Korean Colour, Yesterday and Today*,
 The Library of the First President of
 the Republic of Kazakhstan-Elbasy,
 Nur-Sultan, Kazakhstan
2019 *SOFA CHICAGO 2019*, Navy Pier
 Festival Hall, Chicago, USA
2018 *THE JOURNEY OF TIME*, Museo
 Nacional de Artes Decorativas,
 Madrid, Spain
2017 *Schmuck 2017*, Munich Messe,
 Munich, Germany
2016 *KOREA NOW in Munich 2016
 Contemporary Korean Crafts &
 Design*, Bavarian National Museum,
 Munich, Germany
2015 *COLLECT 2015*, Saatchi Gallery,
 London, UK

Collections
National Museum of Modern and Contemporary
 Art, Korea
Seoul Museum of Craft Art, Seoul, Korea
RIAN Design Museum, Falkenberg, Sweden

현광훈 (b.1981)

학력
2021 홍익대학교, 금속조형디자인, 박사, 서울
2012 홍익대학교, 금속조형디자인, 석사, 서울
2007 홍익대학교, 금속조형디자인, 학사, 서울

주요 개인전
2020 *Alternate History_CLOCK*, 스페이스
 금채, 서울
2019 《톱니바퀴, 움직임을 잇다》, HOMA, 서울
2018 《그 남자의 공예 : 현광훈 금속공예전》,
 디티에이블, 서울
2017 《Cabinotier 현광훈 개인전》,
 체어스온더힐, 서울

주요 단체전
2019 《메종&오브제》, 노르 빌르뱅트 전시 센터,
 파리, 프랑스
2018 《한국 철 공예와 주거 문화-세대를
 잇는 작업, 이음전》, 국가 무형 문화재
 전수교육관, 서울
2018 《크래프트 리턴》, KCDF 갤러리, 서울
2017 *Munich Creative Business Week 2017*,
 Goldberg Studio, 뮌헨, 독일
2013 《베이징 국제 현대 금속 미술전》, 중국
 천년 기념비 관리 센터, 베이징, 중국

Hyun Kwanghun

Education
2021 PhD, Metal Art & Design, Hongik
 University, Seoul, Korea
2012 MFA, Metal Art & Design, Hongik
 University, Seoul, Korea
2007 BFA, Metal Art & Design, Hongik
 University, Seoul, Korea

Selected Solo Exhibitions
2020 *Alternate History_CLOCK*, Space
 Keumchae, Seoul, Korea
2019 *Cogwheel, Connecting the movement*,
 HOMA, Seoul, Korea
2018 *The Crafts of the man : Metal Works
 of Hyun Kwanghun,* DT.able Gallery,
 Seoul, Korea
2017 *Cabinotier*, Chairs on the Hill Gallery,
 Seoul, Korea

Selected Group Exhibitions
2019 *Maison & Objet*, The Parc des
 Expositions de Paris-Nord Villepinte,
 Paris, France
2018 *Korean iron crafts and housing
 culture-Work that connects
 generations: ieum*, National Intangible
 Heritage Center, Seoul, Korea
2018 *Craft Return*, KCDF Gallery, Seoul, Korea
2017 *Munich Creative Business Week 2017*,
 Goldberg Studio, Munich, Germany
2013 *Beijing International Contemporary
 Metal Art Exhibition*, China Millennium
 Monument Administration Center,
 Beijing, China

이상민 (b.1979)

학력
2011 경기대학교, 금속디자인, 석사, 수원
2008 경기대학교, 금속디자인, 학사, 수원

주요 개인전
2021 《크래프트 브로 컴퍼니 10주년》,
 뉴스프링프로젝트, 서울
2019 *MY KIND OF BESPOKE FURNITURE*,
 AREA+, 서울
2016 *100 Objects*, 완물취미, 서울
2015 *LightHouse of Home*, 아트스페이스
 남케이, 서울
2014 *Craft Bro. Company_Beyond Ordinary*,
 메종 르베이지, 서울
2013 《이상민 초대 개인전_analog studio》,
 갤러리 보고재, 서울

주요 단체전
2019 《메종&오브제》, 노르 빌르뱅트 전시 센터,
 파리, 프랑스
2017 《랑데부, 그녀를 만나다》, 플랫폼엘, 서울
2016 공예트렌드페어 주제관 《가치, 또 다른
 새로움》, 코엑스, 서울
2015 《움직이는 공작소 TIME》, 갤러리 아원, 서울
2013 《금속공예가의 조명-빛을 내는 사물》,
 갤러리 로얄, 서울

Lee Sangmin

Education
2011 MFA, Jewelry Metal Design, Kyonggi
 University, Suwon, Korea
2008 BFA, Jewelry Metal Design, Kyonggi
 University, Suwon, Korea

Selected Solo Exhibitions
2021 *Craft Bro. Company 10 anniversary*,
 NewSpring's Project, Seoul, Korea
2019 *MY KIND OF BESPOKE FURNITURE*,
 AREA+, Seoul, Korea
2016 *100 objects*, Wanmulchwimi, Seoul,
 Korea
2015 *LightHouse of Home*, Art Space NAM.
 K, Seoul, Korea
2014 *Craft Bro. Company_Beyond Ordinary*,
 Maison Le Beige , Seoul, Korea
2013 *Invitational Exhibition of Gallery
 VOGOZE-analog studio*, VOGOZE,
 Seoul, Korea

Selected Group Exhibitions
2019 *Maison & Objet*, The Parc des
 Expositions de Paris-Nord Villepinte,
 Paris, France
2017 *Rendez-Vous*, PLATFORM-L, Seoul,
 Korea
2016 *Craft Trend Fair, Heritage to Originality*,
 COEX, Seoul, Korea
2015 *Movement Studio 'TIME'*, Craft
 Ahwon, Seoul, Korea
2013 *The lighting of metal craftsmen-
 Luminous Object*, Gallery Royal,
 Seoul, Korea

이헌정 (b.1967)

학력
2008 가천대학교, 건축, 박사 과정 수료, 성남
1996 샌프란시스코 아트 인스티튜트, 조각, 석사,
 샌프란시스코, 미국
1995 홍익대학교, 도예, 석사, 서울
1991 홍익대학교, 도예, 학사, 서울

주요 개인전
2021 《흙의 일상》, 아라리오뮤지엄 인 스페이스,
 서울
2020 《이헌정의 도자, 만들지 않고 태어난》,
 박여숙화랑, 서울
2019 《서핑》, 일우아트스페이스, 서울
2018 《이헌정 : 세 개의 방》, 소피스갤러리, 서울

주요 단체전
2020 《아트부산 2020》, 부산
2020 Korean Ceramics, 메섬스 런던, 영국
2019 한국-필리핀 수교 70주년 한국공예전
 《생활미학》, 마닐라 메트로폴리탄 미술관,
 필리핀
2018 SOFA CHICAGO 2018, Navy Pier
 Festival Hall, 시카고, 미국
2017 《한국공예의 법고창신 2017-한국도자의
 정중동》, 트리엔날레 밀라노
 디자인 뮤지엄, 밀라노, 이탈리아 /
 주영국한국문화원, 런던, 영국

작품 소장
아치 브레이 재단 센터, 몬타나, 미국
디자인하우스
핀크스 비오토피아, 제주
정림건축, 서울
본태박물관, 제주
아라리오뮤지엄 탑동시네마, 제주
아라리오뮤지엄, 제주
구하우스, 양평
LH Project

Lee Hunchung

Education
2007– PhD, Architecture, Gachon University,
 Seongnam, Korea
1996 MFA, Sculpture, San Francisco Art
 Institute, San Francisco, USA
1995 MFA, Ceramic Sculpture, Hongik
 University, Seoul, Korea
1991 BFA, Ceramic Sculpture, Hongik
 University, Seoul, Korea

Selected Solo Exhibitions
2021 Daily Life of Clay, ARARIO MUSEUM in
 SPACE, Seoul, Korea
2020 Lee Hun-Chung Ceramic art, Born
 without Making, Park Ryu Sook Gallery,
 Seoul, Korea
2019 Surfing, ILWOO ART Space, Seoul, Korea
2018 The Rooms with Three Stories, Sophis
 Gallery, Seoul, Korea

Selected Group Exhibitions
2020 ART BUSAN 2020, Busan, Korea
2020 Korean Ceramics, Messums London, UK
2019 Korea Craft Exhibition celebrating the
 PHL-KOR 70th anniversary of Diplomatic
 Relations, Korean Life Aesthetics,
 Metropolitan Museum of Manila, Philippines
2018 SOFA CHICAGO 2018, Navy Pier Festival
 Hall, Chicago, USA
2017 Constancy and Change in Korean
 Traditional Craft 2017 Between Serenity
 and Dynamism; Korean Ceramics,
 Triennale di Milano, Milano, Italy / Korean
 Cultural Centre UK, London, UK

Collections
Archie Bray Foundation Center, Montana, USA
Design House
PINX BIOTOPIA, Jeju, Korea
JUNGLIM Architecture, Seoul, Korea
bonte museum, Jeju, Korea
ARARIO MUSUEM TAPDONG CINEMA, Jeju, Korea
ARARIO MUSEUM JEJU, Jeju, Korea
KOO HOUSE, Yangpyeong, Korea
LH Project

이준아 (b.1984)

학력

2012	파슨스 디자인 스쿨, 패션디자인, 학사, 뉴욕, 미국
2008	가톨릭대학교, 경영학, 학사, 부천

주요 단체전

2021	《예술선물》, 스페이스엄, 서울
2020	《개인의 취향》, 스페이스엄, 서울
2020	*This is Paper*, Space B-E, 서울
2020	《이기적 사물》, 온유갤러리, 안양
2019	신당창작아케이드 10주년 기념전 《Quantum Leap: 비약적 도약》, 송원아트센터, 서울
2019	*Craft Pairing*, Space B-E, 서울
2018	신당창작아케이드 9기 입주작가 전시 《23.1 제곱미터》, S FACTORY, 서울
2018	《평창동계올림픽 잠실대로 공공미술 프로젝트》, 서울
2017	신당창작아케이드 8기 입주작가 전시 《미공창고》, 체어픽, 서울
2012	*Parsons Benefit Fashion Show*, Pier Sixty, 뉴욕, 미국

Lee Joona

Education

2012	BFA, Fashion Design, Parsons School of Design, New York, USA
2008	BBA, Business Administration, Catholic University of Korea, Bucheon, Korea

Selected Group Exhibitions

2021	*The Art of Gifting*, SPACE UM, Seoul, Korea
2020	*Personal Preference*, SPACE UM, Seoul, Korea
2020	*This is Paper*, Space B-E, Seoul, Korea
2020	*Selfish Things*, Gallery Onyou, Anyang, Korea
2019	*Project Exhibition to celebrate the 10th Anniversary of Seoul Art Space Sindang, Quantum Leap*, Songwon Art Center, Seoul, Korea
2019	*Craft Pairing*, Space B-E, Seoul, Korea
2018	*Residency Exhibition of Seoul Art Space Sindang, 23.1 Square Meters*, S FACTORY, Seoul, Korea
2018	*Public Installation for Pyeong Chang Winter Olympics on Jamsil Road*, Seoul, Korea
2017	*Residency Exhibition of Seoul Art Space Sindang, Migong Changgo*, Chairpick, Seoul, Korea
2012	*Parsons Benefit Fashion Show*, Pier Sixty, New York, USA

엔오엘

주요 작업
2019 무신사 테라스
2018 앤트러사이트 연희
2017 오설록 1979

남궁교 (b.1984)
주요 경력
2019– arr 아르 공간디자인 사무실 설립
2017– NOL 엔오엘 프로젝트 그룹 결성
2011–2014 flat.m 플랏엠 디자인 사무실

오현진 (b.1988)
주요 경력
2019– arr 아르 공간디자인 사무실 설립
2017– NOL 엔오엘 프로젝트 그룹 결성
2014–2016 네임리스 건축
2012–2014 flat.m 플랏엠 디자인 사무실

이광호 (b.1981)
177p 약력 참조

NOL

Main Projects
2019 musinsa terrace
2018 anthracite yeonhui
2017 osulloc 1979

Namkoong Kyo
Selected Careers
2019– arr design office establishment
2017– NOL project group
 establishment
2011–2014 flat.m design office

Oh Hyunjin
Selected Careers
2019– arr design office establishment
2017– NOL project group
 establishment
2014–2016 NAMELESS architecture
2012–2014 flat.m design office

Lee Kwangho
Refer to 177p

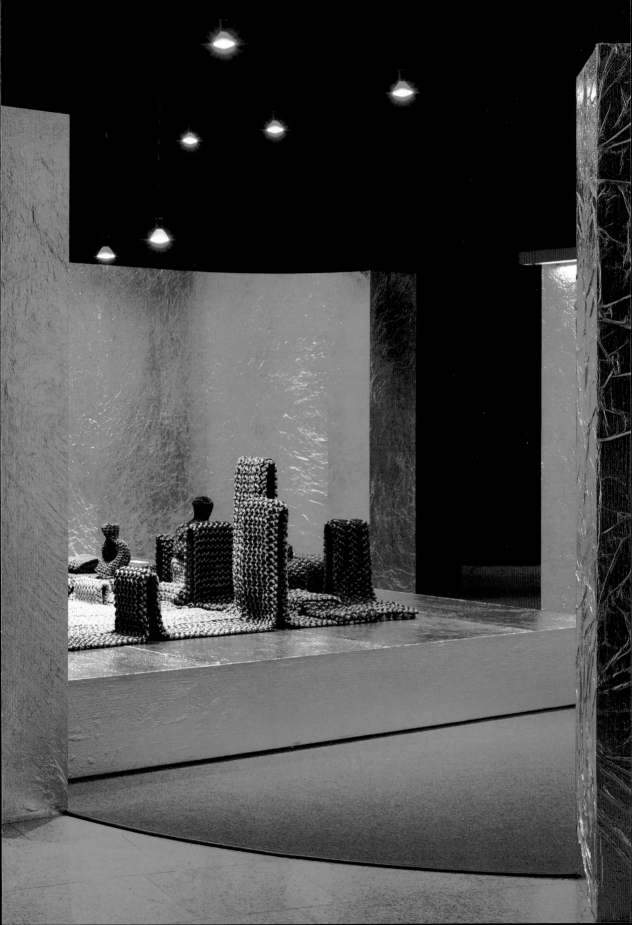

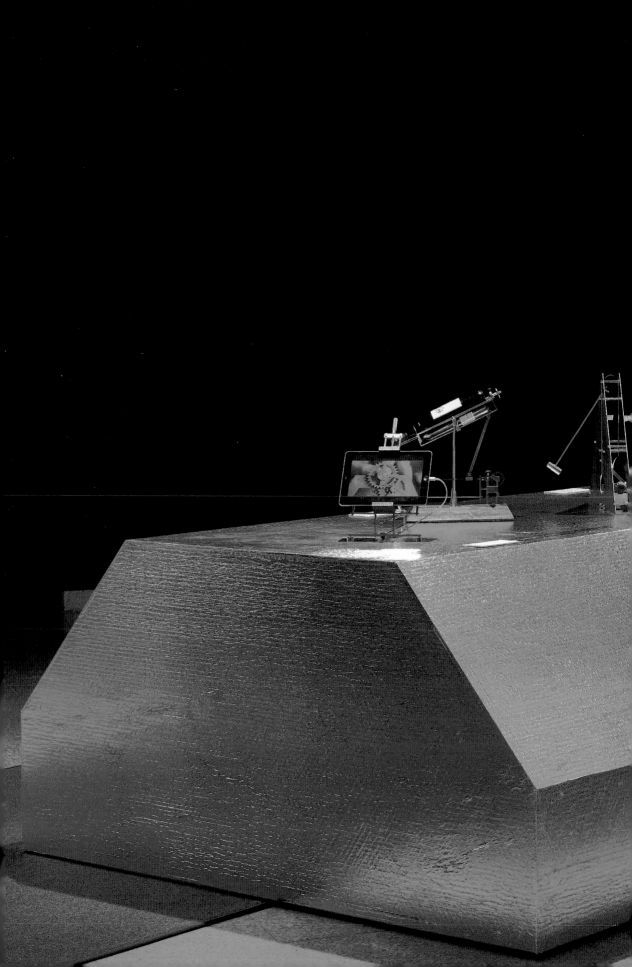

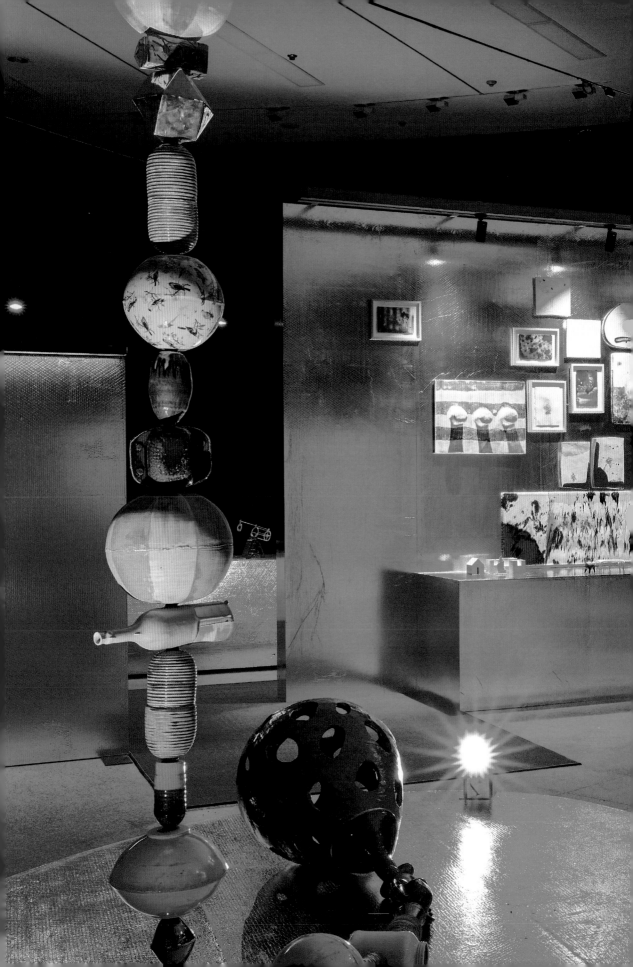

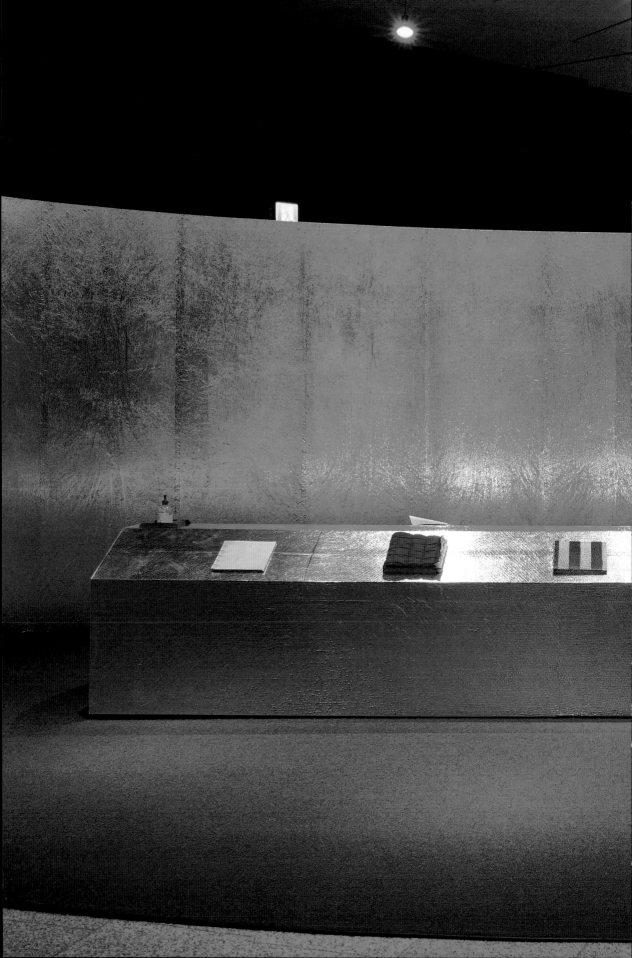

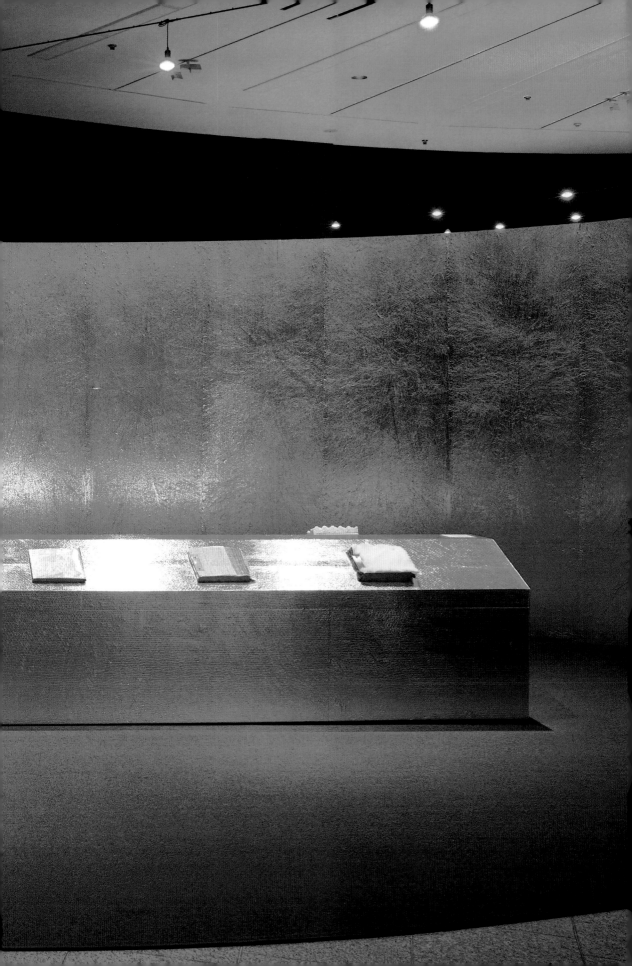